Sweden: A Royal Treasury

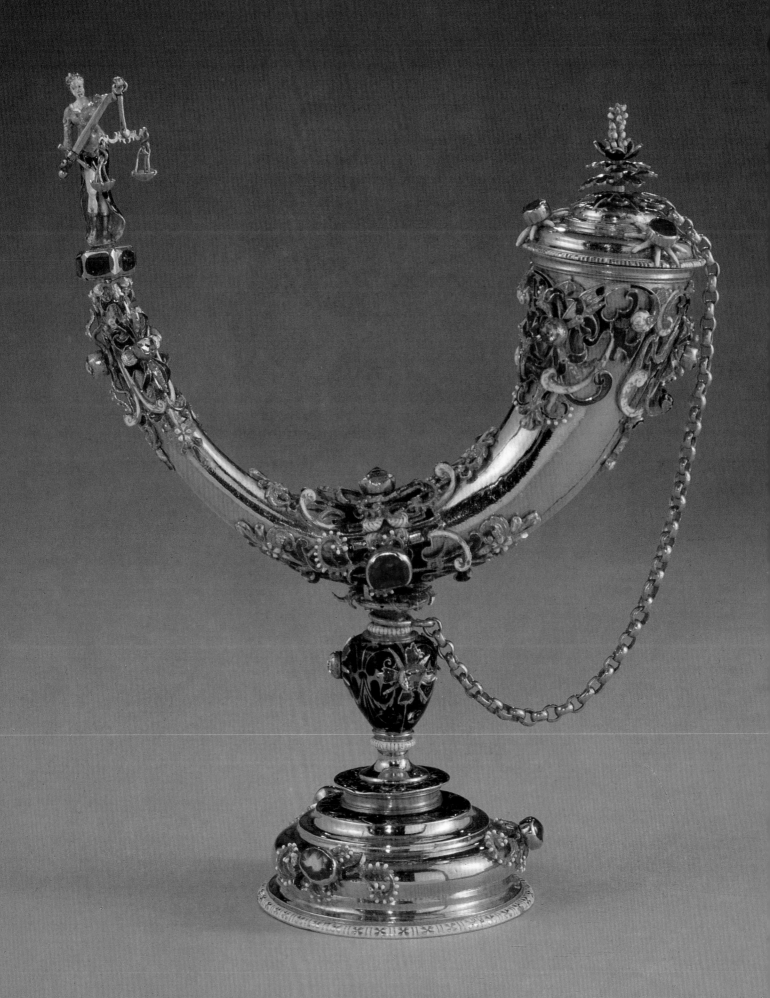

SWEDEN

A Royal Treasury
1550-1700

Michael Conforti and Guy Walton

Editors

National Gallery of Art, Washington

The Minneapolis Institute of Arts

This exhibition is made possible through contributions from The Boeing Company, the Federation of Swedish Industries, and the Swedish Government. It is indemnified by the Federal Council on the Arts and the Humanities

Exhibition dates
National Gallery of Art, Washington, 13 April–5 September 1988
The Minneapolis Institute of Arts, 9 October 1988–1 January 1989

The catalogue was produced by the Editors Office, National Gallery of Art, Washington, and is distributed by the University of Chicago Press

Edited by Tam L. Curry
Designed by Melanie B. Ness

Printed by Princeton Polychrome Press, Princeton, New Jersey, on eighty-pound Warren's lustro offset enamel
The type is Meridien, set by VIP Systems, Inc., Alexandria, Virginia

COVER ILLUSTRATION: Detail, cat. 51, courtesy Royal Armory
(photo by Göran Schmidt)
FRONTISPIECE: Cat. 3, courtesy the Treasury, Royal Palace
(photo by Sven Nilsson)

Library of Congress catalog card number: 88–5225

ISBN 0-89468-111-7

Contents

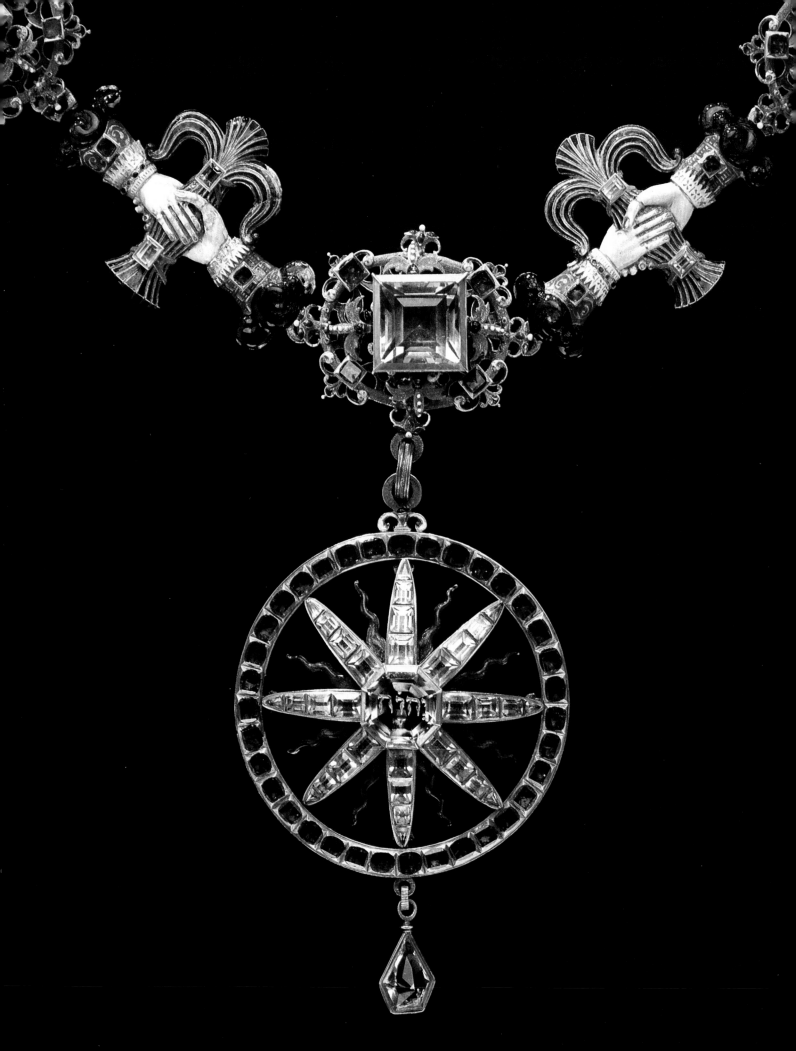

Directors' Foreword

As early as the first century after Christ, Tacitus saw fit to mention the powerful king of the Swedes in his *Germania*, thus documenting the prestige of a monarchy that has spanned many centuries. This exhibition, *Sweden: A Royal Treasury 1550–1700*, focuses on that glittering epoch, which began with the rule of Gustav Vasa and ended with the death of Charles XII. During this period of a century and a half, Sweden's royal house acquired the splendid trappings that we have come to associate with Europe's late Renaissance and baroque courts. As diplomatic gifts, as crown commissions, and as perquisites of victory, sumptuous decorative arts came to furnish the reigns of Sweden's remarkable monarchs. These national treasures have never been seen in the United States, and many of them have never traveled outside of Sweden.

The timing of this exhibition has been chosen to coincide with the 350th anniversary of the founding of the first permanent Swedish settlement in the United States. In 1638 two Swedish ships landed at the mouth of the Delaware River, near present-day Wilmington, and the resulting colony encompassed most of Delaware as well as parts of New Jersey and Pennsylvania. In honor of this historic event a joint congressional resolution passed in May 1987 that proclaimed 1988 "The Year of New Sweden." This exhibition is the primary artistic enterprise in the year-long celebration *New Sweden '88*, which commemorates not only this important anniversary but also the warm ties that Sweden and the United States have enjoyed for so many years.

To Their Majesties King Carl XVI Gustaf and Queen Silvia of Sweden we would like to convey our grati-tude for their gracious willingness to open the exhibition in Washington. Their Majesties' interest in *Sweden: A Royal Treasury 1550–1700* has enhanced this project immeasurably from the outset.

Special thanks go to our colleagues in Sweden, particularly Agneta Lundström, director of the Royal Armory; Bo Vahlne, director, and Stig Fogelmarck, former director of the Royal Collections; Per Bjurström, director of the Nationalmuseum; Sven-Eric Nilsson, director-general of the National Judicial Board for Public Lands and Funds; and Arne Losman, director of the Skokloster Castle collection.

The exhibition has been made possible through contributions from The Boeing Company, the Federation of Swedish Industries, and the Swedish Government. It has also been supported in the United States by an indemnity from the Federal Council on the Arts and the Humanities. At the Embassy of Sweden in Washington, His Excellency Count Wilhelm Wachtmeister encouraged the organizers. An indispensable role was played by Count Peder Bonde of Stockholm, chairman of *New Sweden '88*'s working committee. A great number of others, on both sides of the Atlantic, have made essential contributions to the completion of this exhibition, and their names appear below in this catalogue. Our final thanks here go to the Swedish people and their government, who have so generously shared with us their invaluable cultural patrimony.

J. CARTER BROWN
Director
National Gallery of Art

MICHAEL CONFORTI
S. TIMOTHY FISKE
Interim Co-Directors
The Minneapolis Institute of Arts

Detail, cat. 11

Lenders' Preface

THE EXHIBITION *Sweden: A Royal Treasury 1550–1700* has been organized as part of the celebration *New Sweden '88*, commemorating the 350th anniversary of Sweden's first permanent settlement in North America. More than one hundred precious objects—regalia, arms and armor, textiles and costumes, and other works of art associated with the royal family in Sweden during the sixteenth and seventeenth centuries—have been selected to illustrate the splendor that surrounded the monarchy at this time and to provide insights into the political and cultural history of Sweden.

The institutions in Sweden that have lent works to this exhibition are: the Royal Armory, Sweden's oldest museum, founded in 1627; the Royal Collections, which today, as three hundred years ago, care for the furniture, textiles, and works of art in the royal palaces of Sweden; and the Royal Treasury, which exhibits the Swedish regalia, important national symbols under the custody of the National Judicial Board for Public Lands and Funds. Loans have also been included from the National Swedish Art Museums, from Skokloster Castle,

a famous baroque museum near Stockholm, and from Strängnäs Cathedral.

It is the first time these valuable objects have ever been shown in the United States of America. In fact, very few of them have been exhibited outside Sweden before. This is especially true of the regalia, of which only the anointing horn has once crossed the Swedish border.

Thanks to special permission from His Majesty the King of Sweden and the Swedish government, these unique works of art will now be on view to the American public. We hope that this exhibition will enhance the understanding and appreciation in America for the abundant cultural heritage of Sweden.

AGNETA LUNDSTRÖM
The Royal Armory

BO VAHLNE
The Royal Collections

SVEN-ERIC NILSSON
The National Judicial Board for Public Lands and Funds
(Kammarkollegiet)

Acknowledgments

A T THE 1983 International Congress on the History of Art in Vienna, Guy Walton of New York University convinced me to join a group of five French and American scholars in Sweden the following summer. Ulf G. Johnsson, chief curator of the royal castles collections and the portrait collection at Gripsholm Castle, organized a tour of some of the castles and collections that comprise Sweden's artistic heritage. Our group included Danielle Gallet of the Archives Nationales, Paris, Christian Baulez of Versailles, Sir Francis Watson, former director of the Wallace Collection, Gillian Wilson of the J. Paul Getty Museum, and William Howard Adams. As the history of the Swedish royal collections began to unfold for us that July, the idea of mounting a substantial exhibition for America began to take form. In June 1985 Anders Clason, director of the Swedish Institute in Stockholm, and Ulf Lundin, former cultural counselor for Sweden in Washington, asked Guy Walton and me to plan this exhibition in the context of the projected *New Sweden '88* festival.

Sweden: A Royal Treasury 1550–1700 would not have been possible without the commitment and support of the *New Sweden '88* national committee. Count Peder Bonde, chairman of the working committee, and Ambassador Peter Hammarström, secretary general, worked tirelessly to see the exhibition realized. The Princess Christina, Mrs. Magnuson, met with us to discuss the exhibition, and we gratefully acknowledge her interest and encouragement. On this side of the Atlantic, Curtis Carlson, honorary chairman of the American committee for *New Sweden '88*, along with Marilyn Nelson, a member of the American committee, and Betty Throne-Holst, a member of the New York committee, also assisted in preparations for the project.

Agneta Lundström, director of the Royal Armory, agreed to serve as coordinator of the project for the Swedish museums. Her thoughtful advice and careful attention to detail have been invaluable at every stage of the organizational process. Stig Fogelmarck, former director of the Royal Collections, and Bo Vahlne, present director, were unfailingly helpful. Per Bjurström, director of the Nationalmuseum, and Ulf G. Johnsson, Lars Sjöberg, Görel Cavalli-Björkman, Börje Magnusson, and Barbro Hovstadius, curators, provided essential support and advice there. Ulla Landergren, curator of the Royal Treasury, Arne Losman, director of the Skokloster Castle collections, Sven Silow, Architect of the Royal Palace, Michael Metcalf of the University of Minnesota, and Margareta Revera of Uppsala University gave important advice throughout the project. Sven-Eric Nilsson, director-general of the National Judicial Board for Public Lands and Funds, with Gösta Reuterswärd and Karin Dahnell, was responsible for coordinating the extraordinary loan of objects from the Swedish royal regalia. And Bishop Tord Simonsson and Gunnar Samuelsson, as well as Åke Nisbeth from the Central Board of National Antiquities, aided in the procurement of the loans from Strängnäs Cathedral. Birgitta Kock of the Museum of National Antiquities in Stockholm assisted in coordinating the project for the Swedish museums.

The staff of the Royal Armory were deeply committed to making the exhibition a success, undertaking many months of research for the catalogue and conservation of objects in the collections. I would like to commend Astrid Tydén-Jordan, Nils Drejholt, Lena Nordström, Lena Rangström, Gudrun Ekstrand, Ann Marie Dahlberg, Hans Johnson, Eva Möller, Marta Swartling Andersson, Rebecca Enhörning, Maud Marcus, Marianne Lundeberg, Helena Forshell, Peter Sedelius, Hilka Mälarstedt, Nils Olander, Nils Wahlberg, Rostislav Starhill, Göran Schmidt, and Per Åke Persson for their work and warmly thank them for their help. I also appreciate the support of Bengt Kyhlsberg at Skokloster.

Assistance at the Royal Collections was no less important, and the staff that contributed to this project includes Göran Alm, Lis Granlund, Hans Lepp, Per Ahldén, Anna-Stina Gröndahl, Ulla Löfgren, Henry Elander, and Lennart Andersson. Elin Törnquist of the Central Board of National Antiquities served as conservator and Sven Nilsson as photographer of the Royal Collections for this project. Karl-Erik Granath photographed the burial regalia from Strängnäs Cathedral.

When the National Gallery of Art, Washington, was approached by the Swedish ambassador, together with Count Bonde and Agneta Lundström, director J. Carter Brown went to Sweden with key members of the Gal-

lery staff and came away enthusiastic about the project as an important chapter in the history of collecting, one that is largely unknown in the United States. Narrowing the focus somewhat, the Gallery has been invaluable in the organization of the show. I appreciate the support of Carter Brown and the Gallery's deputy director John Wilmerding. I would also like to thank Gaillard Ravenel and Mark Leithauser, not only for lending their expertise to the design and installation but also for helping to select the objects included in the exhibition. D. Dodge Thompson, chief of exhibition programs, Ann M. Bigley, exhibition coordinator, Elizabeth A. Croog, associate secretary-general counsel, Mary Suzor, registrar, and Mervin Richards, conservator, managed the exacting task of bringing the royal treasures from Sweden to the United States. Melanie B. Ness, managing editor, and Tam L. Curry, editor, coordinated publication of the catalogue, with assistance from Carl Nylander, director of the Swedish Institute of Classical Studies in Rome and senior fellow at the Gallery's Center for Advanced Study in the Visual Arts. Ruth Kaplan, Katie Ziglar, and Susan M. Arensberg have developed the public information and educational programs to accompany the exhibition. Thanks also go to Alice M. Whelihan of the Federal Council on the Arts and the Humanities for her gracious assistance in coordinating the details of the indemnity received.

I would like to recognize the staff at the Minneapolis Institute of Arts responsible for the organization of the show and thank them for their support: S. Timothy Fiske, interim co-director, Kathryn Johnson, chairman of the education division, Gwen Bitz, registrar, Roxan Ballard, exhibition designer, as well as Beth Desnick, Louise Lincoln, Liz Sela, Kathy Hedberg, Anne Knauff, Jane Satkowski, Thomas Jance, and Mary Mancuso.

I wish to express our special appreciation for the advice given by Leonid Tarrasuk, Cora Ginsburg, Madelyn Shaw, Thomas DaCosta Kaufmann, and Hugh Tait. Bo Lindwall, Patrik Reuterswärd, and Birgitta Sandström shared their expertise, and Roger Tanner worked against strict deadlines to complete a workable English translation of the texts written in Swedish. Karl-Erik Andersson and the staff of the Swedish Consulate in Minneapolis and Beate Sydhoff, cultural counselor for Sweden in Washington, have also been very helpful. Further thanks go to Gunnar Svensson of the Swedish Ministry of Education, Ulla Rasch-Andersson, Birgitta Ridderstad, and Erik Törnell of the *New Sweden '88* Secretariat, Ove Svensson of the Swedish Institute, Per-Erik Brolén of the Swedish Royal Air Force, and Gunnar Green and Karl Gustaf Jansson of the National Swedish Police Board.

Finally, I would like to acknowledge Guy Walton's fundamental contributions to the project and thank him for his patience, good humor, and tireless efforts on behalf of the exhibition and the catalogue. M.C.

Introduction

Few countries have risen to power and influence as dramatically as did Sweden during the baroque age. The roots of its ascendancy lay in the sixteenth-century consolidation of the Nordic state by Gustav Vasa, and the zenith of its political and military might was reached under Charles XII in the first decade of the eighteenth century. From the time of Gustav Vasa to that of Charles XII, Sweden was ruled by some of the most fascinating monarchs in Western history, each a study in the complex psychology that drives ambition into leadership and molds leadership into statecraft. Although all of these rulers contributed to Sweden's territorial expansion and its fame as a military leader, each also understood that intellectual and artistic development was integral to the establishment of a new status for the country as a European power.

Sweden: A Royal Treasury 1550–1700 is the story of these rulers and their role in the internationalization of Swedish sixteenth- and seventeenth-century culture. The story is told through the textiles, goldsmithwork, arms and armor acquired by the court during their reigns. The royal collections of Sweden are little-known outside of Scandinavia. Yet in spite of Queen Christina's removal of many treasures to Antwerp and Rome in 1654, and the disastrous fire that devastated the contents of the Royal Palace in 1697, the collections are extraordinary in both quality and state of preservation. The Royal Armory's seventeenth-century French costume and textile collection is the most important holding of its kind in the world. The goldsmithwork in Sweden's Royal Treasury has only rare parallels in the collections of other European countries. The country's legacy of arms and armor is one of the most impressive in Europe.

With few exceptions, the works chosen for this exhi-bition were commissioned for ceremonial purposes, acquired as diplomatic gifts, or taken as war booty. Seen together, they represent a tangible expression of Sweden's hegemony in northern Europe and they illustrate the theme of this exhibition: the role of decorative arts as symbols of royal power and prestige in the sixteenth and seventeenth centuries. Their acquisition by an ambitious monarchy and an increasingly educated, refined, and powerful upper class also represents a study in cultural confrontation and cultural change. During the course of Sweden's rise as a great power, the kingdom evolved from a nation with strong cultural ties to Germany to one of the major self-consciously Francophile artistic centers of seventeenth-century Europe. Motivated by political and military alliances with France after the mid-1660s, the Swedish court adopted a style based largely on the example of Louis XIV's Versailles, eventually importing French craftsmen to execute commissions. French influence in the arts, which were sensitively incorporated into native traditions, remained a fundamental aspect of Swedish artistic inspiration throughout the eighteenth century.

The history of sixteenth- and seventeenth-century Sweden as presented in the following pages is a royal history exclusively. This restriction has been dictated by the theme of the exhibition. The social and economic background of this history is also outlined in the volume of essays, *The Age of New Sweden*, written by Swedish historians and art historians for the occasion and produced by the Royal Armory. We hope both volumes will provide a lasting contribution to America's understanding of sixteenth- and seventeenth-century Sweden, a fascinating era hardly known to most Americans, even those of Swedish descent. M.C.

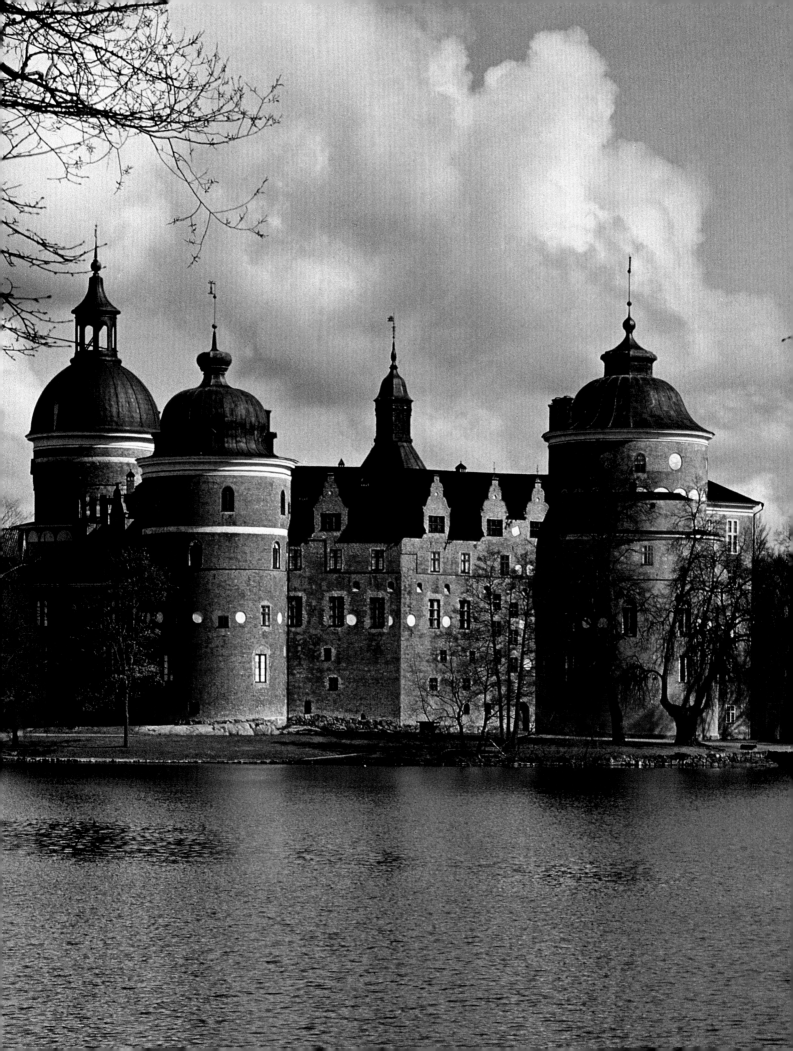

The Swedish Imperial Experience and Its Artistic Legacy

Michael Conforti

The Swedes are well made, strong, and active, and capable
of enduring the greatest fatigue, want, and hunger. Born
with a military genius, and high spirit, they are more brave
than industrious, having long neglected the arts of commerce.
—*Voltaire,* History of Charles XII *(1731)*

IT MAY BE HARD to believe that eighteenth-century Europe held this alarmingly militant image of one of the more peace-loving nations of our time, but Voltaire could easily conjure a sense of shared recollection in his reader by introducing his subject, Charles XII of Sweden, with these words. Charles was, in Voltaire's opinion, "the most extraordinary man, perhaps, that ever appeared in the world." He had ruled a country that was the fear of European military leaders, a country that had garnered enough money and power to rival Louis XIV's France in the extent and grandeur of its artistic commissions for a brief time in the 1690s. Charles was the last in a succession of sixteenth- and seventeenth-century Swedish monarchs who had won this role for their country in European affairs through military bravery and diplomatic skill. In the process, they created an "empire" of sorts around the Baltic Sea, with all the attendant revenues from tax levies and customs duties that such a position could provide.

Sweden's rise as a great power was as remarkable in its creation as its fall was catastrophic in its speed. In less than one hundred years, from the 1520s to the 1620s, Sweden grew from a collection of disparate village enclaves tucked along the shores of the country's innumerable inland lakes into a nation of world stature, whose armies were the most successful in Europe—the nation that had saved the Protestant cause from annihi-

lation in the Thirty Years War. In less than another hundred years Sweden was defeated and its possessions dispersed as a result of one of the most momentous battles in European history. Peter the Great's victory at the Battle of Poltava in 1709 cast Charles XII into exile, and allowed Russia an influence in Europe and its affairs that it has maintained to this day.

Historians have often considered Sweden's empire of Baltic provinces as having been motivated by two forces: the need for protection, and a desire for the economic advantages of food production, customs revenues, and trading rights that could accrue from strategically placed provinces. The center of the European economy had moved north of the Alps in the sixteenth century, and the seventeenth-century struggle for advantage in this new arena usually pitted France against Spain and its Austrian allies, with all participants ever cognizant of the sea power of the Dutch. The changing alliances that characterize this period usually found the Swedes siding with France against varying coalitions. Sweden was almost always allied against the Danes and their north European neighbors for control of the increasingly important Baltic grain trade that supplied food for much of western and southern Europe.

Although Sweden's military and diplomatic policy in the late sixteenth and seventeenth centuries emanated from this economic reality, success in these ventures would never have been realized without the direction of a series of remarkable monarchs. The Vasas and their Pfalz cousins represent one of the most extraordinary

1. Gripsholm Castle, courtesy Nationalmuseum

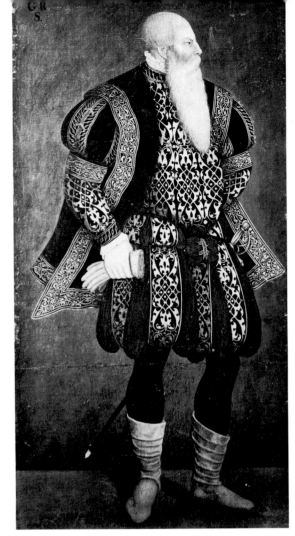

2. *Gustav Vasa* by Willem Boy, c. 1550, courtesy National-museum

royal houses of early modern Europe, a family characterized by sharp personalities, always determined, often proud and difficult. At the same time, they were natural leaders and capable judges of men, and they shared ambitions and talents essential to Sweden's formidable triumphs and standing: from the military brilliance of Gustavus Adolphus, Charles X, and Charles XII, and the administrative efficiency of Gustav Vasa, Charles IX, and Charles XI, to the intellectual and cultural accomplishments of Erik XIV, John III, and Christina. The leadership skills of the Swedish rulers were key to the creation and the success of the Swedish imperial experiment.

In an age in which extravagant material display was synonymous with royal authority, the Vasa and Pfalz houses enhanced the material culture of their courts to complement their dynastic ambitions. Only on rare occasions before 1645 did the art works reflect a collecting "taste" as one might define it today. Instead the objects were acquired through victorious military campaigns and diplomatic missions, and they symbolized national prestige and dynastic supremacy, the cultural veneer needed for the country to function authoritatively in European political circles. Sweden's imperial

ambition was therefore coordinated with an artistic policy that supported its territorial aims. Although the policy was never formally stated, it represented no less an instrument of propaganda than that of Emperor Charles V in the early 1500s or Louis XIV of France over a hundred years later. And its results, as manifested in architecture, decorative painting cycles, and the goldsmithwork, arms, armor, and textiles of this exhibition, were the equal of anything produced in Europe at the time, the material demonstration of Sweden's acceptance as one of the great powers of Europe.

Beginning of the Vasa Dynasty, 1520–1560

Before Sweden could become a great power, it first had to become a country, and credit for the amalgamation of its disparate provinces and the country's subsequent self-identification is given to Gustav Vasa (c. 1494–1560) (fig. 2). In 1397 Sweden had joined Denmark and Norway in a federation of Scandinavian countries led by a hereditary monarch who resided in Denmark. But this union, formed largely as protection against the common enemy of the Hanseatic League and the princes of northern Germany, was often regarded in Sweden as rule by a foreign power. Throughout the fifteenth century independent kings were elected in Sweden, with the Danish unionist kings intermittently recovering sovereignty by force. It was as a consequence of one such attempt by Christian II to regain control in 1520 that Gustav Vasa became the hero of the Swedish call for self-government. Having escaped the "Bloodbath of Stockholm," in which Christian II slaughtered over eighty of his Swedish opponents, Vasa raised an army of rebellion in the province of Dalarna. The unionists were eventually overcome, and on 6 June 1523 Gustav Vasa was elected king, an event still commemorated as symbolizing the consolidation of the country and its independence as a national monarchy.

Gustav Vasa, though often irascible, was also skilled in writing, formidable in oratory, and confident in his ability to lead his country. He put into effect innovative administrative and military strategies to build and maintain a strong centralized government, just as other Europeans had done in the previous generation. Maximilian of Austria, Edward IV and Henry VII of England, and Ferdinand and Isabella of Spain had all strengthened monarchial authority to the detriment of the feudal system. Gustav Vasa modernized his state along the pattern of these other powers, also creating a more efficient economy in the process.

Sweden was a vast land even in the early sixteenth century, and significantly, it faced east rather than west (fig. 3). What are now Sweden's southern provinces,

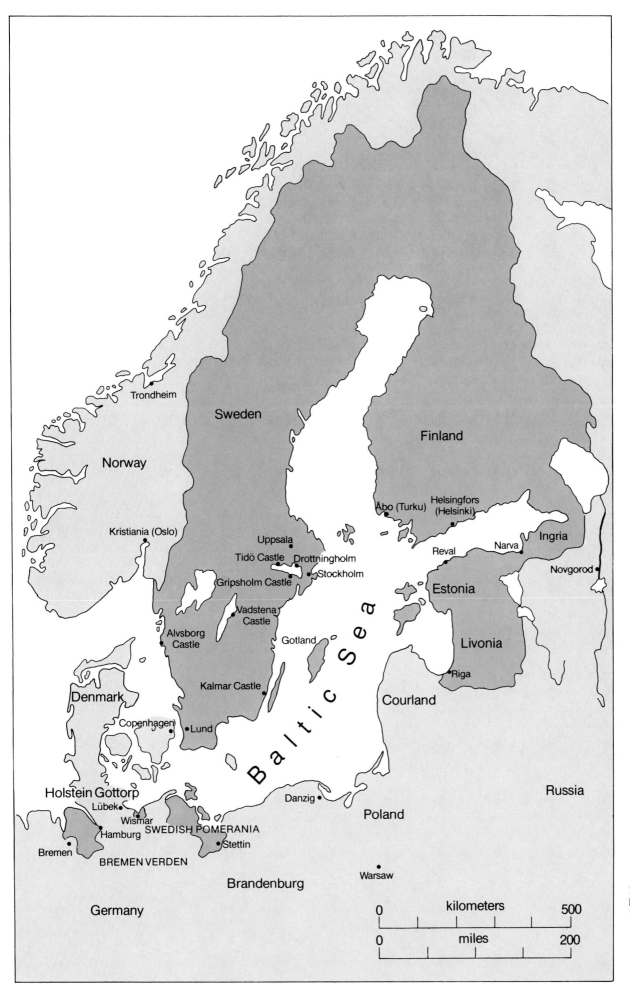

Trondheim

Sweden

Norway

Finland

Kristiania (Oslo)

Åbo (Turku) Helsingfors (Helsinki)

Uppsala

Tidö Castle Drottningholm

Gripsholm Castle Stockholm

Reval Narva Ingria

Estonia Novgorod

Vadstena Castle

Livonia

Alvsborg Castle

Gotland

Riga

Kalmar Castle

Courland

Denmark

Copenhagen Lund

Baltic Sea

Russia

Holstein Gottorp

Lübek

Danzig

Wismar Poland

Hamburg SWEDISH POMERANIA

Bremen Stettin

BREMEN VERDEN

Brandenburg Warsaw

Germany

0 kilometers 500

0 miles 200

3. Sweden and its Baltic provinces, 1660

Skåne, Halland, and Blekinge, were then Danish. But Finland, with its eastern border flanking Russia, had been a Swedish territory since the Middle Ages. This enormous domain, stretching north to the Arctic Circle, was sparsely populated and, though rich in minerals, was limited in tillable land and in growing season. Given its geographical position, Sweden's tie to Europe had developed rather late, and the great distances to Rome and the monastic centers of Europe hampered the degree of education and civilization fostered by the church. As a rural country, Sweden also resisted developing its own commerce and instead encouraged Hanseatic merchants to develop trade in its cities and towns.

Gustav met numerous challenges in his first years on the throne. On more than one occasion he suppressed rebellions instigated by supporters of the Sture family, who had been regents in Sweden during the Scandinavian Union. To pay off his debts to the merchants of Lübeck, who had financed his assumption of power, he took advantage of the new doctrine of Martin Luther as espoused by a local cleric, Olaus Petri (a student of Luther's at Wittenberg), and confiscated church lands in 1527. The revenues that this provided eventually produced a solvent regime. Gustav's policy toward the church had a negative effect on the intellectual life of the country, however. The nobility in Gustav's time were ill-educated and untraveled. Catholic priests and bishops were virtually the only educated segment of the population. The forced reforms in the church caused the clergy to flee Sweden, abandoning Uppsala University, which had been formed only fifty years before Gustav came to power. Thus early in his reign the king had to begin importing administrators from the Continent, mostly from Germany, and this practice continued through the century. These same foreigners would later recommend new mining ventures and farming initiatives that increased the king's personal wealth as well as that of the state.

The Swedish Riksdag, a representative assembly of nobles, clergy, burghers, and peasants that evolved during the fifteenth century, had supported Gustav Vasa's election as king and his creation of a state church. In 1544 it approved the hereditary right of the Vasas to the throne. The king had also sought to legitimate his claim to royal status by marrying into the noble German house of Saxony-Lauenburg. And as the years progressed, he used his considerable wealth to create a court with some semblance of culture, a court that he hoped would begin to gain respect for the Vasa regime both in Sweden and on the Continent. The Vasa castles served for defense and administration but also as strategic symbols of the power and refinement of his court. The culture behind the massive facades, although simple and crude by European standards, included a modest

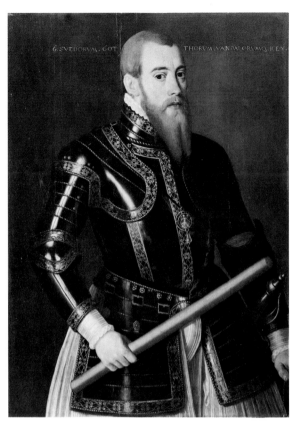

4. *Erik XIV*, attributed to Domenicus ver Wilt, 1561–1562, courtesy Nationalmuseum

collection of paintings and tapestries and an armory with decorated helmets, shields, and swords, mostly imported from Germany (cats. 4, 5). Gustav Vasa's court also maintained a complement of scholars whose primary function was to provide a formal education for his children that was lacking in himself.

A Northern Renaissance Court, 1560–1611

It is often said that while Gustav Vasa brought the Reformation to Sweden, his sons Erik XIV (1533–1577) (fig. 4) and John III (1537–1592) ushered in the Renaissance. Erik spoke Latin, German, and French. He could draw and play the lute, was schooled in geography and the technological sciences of the time, and had a mind for abstract theoretical problems. Unlike his father, Erik assumed power easily, having known for most of his life that he would be king. His self-esteem was enhanced by a political triumph early in his reign, when in 1560 the merchants of Reval in Estonia asked for Swedish protection against Russia, agreeing to Swedish rule in the process. This established Sweden's first presence on the southern shores of the Baltic, and

laid the foundation of the Baltic empire that Sweden developed in later years.

Erik created Continental-style courts at the castle of Kalmar and in Stockholm, and he became famous for the pageantry and festivals that accompanied his reign. He and his court would often parade through triumphal arches in magnificent horse equipment and armor fashioned by the most outstanding craftsmen in Europe (cats. 6, 7). Erik also established new court traditions to enhance his royal image. Following Continental precedents, he instituted hereditary titles for the nobility, and he distanced himself from the nobles of the court by asking to be addressed as "Majesty." The elaborate rituals surrounding his coronation, the first organized for a Vasa heir, were institutionalized, and the regalia created for it are still preserved today.

Hoping for an important political marriage, Erik sought the hand of Elizabeth I of England. A delegation led by his brother John arrived at the English court in 1559 with a portrait of the young heir and a statement of the trade advantages that such an alliance would bring to Britain, mentioning too the common bond of the two countries in the Protestant faith. After what appeared to be serious interest on Elizabeth's part, she refused.

Through the promise of a dynastic marriage and the institution of court ceremonies with appropriately splendid accoutrements, Erik sought to confirm the Vasas' legitimate right to the Swedish throne. But during frequent periods of depression, he revealed a deep fear for the security of his position. Erik possessed many of the positive Vasa traits, but the family temper that his father had controlled through good judgment and common sense, in Erik turned into a certain obsessiveness. His fears led to the murder of members of the Sture family, chief rivals to the Vasas' dynastic claim, and eventually to his temporary insanity and imprisonment by his brother John, who seized power.

Locked in Gripsholm Castle, Erik drew, read, and spent many hours translating a long Latin text, *Historia Gothorum Sveonumque*, written in 1534 by a Swedish Catholic cleric resident in Rome, Johannes Magnus. This book created a genealogical line of descent for the kings of Sweden and provided a detailed account of each ruler of the ancient Goths. The image of Gothic superiority inherent in these pages would inspire generations of Swedes to feats of bravery on the battlefield.

In 1562 Erik's brother and successor John III negotiated the dynastic union that Erik could not, marrying Katarina Jagellonica, sister of Sigismund August II of Poland and daughter of Queen Bona Sforza, who had established an outpost of the Italian Renaissance in the Polish capital of Cracow. The hoped-for political advantages of this match were never fulfilled, but the artistic

benefits were considerable: spectacular works of art descended to the Swedish royal house (cats. 8, 9), and contacts were made with Continental artists who would later be employed by John to embellish and enlarge the Vasa castles.

John's appreciation for architecture rivaled Erik's love of court ceremony, and his insistence on continuing to build while engaged in costly eastern wars seriously threatened the financial stability that Gustav Vasa had bequeathed to his heirs. Many of the other three-dimensional arts also began to flourish in Sweden during John's reign. Continental goldsmiths, encouraged to establish themselves in Stockholm to work for the crown, created objects of great refinement, such as the orb, crown, and scepter ordered in 1585 for John's second marriage to Gunilla Bielke (cat. 2). As a result, goldsmithwork became an important artistic tradition in Sweden.

The artistic patronage of Erik and John was formed by the education provided by their father and sharpened by the insecurity inherent in their family's recent dynastic claim. But Sweden was still a remote frontier of European civilization in the late sixteenth century. Visitors often remarked on the simplicity of living conditions and on the boorish manners of the nobility. In attempting to transform the image of the country and its royal house, Erik and John had to look to Continental courts for models. Not only were the humanistic papacy of Rome and the court of the Medici in Florence exemplars of cultural patronage, the dukes of Burgundy and their Habsburg descendents were equally significant supporters of the arts. They were also more cognizant of the political utility of acquiring costly art objects. Maximilian I Habsburg used art, ceremony, and literature as instruments of court propaganda, and his successors Charles V and Philip II of Spain collected on an unprecedented scale. Humanistic theory supported such patronage, with fifteenth-century Italian treatises on "magnificence" suggesting that purchases of art were a civic virtue.

The reigns of Erik and John were contemporaneous with those of the Habsburg emperors Ferdinand I, Maximilian II, and Rudolph II, whose courts were known for their sculpture, goldsmithwork, and elegant decorative surroundings. Prague in Rudolph's day was a recognized center of the arts. The Swedish kings, although aware of the Habsburg collections, could only aspire to such splendor at this early point in their country's history. By the close of the Thirty Years War in 1648, however, Queen Christina could oversee the plundering of the imperial art gallery in Prague and the shipment of the great treasures of Rudolph II to Stockholm.

John III's son Sigismund (1566–1632) was elected

king of Poland in 1587, a few years after the death of his uncle, Sigismund II August. When John died five years later, the crowns of Poland and Sweden were united under him. But Sigismund III was raised in the Catholic faith of his mother, and many Swedes, outraged by the thought of a Catholic monarch, looked for support from John's brother, Duke Charles (1550–1611). While Sigismund resided in Warsaw, Charles acted as his regent in Sweden, slowly increasing his base of support. Then in 1598 Charles thwarted Sigismund's attempt to attain control in Sweden and was hailed as king, later eliminating some of the most prominent nobles still loyal to the rightful monarch. Charles IX waited until 1604 to accept the formal title of king from a willing Riksdag. To consolidate his power even further, he held off another three years before agreeing to a coronation.

Usurping the throne in the face of an aristocracy's lukewarm reception, Charles could be accused of imitating his father, Gustav Vasa. He was, like the elder Vasa, a cool and competent administrator, while able to rally the common man to his objectives. Although seemingly uninterested in the arts, he was willing to spend large amounts of money when the symbols of his kingship could be enhanced. Glorious objects of silver, gold, and enamel were commissioned for his coronation, including the extraordinary anointing horn (cat. 3) made by Stockholm's first native goldsmith, Peter Kempe. To further increase the impact of this ceremony, his horse was to have been outfitted with dazzling enamel and gilt-silver fittings (cat. 10) made by Stockholm's most prominent goldsmith at the time, Ruprecht Miller. Royal patronage of goldsmithwork continued after Charles' death in 1611, when a magnificent crown, orb, and scepter were commissioned for his burial (cat. 12).

Sweden in Europe, 1611–1650

Charles' heir, sixteen-year-old Gustavus Adolphus (1594–1632) (fig. 5), was already at war when his father died. He soon defeated the Danes, who had attacked in 1611, and by 1617 he had finished the war with Russia that his father had begun. Sweden now controlled the entire eastern coast of the Baltic, and with these successes, the young king began a series of brilliant military victories that would create his reputation as a formidable and innovative warrior. In the twenty-one years of his reign he accomplished military and political feats that his forebears never dreamed possible, enlarging Sweden's territorial and economic profile and establishing the legitimacy and reputation of the Vasa dynasty in the process.

Gustavus Adolphus had been trained for kingship. He was included in council meetings at the age of ten, and was granted a military command at fifteen. He also had an inventive mind, which enabled him to design armaments and experiment with new military maneuvers. He knew Latin and Greek, had an aptitude for spoken languages, and was fluent in five. Like many Vasas, he was physically brave, and a gifted, even demogogic, orator. His temper was a constant, but it was not vindictive. His sense of responsibility, humility, and humor counteracted any possibility of despotic behavior. Gustavus had been taught to believe in his own nobility and the power inherent in his descent from Gothic kings of the past. In holding these beliefs, he felt himself privileged and different from ordinary monarchs. By the late 1620s this feeling of separateness turned in his mind to high moral mission when events of the Thirty Years War made him confront the threat of the annihilation of the Protestant cause.

After Gustavus Adolphus was crowned in 1617, his marriage and the continuation of the Vasa line became concerns for the country. He had fallen in love early in his reign with Ebba Brahe, but his mother kept him from marrying into a Swedish family, however noble. His had to be a dynastic union, and in the end the

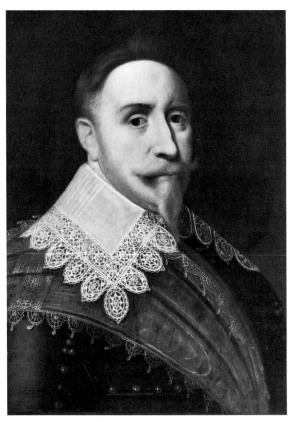

5. *Gustavus Adolphus* by J. Hoefnagel, c. 1624, private collection, deposited at the Royal Armory

18

young king agreed. After considerable negotiation, he proposed to Maria Eleonora of Brandenburg, and the wedding took place in Stockholm on 26 November 1620. It was celebrated in a style commensurate with the importance of this union of two north European powers (cat. 17). Ruprecht Miller made a crown for Maria Eleonora's coronation three days later that became the most revered item of queenly regalia in the Treasury (cat. 1).

Shortly after his marriage Gustavus went to war. With Bible in hand, kneeling in prayer before every battle, he began an unprecedented expansion of Sweden's territories and economic influence. His first campaign along the Polish coast pitted his army against that of his cousin Sigismund led by Prince Radziwill. In 1621 Riga was taken, followed by Mitau and the rest of the fiefs of the dukes of Courland. His battles in Poland continued intermittently until 1629, when a truce gave Sweden control of Livonia and certain strategic and profitable Baltic ports. At the same time, Gustavus signed an alliance with Cardinal Richelieu of France, who was beginning to fear the increased power of the Habsburgs more than the threat of Protestantism. With this support, Gustavus turned to the cause of the Protestant princes, who desperately needed help against the seemingly invincible forces of the emperor. In 1631, at Breitenfeld in central Germany, the Swedish army routed the imperialists and the war turned in their favor. The king's death on the battlefield at Lützen in 1632 quashed any hope for a quick victory, however, and the war dragged on sporadically for the next sixteen years until Prague was finally taken by Swedish troops in 1648.

The almost three decades of conflict on the Continent caused dramatic changes in Swedish culture. Nobles of varying rank who had never left their country before had now spent much of their lives in Germany. During the many long lapses in combat, Protestant courts in Europe became familiar to the Swedish aristocracy, who began to recognize Sweden's own cultural limitations and returned home with a commitment to change the situation.

These same Swedish nobles also returned with material manifestations of their enemies' civilization, which they pillaged whenever it was expedient to do so. The booty of war was considered the right of any victor in the seventeenth century. If art lent power and prestige to a dynasty, a conquering army would naturally try to capture this source of its enemy's strength. But the Swedes' victories were so numerous and their appetite for objects so voracious, that their plundering quickly tarnished their national reputation. Whether it took the form of literal reminders of war such as the arms that Gustavus Adolphus acquired at Mitau (cats. 21, 22), the paintings and treasures Christina obtained from Prague

in 1648 (cats. 30, 31), or libraries, such as that from Würzburg now housed in Uppsala University, booty was a quick means for an ambitious society to acquire the trappings of culture.

Grateful individuals or communities fearful of being robbed also offered gifts to the Swedish leaders. Augsburg arranged for an extraordinary cabinet to be given to Gustavus Adolphus when he agreed to a peaceful entry into the city (Fogelmarck fig. 4), and a portrait by the famous Augsburg sculptor Georg Petel was commissioned by an unknown patron to honor the conquering northern king (cat. 25). Protestant cities thankful for the protection of Gustavus' army expressed their appreciation as well. In 1632 Nuremberg presented two exquisite covered silver goblets to the Swedish monarch (cat. 24). Swedish nobles also left the Continent with many purchases, and with the names of agents who were later employed to obtain objects and books for their collections and to hire artisans for the innumerable palaces and country houses they were planning in Sweden.

Gustavus Adolphus' only child, Christina (1626–1689), was just six when her father died, and Axel Oxenstierna, chancellor of the realm, was appointed regent. Oxenstierna (1583–1654) (fig. 6), often likened to

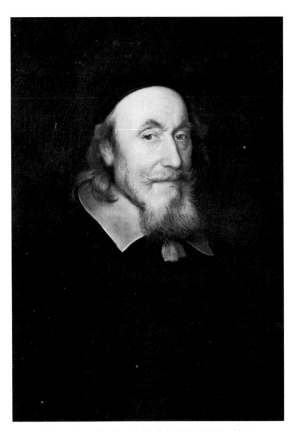

6. *Axel Oxenstierna* by David Beck, 1647–1651, private collection, courtesy Nationalmuseum

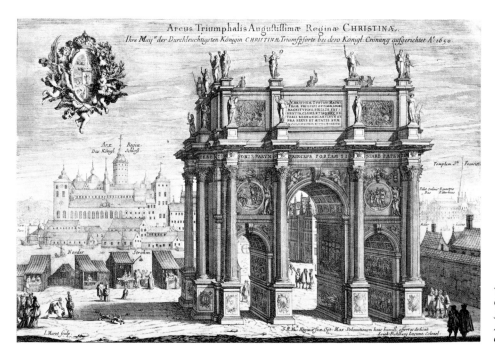

7. Triumphal arch built for Queen Christina's coronation, engraved by J. Marot after Erik Dahlberg, from *Svecia Antiqua e Hodierna* (Stockholm, 1719), courtesy Nationalmuseum

Richelieu and Mazarin as one of the great chancellors in European history, founded his statecraft on the belief that king and nobility should share responsiblity in government. His views were similar to those of a number of other chief ministers in the early 1600s, but few were as successful in implementing their ideas. Oxenstierna and the king established a House of Nobles in 1626 to institutionalize this division of power. They also created preparatory schools, reorganized Uppsala University, and founded a system of appeals courts. And by encouraging foreign capitalists to develop Sweden's rich mining resources and trading ventures, they established an economy that could support the war effort. Oxenstierna organized an administration that was so effective in running the far-flung empire that it was the model for later administrative systems such as that of Peter the Great. During Oxenstierna's regency, Sweden expanded its empire to reach America and Africa, following similar moves by other European nations. Small settlements developing tobacco crops in the Delaware Valley and the slave trade on the coast of West Africa were short-lived, but they reflected Sweden's belief in its own capabilities at this time and its status as an international, and now colonial, power.

The education the chancellor organized for the young Christina included languages, art, music, and philosophy. Christina excelled in these pursuits, and she learned to ride and hunt with the best horsemen of her day. It was Christina, too, who inspired the Swedish court and its nobility to strive for the highest level of European culture and intellectual sophistication. She employed agents throughout Europe to buy art objects for the Royal Collections. She corresponded with Pascal, brought the French philosopher Descartes to Stockholm, and made the prominent Parisian artist, Sebastian Bourdon, her court painter. She supported the removal of Prague's treasures to Stockholm, and anxiously awaited its collection of Italian Renaissance paintings, which she came to prefer above all else. The money lavished on the court rose dramatically during Christina's reign, from 3 percent of royal revenues at the beginning, to 20 percent at the end. This was financed in large part by the sale of crown lands to the nobles, a practice Oxenstierna recommended.

Christina's sense of duty was established in the stoic training of Oxenstierna. By the late 1640s, however, she had decided not to marry, and therefore she would not fulfill her ultimate obligation as monarch: producing an heir. This fact, combined with her growing disenchantment with the Protestant culture of Sweden, for years kept her from agreeing to a coronation. But after outmaneuvering Oxenstierna and convincing the Riksdag to support the choice of her cousin Charles Gustav (1622–1660) as hereditary heir, she could proceed with the coronation ritual.

An Empire on the Baltic, 1650–1680

The coronation of Queen Christina in 1650 was the most lavish in Swedish history, and it symbolized the country's new role as the preeminent power in northern

Europe, cosignatory of the Peace of Westphalia (fig. 7). Her regalia included her mother's crown, embellished for the occasion by Jürgen Dargeman, who had succeeded Ruprecht Miller as the leading goldsmith in Stockholm (cat. 1). The streets along the route of the royal procession were lined with tapestries, and the coaches included one commissioned by the heir apparent, Charles Gustav, which was covered with red silk and velvet hangings, embroidered with gold and silver (cat. 34). The court favorite, Magnus Gabriel De la Gardie (1622–1686), who had regularly delighted Christina by sending her artistic masterpieces from Europe (cat. 33), ordered a silver throne from Augsburg that is still maintained as the Swedish throne of state (Fogelmarck fig. 5). As Christina's heir, Charles rode behind her carriage on a horse draped with a spectacular gold- and silver-embroidered caparison (cat. 35).

After her coronation Christina began to question the Protestantism of her father and her countrymen more seriously than she had in the past. To her it represented a provincializing, puritanical force, inconsistent with the Italian humanism she found so attractive. She soon began secret instruction in the Catholic faith with two Jesuits sent to Stockholm in disguise by the pope. In 1654 Christina shocked Sweden and the world by announcing her abdication. In a formal ceremony at Uppsala Castle, she took the crown from her own head and presented her heir to the assembled crowd. Charles X's coronation began a few hours later, and Christina soon left Sweden for a new life in Rome.

After his coronation Charles X engaged his country in a series of wars with Denmark. He eventually overwhelmed his foes, and with the Peace of Roskilde in 1658 forced the Danes to yield their northern provinces and islands in the Baltic. The last significant booty from the Continent reached Stockholm after this victory, including the great garden sculptures by Adriaan de Vries taken from Frederiksborg Castle and installed at Drottningholm (Walton fig. 14). At Charles' death in 1660, Sweden's territories encompassed the entire eastern Baltic region, the southern provinces of the Swedish peninsula, and the most strategic positions along the southern Baltic shore: the profitable port cities at the mouths of the great German rivers. This disposition of lands would not change appreciably until the beginning of the next century.

Although the term "empire" has been used for the collection of Swedish territories strung along the Baltic Sea, a question could be raised as to whether an empire, in a real sense, was created at all. The idea of a Baltic "lake," *dominium maris Baltici*, had been mentioned in Swedish documents since the early 1600s, but it was never assumed that all territories surrounding the sea had to be Swedish for the concept to be fully real-

ized. The acquisition of lands had a clear purpose: defensive protection against Sweden's oldest enemy Denmark to the south and west, against the potential threat of Russia in the east, and after 1600, against Poland, whose ruler continued to call himself king of Sweden well into the seventeenth century. Protection, however, was secondary to economic advantage in directing Sweden's policy of acquisition. The rich wheat fields of Livonia, Skåne, and Blekinge could now be relied upon for food both for its own use and for export, and the tolls and taxes of the river ports and Baltic channels could go straight into the exchequer.

Sweden in fact did not take as much land as its military successes would have allowed. Gustavus Adolphus might have seized more territory in Germany (as Richelieu feared he would). Charles XII could have enhanced Swedish holdings after his early victories. Several factors held Sweden back, not the least of which was a keen awareness of the relative European balance of power at the time. After the Peace of Westphalia in 1648, France succeeded Spain and Austria as the premier power in Europe, while Holland, England, Denmark, and Sweden formed varying alliances—mindful of France's ambition—in battles for trade advantages and territorial gains. In these conflicts France and Sweden were often allied against Holland and Denmark, and usually against the southern Baltic states as well, particularly Brandenburg-Prussia. The most significant factor in containing Sweden's own ambitions, however, was Dutch sea power. The Swedes had failed to produce an effective navy, despite attempts, and the Baltic could not be fully dominated without one. If Sweden overstepped what other countries considered its territorial limits, conflicts might have ensued that Sweden would not have had the resources to win.

Sweden's expansion was also restricted by its small population, which provided too few people to raise sufficient armies or administer a large empire. Swedish armies were often supplemented with mercenary troops, and they were frequently outnumbered in battle. Their successes were due to skilled leadership and the stamina that such influence inspired in the troops. Swedish diplomats used the threat of further war to negotiate concessions, but in fact the financial and human resources of the country could not have sustained vast foreign territories.

The long regency that followed Charles X's death was an unstable time for the monarchy. The regents of Charles XI (1655–1697), led by Magnus Gabriel De la Gardie, took particular care of their own interests, but at tremendous costs to the crown. In fact, the 1660s and 1670s saw the greatest enrichment of the upper nobility in Swedish history. Building activity and the importing of fashionable goods for the aristocracy were at their

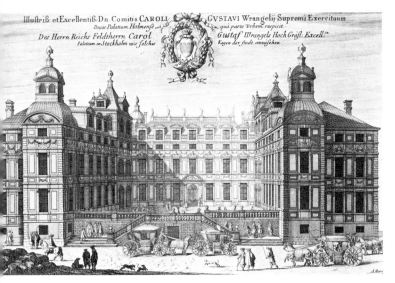

Illuſtriß: et Excellentiß: Dn. Comitis CAROLI GVSTAVI Wrangelij Supremi Exercituum
Ducis Palatium Holmenſe ad qua parte Vrbem reſpicit.
Das Herrn Reichs Feldtherrn Carol Guſtaf Wrangels Hoch Gräfl. Excell:
Palatium in Stockholm wie ſolches Kegen der ſtadt anzuſehen.

8. Wrangel Palace on Riddarholmen, designed for Count Carl Gustaf Wrangel by Nicodemus Tessin the Elder, completed 1660. Engraving by J. Marot after Erik Dahlberg, from *Svecia Antiqua e Hodierna*, courtesy Nationalmuseum

height. European courts known through the German wars, the example of Christina, and the greater prominence of Sweden in world affairs gave the nobility a taste for opulence and grandeur. De la Gardie along with the families of Wrangel, Oxenstierna, Bonde, Stenbach, Piper, and others constructed castles and palaces with magnificent French gardens throughout the country. In this atmosphere of money and luxury, many of the new rich were foreigners: the De Geers, Hamiltons, Mommas. They all lived so sumptuously and fashionably that the late seventeenth century Italian traveler Lorenzo Magalotti claimed that the architecture of Stockholm at the time was unmatched outside of Italy (fig. 8).

Until this time, architecture in Sweden had been inspired mainly by German examples. Geography, trade, and religious ties made Germany a natural inspiration for painting, the decorative arts, and fashion as well. In the mid-1600s France began to supplant Germany as the source of artistic inspiration in Sweden. France's diplomatic ties to Sweden after 1660 meant that the French style was openly and quickly received in Stockholm. This influence coincided with France's rise to artistic preeminence in Europe, which culminated in the 1660s when Versailles was enlarged and the Gobelins workshops began creating furniture, tapestries, silver, and other objects of unprecedented quality.

The close diplomatic ties between Sweden and France are chronicled also in royal gifts during this period. On Louis XIII's death, important Italian guns were given to the young Queen Christina (cat. 29). Some years later

Mazarin sent a suite of Mortlake tapestries to Charles X. During the regency of Charles XI, De la Gardie continued to support Sweden's tie to France, and in 1673 the tie was secured with the most important diplomatic gift of the seventeenth century. Sweden had joined Holland and England in an alliance against France in 1668, but Louis XIV, hoping to enhance his position in the Lowlands, was anxious for Sweden to change its loyalties and join him in war against the Dutch and the Danes. Sweden's recent economizing in military affairs placed it in no position to take on a conflict at this time. But in April 1672 De la Gardie persuaded the Swedish Council of State to sign an agreement with France. The following year, to cement the alliance, French diplomats sent Charles XI twelve of the finest horses from Louis XIV's stables, spectacularly outfitted with embroidered saddles and caparisons and accompanied by garnitures of guns and pistols (cats. 51-53).

The alliance with France, which led to Swedish military defeats early on, discredited De la Gardie in foreign affairs, but the ensuing war brought confidence and fame to the otherwise shy twenty-year-old monarch. Charles XI was not an articulate leader, but through his integrity, drive, and bravery in battle he earned the respect of the country. With the war going badly on all fronts, its southern provinces and Danish and German possessions in the hands of Sweden's enemies, the king chose to stake all on one battle. On 3 December 1676 he attacked Danish lines outside Lund in southern Sweden. The young king's personal leadership of the army's right wing helped rout the enemy (fig. 9). With France's successes to the south, Sweden recovered all of its lost territories at the peace table.

The Age of Autocracy, 1680–1718

Charles XI returned to Stockholm in triumph, ready to assert his power. The positive features of Louis' absolutist rule in France were not lost on Charles' personal advisors, who were angling against De la Gardie's regency council, which still hoped to exert its influence in Charles' maturity. Charles eventually reclaimed the authority and revenues taken by the regency council. But absolutism was instituted in Sweden by the consent of the many. Charles had support for these moves in the Riksdag from the peasants, burghers, and lower nobility, anxious to see the high aristocracy reduced to its former state. In the correction that followed, many rich nobles, including De la Gardie, lost the estates they had obtained from the crown over the preceding decades.

With the Swedish state on more solid financial ground, the 1680s and 1690s were among the country's most peaceful and prosperous decades. The army be-

22

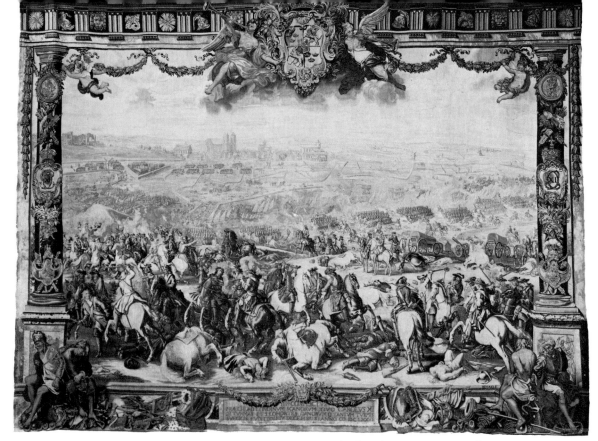

9. *Battle of Lund,* Beauvais tapestry after a design by Johan Philip Lemke with borders by Jean Berain, 1696, courtesy Royal Collections

came conscriptive again, well paid, and sufficiently organized to defend the country. The arts flourished as well, mainly through the patronage of the dowager queen, Hedvig Eleonora. Hedvig Eleonora came to Sweden from Holstein-Gottorp, with her family's taste for art and collecting, enhanced by her admiration for Queen Christina, ten years her senior. She was, like Christina, sensitive to the provincial and often unfashionable character of traditional Swedish culture and was convinced that the Swedish court should display the grandeur and richness of a great power. She built magnificent royal palaces in the latest styles, one of which—Drottningholm, her principal country residence—is known as Sweden's Versailles. At Ulriksdal, her smaller country retreat, she installed a treasury to house the ivory, rock crystal, and enameled objects she collected in great abundance (cats. 54–59).

Indeed, the artistic atmosphere in Stockholm at the close of the seventeenth century could not have been more promising. The empire, while politically fragile, was still profitable, and the state more financially sound than it had been in decades. Nicodemus Tessin the Younger, the court architect (1654–1728) (fig. 10), took it upon himself to equal the settings and fashions of the French court, creating an image appropriate to the ruler of so important a country. In 1696 Tessin asked the renowned French designer Jean Berain for plans for a

10. *Nicodemus Tessin the Younger* by Georges Desmarées, c. 1720, courtesy Nationalmuseum

11. Baptismal font for the Royal Chapel by Jean François Cousinet and Bernard Foucquet, silver on wood frame, 1696–1707, courtesy Royal Collections

new state coach. It was completed in Stockholm a few years later, with painted silk interiors still preserved, astonishingly, in their original condition (cat. 61). It was also at this time that the French silversmith Jean François Cousinet worked with the sculptor Bernard Foucquet to produce a silver baptismal font, four feet high (fig. 11), which reflected the scale of the silver furniture cast earlier for Versailles (melted down in January 1690 to help France pay its pressing war debts).

The momentum that Sweden had developed in art patronage during Charles XI's reign is indicated by the government's reaction to the terrible fire in Stockholm's royal palace as Charles XI lay in state there in 1697. Rather than linger over the staggering losses (only a few of the extraordinary collections, such as the clothes of Charles X, were saved), they seized the opportunity to rebuild the palace to the highest contemporary standard. Nicodemus Tessin the Younger immediately produced plans for a suitably grand residence, designed in a Roman baroque style on the exterior, and finished with the latest French refinements on the interior. At the center of the courtyard was to be an equestrian figure of

the recently deceased king, based on the work of French sculptor François Girardon and executed by Bernard Foucquet (see cat. 64).

Sweden, under the artistic impresario Tessin, looked economically more promising for young artists than France in the late 1690s, a time when artistic commissions at Versailles were down to a minimum. In 1697 Louis XIV's brother made frequent comments to Sweden's envoy Daniel Cronström regarding the poor state of artistic commissions in France, complimenting Sweden on the other hand for being able to afford its ambitious projects. As Cronström reports to Stockholm, ''I find that they [the king's brother and sister-in-law] are somewhat distressed because we are engaged in so many great building projects that they are unable to undertake themselves. They recently commissioned twelve marble vases for Marly, but it was very difficult for them to arrange.''

Charles XII (1682–1718), only fourteen when his father died, was at the center of these new activities in the arts. He was close to Tessin and supported the architect's vision of opulence and grandeur for the capital. The young king personally reviewed architectural plans with Tessin, making many suggestions. Unlike his father, Charles was something of an intellectual, with a mathematical mind and a gift for languages and music. Indeed, the festivals staged in Stockholm during the first years of Charles XII's reign were a striking departure from the lack of interest in such entertainments in his father's time. At the king's request, Tessin organized theatrical performances, masquerades, and balls, all in the spirit of the extravaganzas the architect recalled from his study in France. Princesses from all over Europe passed through Stockholm, hoping to attract the attention of the dashing and spirited young monarch, but without success. Charles never married. Instead, he left Stockholm in 1700 two months before his eighteenth birthday, forced into war by a host of European powers who felt the time was right to pull the territories of Sweden apart, led as it was by an adolescent king.

Charles XII loved the battlefront and exhibited such bravery in the field that his armies were devoted to him. After important victories against the Danes in the south, the king turned to the east, where Peter the Great had made advances against Swedish provinces on the Baltic. Charles' army was outnumbered in battle, but they defeated the Russians at Narva against overwhelming odds. Word of this victory soon resounded throughout Europe. Charles then turned to Livonia, where for five years he fought successfully against Augustus the Strong, deposing him in Poland and placing his own candidate, Stanislas Lesczynski, on the throne. Saxon folklore is still rich with tales of the fearlessness and determination of Charles and his troops. Eventually

Charles captured Dresden and installed himself in the castle in Altranstädt, in temporary command of the entire region. Charles' reputation was at its height in these years, from 1706 to 1707. All Europe talked of the young warrior-king, wearing the plain blue uniform of his soldiers, displaying no decoration, wearing no wig, sleeping in the simplicity of his soldiers' camp, and leading them to victory after victory (fig. 12). With this dedication and feeling of invincibility, Charles made his first and fateful mistake.

In 1707 Europe wondered where Charles would next direct his armies. In choosing to move into Russia in pursuit of Peter the Great, Charles' judgment failed him, as would Napoleon's and Hitler's in later centuries. The Swedish armies won initial victories against the Russians in 1708, but the winter of 1708-1709 was brutal. Half the Swedish army starved or froze to death. When spring finally broke, it was remarkable that there was a Swedish army left to fight at all. At Poltava, in the

spring of 1709, Charles XII's army was wiped out by the Russians, who now gained access to the Baltic Sea. Charles retreated with the remnants of his army to Turkey, where he stayed for five years, all the while hoping to mount a new offensive against Russia.

In the meantime, Sweden was attacked by its many other enemies, now poised for the kill. The country rallied. Women and children worked the farms, as men young and old joined the defense. But little could be done without the king or sufficient forces, and the suffering was enormous. Although Charles reached the Baltic in 1714, after an heroic fourteen-day ride from Turkey, he could not turn the tide of war. His advisors constantly urged him to cease the fighting in following years, but he persisted, at great expense in lives and money. Many believe that the bullet that entered Charles' head on a Norwegian campaign in 1718 came from a Swedish gun. After the death of Charles XII, Sweden's overseas territories were divided, and the country's tenure as one of the great military powers of Europe came to an end.

Was Sweden's empire on the Baltic so fragile that the aftermath of one battle, Poltava, could annihilate it? As we have seen, Sweden's position as a great power had been built on a foundation of limited resources of both money and people. It was an empire created primarily by the will of individuals, the often temperamental but always exceptional leadership of the Vasa and Pfalz monarchs, the wise counsel of men such as Axel Oxenstierna, and the support of a host of military heroes and their armies. In some ways, the empire had no justification for reaching the size it did, and it ended as it began, the result of conditions brought on by the character of one of its leaders.

Charles was a ruler who precipitated an otherwise avoidable defeat through a belief in his own invincibility. After many military successes his self-confidence eclipsed his judgment. There is no doubt, however, that it was this single-minded sense of purpose that had pushed Charles and his ancestors to extraordinary military achievements in the first place. As we have seen, these achievements established a significant role for Sweden in the fabric of European political and cultural history. That role would change in subsequent years, but Sweden would never retreat to its former position as a provincial Baltic state. The traditions, institutions, and national pride the country acquired during the late sixteenth and seventeenth centuries would be remembered and revived by its people as the years progressed. And great works of art and architecture would endure as a tangible legacy of Sweden's period of dominance in northern Europe.

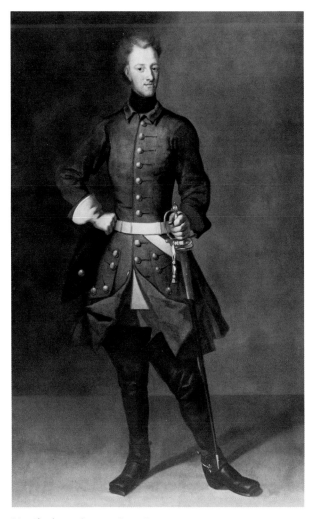

12. *Charles XII* by David Krafft, c. 1704, courtesy Nationalmuseum

Bibliography

Bengtsson, Frans G. *The Sword Does Not Test: The Life of Charles XII, King of Sweden, 1697–1718.* London, 1960.

Christina of Sweden: A Personality of European Civilization. Nationalmusei utställningskatalog 305. Stockholm, 1966.

Clarke, M. L. "The Making of a Queen: The Education of Christina of Sweden." *History Today* 28 (1978):228-235.

Derry, T. K. *A History of Scandinavia.* Minneapolis, 1979.

Elstob, Eric. *Sweden: A Political and Cultural History.* Haverhill, England, 1979.

Hatton, Ragnhild M. *Charles XII of Sweden.* London, 1968.

Kaufmann, Thomas DaCosta. *The School of Prague.* Chicago and London, 1988.

Lisk, Jill. *The Struggle for Supremacy in the Baltic, 1600–1725.* London Historical Studies 3. London, 1967.

Masson, Georgina. *Queen Christina.* London, 1968.

Roberts, Michael. *Gustavus Adolphus: A History of Sweden, 1611–1632.* 2 vols. London, 1953, 1958.

Roberts, Michael. *Essays in Swedish History.* London and Minneapolis, 1967.

Roberts, Michael. *The Early Vasas: A History of Sweden, 1523–1617.* Cambridge, 1968.

Roberts, Michael. *The Swedish Imperial Experience, 1560–1718.* London and New York, 1973.

Roberts, Michael, ed. *Sweden's Age of Greatness, 1632–1718.* London and New York, 1973.

Sandström, Birgitta. "The Renaissance" and "The Baroque." In *A History of Swedish Art.* Edited by M. Lindgren, et al. Stockholm, 1987.

Stolpe, Sven. *Christina of Sweden.* London, 1966.

Trevor-Roper, Hugh. *The Plunder of Arts in the Seventeenth Century.* Norwich, England, 1970.

Voltaire, François M. A. de. *History of Charles XII, King of Sweden.* 1731.

Von Platen, Magnus, ed. *Queen Christina: Documents and Studies.* Nationalmusei skriftserie, no. 12. Stockholm, 1966.

Walton, Guy, et al. *Versailles à Stockholm.* Nationalmuseums Skriftserie, NS5. Stockholm, 1985.

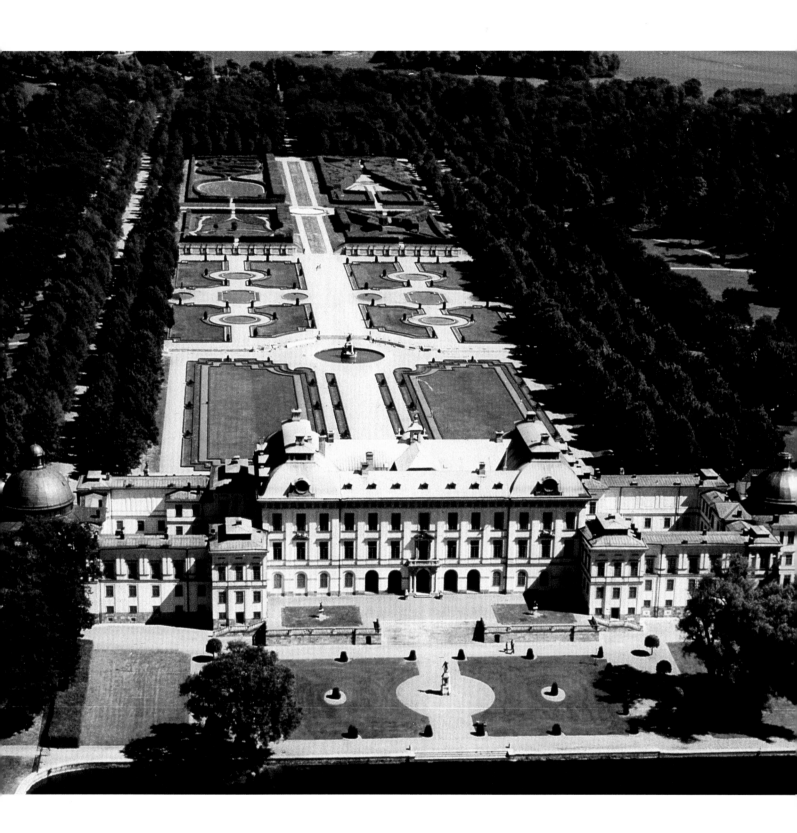

Swedish Royal Heritage:
The Royal Armory, the Royal Collections, and the Nationalmuseum

Stig Fogelmarck

T HE SWEDES WHO went ashore in Delaware in 1638 had left behind them a native country that had undergone an extraordinary transition in the last hundred years. From a politically unstable feudal state, it had developed into a centrally governed nation. Mainly through the successes of Gustavus Adolphus in the Thirty Years War, it had also attained—over and above its internal stability—the status of a political and military power on the continent of Europe. The new nation was born in 1521 when Gustav Vasa, at the head of a peasant army, settled accounts with the country's foreign masters—more specifically, with Christian II of Denmark. Gustav Vasa was proclaimed king of Sweden in 1523.

The consolidation of the Swedish kingdom and establishment of a hereditary monarchy by Gustav Vasa in 1544 made possible the development of a Continental-style royal court, that is, a setting in which the procedures of official ceremony and everyday royal living could be invested with dignity, comfort, and aesthetic qualities imitating the highest standards of the time. Burdened by practical political problems, Gustav Vasa had little time to spare for cultivating the arts. But his son Erik already aspired, as heir apparent, to an opulence in striking contrast to the plainer habits of his father. Musicians, artists, and craftsmen were always to be found at his court.

Erik's coronation in 1561 represented his first opportunity to confirm the status of the Vasa dynasty in visible terms, and the trappings produced for the occasion included the priceless regalia that even today are the foremost symbols of the Swedish monarchy: the royal crown, scepter, orb, and key of state. These, together

with two swords of state preserved from the reign of Gustav Vasa, form the core of the Swedish royal regalia, which in terms of both quality and quantity is one of the most outstanding in the world. The collection includes a second royal crown (cat. 1), made about fifty years after the coronation of Erik XIV, that is directly associated with the period of Sweden's rise as a great power. It was made in Stockholm for Gustavus Adolphus' consort Maria Eleonora, princess of Brandenburg, who wore it at her coronation in Stockholm's great cathedral, the Storkyrkan, in November 1620. It was elevated to the dignity of royal (i.e., regal) crown in 1650, when Queen Christina wore it at her own coronation. She enhanced its splendor partly by adding new gold arches. One of the most distinctive items of the regalia on display here is the elegant anointing horn made in 1606 by the Swedish goldsmith Peter Kempe for the coronation of Charles IX (cat. 3).

Sweden's regalia, unlike those of several other countries, are state property, and the Swedish financial administration, through its subordinate authorities, has jealously guarded these property rights ever since the sixteenth century. Various safe deposits have been used over the centuries, and until as recently as 1970, these articles of outstanding beauty and historical interest were all hidden in the deep vaults of the Bank of Sweden. The active support given by the present king's grandfather, Gustav VI Adolph, made it possible that year to open a fitting but secure public display at the Royal Palace in Stockholm. The Swedish regalia now form an impressive exhibition there, to the delight of scholars and the general public. Many museums had vied with one another for the privilege of displaying the regalia, but all such ideas were rejected in view of the character of the objects as national symbols. Once the Riksdag (Parliament) decided to put the regalia on per-

1. Drottningholm Palace, courtesy Royal Collections

manent exhibition, the Royal Palace seemed the only possible setting.

Gustav Vasa established an armory at Stockholm's royal castle that resembled, though on a more modest scale, the many famous royal and imperial Renaissance arsenals in other European capitals—Vienna, Dresden, Moscow, Madrid. Like some of these institutions, the Swedish Royal Armory changed character at an early stage in its history. Starting as a depot for arms and armory in actual use—part of the monarch's personal equipment for defense and for official ceremonies—it became a repository for items that were no longer in use but had assumed significance as historic national relics and treasures. It thereby assumed an importance as a means of perpetuating and glorifying the memory of turning points in the history of the nation or of the reigning dynasty. The collections of the Royal Armory, unlike the regalia, were not hidden away in vaults, but were soon opened to the general public, no doubt for propaganda reasons. Like the armories of many other countries, this institution became part of the first generation of European museums.

It was Gustav Vasa's grandson, Gustavus Adolphus, who endowed the Royal Armory with its status as a national "memorial museum" by ordaining that certain parts of the royal arsenal should be put on public display. That order was issued after a campaign in Poland in 1627–1628, when the king had twice been seriously wounded. The clothes he had worn on these two historic occasions were given to the Royal Armory in "perpetual memory" of the events and were exhibited there together with earlier mementos (figs. 2 and 3).

By that time, the arsenal had already accumulated a large number of remarkable exhibits, including the ceremonial suits of armor worn by the first Vasa monarchs and their families. In the present exhibition, this earliest Vasa material is represented by the magnificent suit of armor decorated in Antwerp in 1562 by Eliseus Libaerts for Erik XIV (cat. 6). Gustav Vasa's own dramatically designed mask visor and his personal sword are also on display (cats. 4 and 5).

There was more to Gustavus Adolphus' decision to make the contents of the Royal Armory accessible to the public than a desire to underscore particular fateful events in the brief history of the Vasa dynasty. His concern for such memorials also testifies to a realization of the value of cultural heritage, as both a political and an historical force. His desire to foster the national heritage was manifested on many occasions, and very palpably in the far-sighted instructions for preserving and cataloguing remains of the past that he issued for the office of the first Swedish antiquary of the realm.

From the time of Gustavus Adolphus down to the present, costumes and other valuable souvenirs of

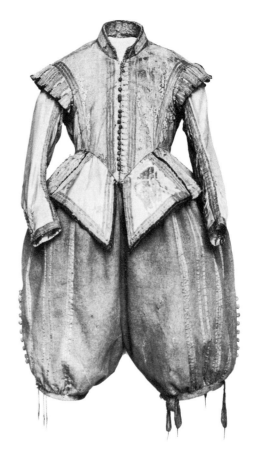

2. Suit of clothes worn by Gustavus Adolphus during the storming of the Kleinwerder bastion near Danzig (Gdansk) on 24 May 1627. Doublet of slashed silver silk satin, and knee breeches of gray cloth. Damaged by a bullet, which hit the king in the back as he crossed the Vistula River, and stained with the king's blood. Courtesy Royal Armory

Swedish monarchs and their families have been continuously added to the collections of the Royal Armory. As a result, this institution has attained, even by international standards, a unique position as a museum of costume history. Its collections include, for example, a perfectly preserved wardrobe belonging to Queen Christina's cousin and successor Charles X. This comprises no fewer than thirty complete costumes, the most magnificent of which, ordered in Paris for a coronation of either 1650 or 1654, is included in this exhibition (cat. 41). This costume, of gold lamé and velvet, lavishly embroidered with gold, was worn by the king for the coronation banquet at Uppsala Castle on 6 June 1654. During the religious ceremony in Uppsala Cathedral, he had followed the tradition of being dressed all in white. That costume also survives.

Not least instructive to the costume historian are the many children's clothes, which bear dramatic witness to

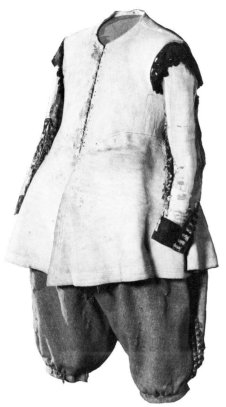

3. Suit of clothes worn by Gustavus Adolphus at Dirchau, where he was wounded on 8 August 1627. Buff elk skin coat with gray breeches. Blood-stained from the wound the king received in the neck near the right shoulder. Courtesy Royal Armory

the severe demands of fashion on the infant children of royalty. The present exhibition includes one of the most typical children's costumes in the Royal Armory: a frock of purple-dyed gold brocade worn by Charles X's son, the four-year-old Charles XI, when he made his first appearance before the Riksdag after his father's death in 1660 to receive the homage due him as the succeeding monarch (cats. 46–49).

In addition to the steady influx of mementos of individual royal or nonroyal personages, the Royal Armory has acquired a number of important groups of objects that have enhanced its display of Swedish historical traditions. The Royal Wardrobe, with its abundant stock of uniforms and accessories relating to the royal family and court, was one major acquisition of this kind. Another was the Royal Stables, the carriages, coaches, and harnesses of which reveal the splendor of the royal family's appearances on both ceremonial and everyday occa-

sions. The dazzling saddle fittings made by the goldsmith Ruprecht Miller for Charles IX's coronation horse will serve in this exhibition to illustrate the high standards of artistry and craftsmanship that could be attained in these ceremonial trappings in the seventeenth century (cat. 10).

The young, culturally minded Vasa court lacked one ingredient supremely typical of the time: an art gallery and treasure chamber of the kind developed, with various degrees of extravagance, at many of the old European courts. One feels it should have come naturally to Erik XIV to establish a prestigious treasury. Great art collections were formed at the courts of Vienna, Munich, and Dresden about this time. But conditions there were vastly different from those prevailing at the court in Stockholm, on the outskirts of Europe. Continental collections were formed in cultural environments with abundant tradition, by members of ancient, firmly established ruling houses. The new Swedish dynasty was rooted in a comparatively primitive environment; and during his brief reign, Erik was fully occupied trying to put together a court bearing some resemblance to its foreign prototypes. To our knowledge, not even his immediate successors—his brother John III, John's son Sigismund, or Erik's youngest brother Charles IX—had any thoughts of establishing an art gallery.

We have already noted Gustavus Adolphus' commitment to fostering Sweden's cultural heritage. We know too that he was genuinely fond of music and the arts. This being so, his contact with a number of established European cultural centers must have made a great impression on him. Rich monastic libraries and princely art galleries would have stimulated the aesthetic sense of this vital monarch and may have aroused a hunger for collecting that was gratified by plunder during the Swedish army's forays through German lands. Gustavus Adolphus also acquired many beautiful and remarkable objects as gifts bestowed on him by the German towns in which he was received as the champion and defender of Protestantism. The most outstanding of these was presented by the city of Augsburg in April 1632: a monumental "art cabinet" assembled between 1625 and 1631 by a well-known cabinetmaker of the time, the art dealer and diplomat Philip Hainhofer (fig. 4). With its incredible diversity of content, including everything from precious works of craftsmanship to sophisticated musical instruments, from scientific instruments to grotesque curiosities, this Renaissance "art cabinet," might well be characterized as a world in miniature. Considered as much a vehicle of instruction as a work of art, the cabinet was eventually donated by Charles XI to Uppsala University.

In the present exhibition, Gustavus Adolphus' collection is represented by the gift he received on his entry

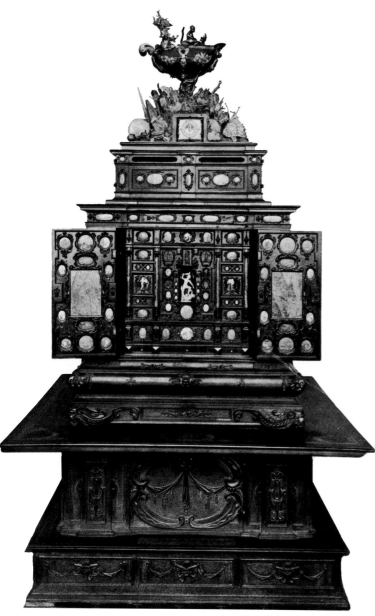

4. Art cabinet of Gustavus Adolphus, made by Philip Hainhofer in Augsburg, 1625–1631, University Collections, Uppsala, courtesy Royal Collections

into the city of Nuremberg on 31 March 1632: two enormous goblets of partly gilt silver (cat. 24). One of these takes the form of Hercules carrying the earth on his shoulders. The other represents Atlas carrying the celestial globe. Both goblets are the work of the Nuremberg silversmiths Christoph Jamnitzer and Jeremias Ritter. The globes are exquisitely engraved and signed by Johan Hauer with a Greco-Latin inscription telling us that the work was done "in the famous city of Nuremberg in 1620."

For all the notable objects added to the collections in Stockholm during the early Vasa period, it is not until the reign of Queen Christina that we can speak of an art gallery in the Continental sense. Through her diverse talents, her intellectual vitality, and her great devotion to art, Christina dramatically elevated Stockholm from a provincial capital to a leading center of culture and the arts. This represented, in the intellectual sphere, a consummation of her father's achievement, whereby the name of the Swedish capital had been firmly imprinted on the political map of Europe. Leading scholars vied with one another for invitations to the court of Christina in the remote city of Stockholm. And we know that the queen's correspondence with the most eminent scholars of the time was both voluminous and varied.

Quite early in her reign, Christina acquired representatives to help in building up her art collections, and her passion for collecting only grew stronger with the passing of years. The capture of Prague by the Swedes in 1648 made all the difference in the subsequent growth of the royal collections in Stockholm. It was in July of that year that a contingent from the Swedish army seized Prague's royal fortress of the Hradschin, the contents of which included the famous art gallery of Emperor Rudolph II. A dispatch was immediately posted, informing the queen that the art gallery had been entered and an inventory made. As soon as the news reached her, she replied in a letter to the supreme commander, her cousin and successor Charles X: "Songe aussi, ie vous prie, de me conserver et m'envoyer la bibliothèque et les raretés qui se trouvent à Prag; vous savez que ce sont les seules choses dont ie fais estime" (And be sure, I entreat you, to preserve and send me the library and the curiosities found in Prague; you know they are the only things I value). The rare books and works of art were carried from Prague to Stockholm in the worst possible winter conditions, but by June 1649 everything was safely installed. The queen must have spent many happy hours studying at first hand all these treasures, which at one blow invested the collections of Stockholm's Royal Palace with a new brilliance.

An inventory from 1652 conveys some idea of the character and extent of Queen Christina's collection: 179 works of ivory, 26 of amber, 25 of coral, 660 ornamental vessels of agate, rock crystal, and other materials, 174 items of pottery and a large table service, 403 East Indian curios, 2 ebony cabinets with gold and silver inlay, 16 precious clocks, various works of precious stones, several boxes of uncut diamonds, 317 mathematical instruments. All these riches came from Prague. To this very substantial collection were added the inheritance from her father, costly presents from native and foreign donors, and last but not least, everything pur-

chased on the queen's own orders, that is, through Pieter Spiering, her personal representative at The Hague. Prominent among the many works of ivory that Spiering added to the queen's art gallery is a magnificent salt cellar made for Peter Paul Rubens by Georg Petel, a sculptor of south German birth. Petel is represented in this exhibition by a bronze bust of Christina's father, Gustavus Adolphus—a portrait made in Nuremberg not long before the king's death in 1632 (cat. 25). Her court favorite, Magnus Gabriel De la Gardie, commissioned a silver throne from Augsburg for her coronation, which still holds a special significance as the traditional throne of state (fig. 5).

The loot from Prague also included a great number of paintings and sculptures, with famous works by such artists as Veronese and Correggio. Christina took a large proportion of these treasures to Rome with her when she left Sweden after her abdication in 1654, including several items that belonged to the nation. Works that were not allowed to leave the country included the regalia and the magnificent suite of woven tapestries ordered from Holland as part of the festive setting for Christina's coronation. After Christina's death, her vast collections were dispersed. The antiquities are now in the Prado Museum, the manuscripts are in the Vatican, and the paintings are scattered in museums all over Europe and the United States.

Charles X, who succeeded Christina in 1654, was not much of a collector, but by effectively "saving" works of art during his various campaigns, he did a great deal to augment the royal collections. Perhaps his most important contribution toward the furnishing of Sweden's palaces and collections, however, was his marriage to Princess Hedvig Eleonora, who came from the north German duchy of Holstein-Gottorp. This energetic queen took a keen interest in the design and beautification of the royal residences, partly influenced perhaps by her father, the connoisseur Duke Frederick III. In the course of a long and active life, she did full justice to her plans, through numerous building enterprises, eager patronage of the visual arts, and untiring acquisition of new articles for her treasury collection.

Thanks to the exhaustive inventories compiled after Queen Hedvig Eleonora's death in 1715, we know much about the scope and character of her collections. Most of the exhibits in the Royal Treasury today originally came from residences she furnished. The most valuable of her possessions, including articles of precious metal and stone, were kept at Ulriksdal. The present exhibition includes the oldest item in the surviving collection, an agate bowl from late antiquity, with mountings of a later date (cat. 58). Another elegant survival from the queen's collections—also included in the exhibition—is a tankard of rock crystal with gold, precious

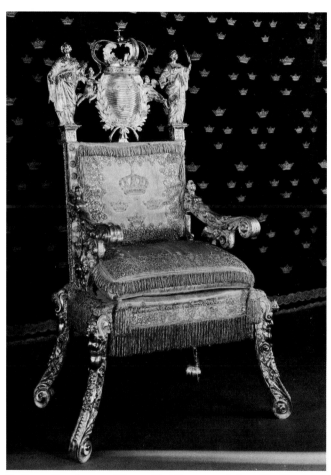

5. Coronation throne of Queen Christina, commissioned by Magnus Gabriel De la Gardie from Abraham Drentwett of Augsburg, 1650, courtesy Royal Collections

stone, and enamel mountings (cat. 59). This was probably made in Milan during the early seventeenth century. Additional collections were housed at Hedvig Eleonora's favorite residence, Drottningholm, a baroque palace on the grand scale designed by the queen's architect Nicodemus Tessin the Elder (see fig. 1). The main emphasis there was on pottery, mostly from East Asia and Holland.

Tradition has often held that the Swedish royal collec-

tions of the seventeenth century mainly consisted of plunder, but this is a great exaggeration and as far as Hedvig Eleonora is concerned, quite misleading. She imported a great many of the items from Italy and Holland, but she also did business with those art dealers who ventured as far afield as Sweden. Native craftsmen, too, received commissions from the queen. For example, a skilled ebony turner was attached to Hedvig Eleonora's court, as contemporary fashion demanded. He had the dual task of supplying the queen with works of art and teaching his difficult trade to the royal children. Exercises of this kind, being such a trial to the patience of the practitioner, were greatly valued as a form of moral education.

Ulrika Eleonora the Younger, granddaughter of Hedvig Eleonora and sister of Charles XII, constitutes the final link in this chain of royal Swedish art collectors. With her, in the early eighteenth century, we come to the end of a long and important tradition, the origins of which can be traced back to the intellectual world of the Renaissance courts of Europe.

The Royal Treasury collections are now the property of the Swedish nation. Unfortunately, though, the material—which in the nineteenth century was gathered in the Museum of National Antiquities in Stockholm—is now divided between a number of different institutions. A vast and very representative section, from which several of the objects here have been taken, is administered by the Royal Collections and is kept on display in the Charles XI Gallery at Stockholm's Royal Palace. Other parts of the collection have been transferred to the Royal Armory, the Nordic Museum, and the Nationalmuseum.

The Nationalmuseum, like the Royal Armory, was established through royal initiative. Gustav III had suggested the idea, and the decision to found what was then called the Royal Museum was made in 1792, shortly after the king's death. Two years later the museum was opened, in one wing of the Royal Palace. It is thus Sweden's oldest public art museum and the first institution of its kind outside Italy.

The core of its collection consisted of earlier royal collections, dating as far back as the sixteenth century. Items from the imperial collections seized in Prague also remained, although the most valuable, as we have already seen, were taken to Rome by Christina. Great paintings by Boucher and Chardin were added by Queen Lovisa Ulrika and King Frederick. But the most important section of the first museum's collections was assembled by one man, Count Carl Gustav Tessin, son of the architect of the Royal Palace in Stockholm, Nicodemus Tessin the Younger, and one of the leading politicians and cultural personalities in eighteenth-century Sweden. During his years as Swedish ambassador in Paris, he came into close contact with French artists and art dealers. A discerning knowledge coupled with ample finances enabled him to build up a magnificent collection of paintings, drawings, and prints. He combined this with art inherited from his father to form one of the largest private collections ever known in Sweden. When in later life financial worries forced him to part with most of his treasures, they were acquired by the royal family and, through Gustav III, became the property of the nation.

With the Tessin collection, the royal museum acquired a collection of drawings, predominantly of the Italian, Dutch, and French schools, that is of an internationally high standard. Particular interest attaches to the drawings relating to French architecture, interior design, and drama. The Tessin material was subsequently augmented through the acquisition of the great collections formed by eighteenth-century architects Carl Hårleman and Carl Johan Cronstedt, making the Nationalmuseum an indispensable quarry for scholars, not least as regards the history of the French royal residences. In this exhibition the Tessin material is represented by drawings by Jean Berain for Charles XI's state coach, built in Paris in 1696 and still surviving in the Royal Armory (cat. 63).

The objects from Swedish royal collections on view in this exhibition are intended to help American visitors survey a fascinating chapter in the cultural history of northern Europe. The underlying theme of the exhibition—art as a representation of politics and propaganda—is most singularly expressed in the objects made before the time of Queen Christina: the coronation and burial regalia of Charles IX, the Libaerts armor of Erik XIV, and Nuremberg's gift of Christoph Jamnitzer's globes to Gustavus Adolphus were all closely related to the political ceremonies and military victories of the Swedish crown. During and after Christina's reign, the collecting of works of art by the royal family began to reflect increasingly humanistic interests. Art acquisition began to be based on the personal taste of cultivated individuals, as well as on its function as state propaganda. Christina and her successors, particularly Charles X's dowager queen Hedvig Eleonora, brought new insights to the buying and commissioning of works of art, showing a full knowledge of the contemporary court culture of Europe. And Charles XI and Charles XII sought the advice of experts, royal architects, and tastemakers, such as the Nicodemus Tessins, whose professional duty was to be fully informed of developments in the arts throughout Europe. Stockholm at the end of Sweden's period of great power became, if only briefly, one of the preeminent centers of artistic creativity of Europe.

When a small nation like Sweden presents some of its royal collections to the American public, many people may assume that the material comes from just one

source. This is not the case. The Swedish Royal Collections represent several institutions of varying age and character, each of which evolved as part of the royal administration, in some cases enshrining significant phases of Sweden's historical and cultural development. All these institutions, while reflecting aspects of Sweden's history, still retain some of their original purpose. And in keeping with the demands of a new age, they exist for the gratification and benefit of the entire Swedish people.

Royal Castles and Palaces: The Architectural Image of the Monarchy in Sweden

Guy Walton

THE MONUMENTAL CENTER of Stockholm is dominated by an enormous building set on a hill (fig. 1). Though unobtrusively colored brown, with its window frames, portals, and other ornament in similarly subtle tones of beige or gray, the structure almost overwhelms its surroundings. In addition to its immense size and rather severe character, its setting contributes significantly to the impact of this building. An expanse of water to the east and northeast allows two of its long sides to be taken in at one time, revealing its vast dimensions. This is Stockholm's Royal Palace.

Visitors to Stockholm are often surprised at the size of the royal residence. Sweden is, after all, a country whose territory lies mostly in the great empty northlands, with a small population even today. When the palace was built, Sweden had less than a million inhabitants. But the country at that time also ruled present-day Finland and substantial domains along the Baltic coast—Estonia, Livonia, western Pomerania—and a number of smaller territories. The building was conceived as the capitol of an empire, a small empire perhaps, but impressive and profitable just the same. The great powers of Europe were in fear of Sweden's military strength.

The political message of the palace has always been understood by the Swedes. In the last century when a new structure was built to house the Swedish parliament (the Riksdag), it was raised on a small island directly in front of the palace's looming north facade.[1] Located to one side of the road leading across the water from the north entrance of the palace to Gustavus Adolphus' Square, parliament stood directly before the eyes of the king.

This compromise of royal authority was not new. It had been a fundamental issue of Swedish politics since the founding of the modern Swedish state in the sixteenth century. The four estates of parliament—and most particularly the nobles—had repeatedly challenged royal attempts to establish absolute rule. And one arena of competition had been in architecture and the arts. Nobles and even merchants had at various times built sumptuous houses to rival that of the king.[2] The Stockholm palace may actually have been intended as the final, supreme gesture in this competition.

Stockholm's Royal Palace is not simply a declaration of royal authority, however. It has a long and complicated history.[3] Although the present building was planned under autocratic monarchs, the financial disasters of the wars of Charles XII brought work on it to a halt from 1707 until 1727. The palace was finished in what is called the "Era of Freedom," a period when the Swedish monarchs had been relieved of their power in the wake of the defeat of Charles XII by Peter the Great. The decision of parliament in 1727 to grant money for work underscores a second equally important meaning of the building for Sweden. The palace was completed because its looming unfinished hulk had disfigured Stockholm for three decades and Sweden wanted to rival Europe in the area of the arts. The greatest painters of the period, such as the Venetians Tiepolo and Piazzetta, were sought for the decoration of a palace that was to be the residence of almost powerless kings and queens.[4]

Nicodemus Tessin's original drawings make clear that the Royal Palace was intended from the start to demonstrate that Swedish designers had arrived at the point where they could avail themselves of the great artistic traditions of Italy and France. The north facade is frequently compared to an Italian palace (art historians

1. Royal Palace, Stockholm, courtesy Gösta Glase

have specifically mentioned Vignola's Villa Farnese at Caprarola and certain projects by Bernini's student Fontana).[5] A grand gallery on the interior dedicated to the exploits of Charles XI (figs. 2 and 17) was clearly inspired by the Hall of Mirrors at Versailles. Tessin's palace is a bold statement of Sweden's intention to become a European leader in the arts, just as Sweden's kings in the seventeenth century had made the country a great European political power.

Since the glory of monarchs was thought to be directly reflected in the buildings they constructed—even more than in their life-styles or the trappings of their courts—the building activities of the Swedish kings and queens provide background necessary for an understanding of the development of the arts in Sweden during the period surveyed by this exhibition.[6] Certain Swedish monarchs, including some who were enthusiastic collectors of treasure and arms, were also great builders. And royal architects served at various times as general purveyors of ideas on culture and style far beyond their particular area of professional competence.[7]

The objects on view in this exhibition were for the most part acquired for and shown in various palaces of the Swedish monarchs.[8] Some were undoubtedly purchased for use in one specific location. An evocation of the early settings thus clarifies some of the purposes for which these works of art and armor were chosen.

The founder of the present Swedish state, King Gustav Vasa, created the type of monumental Swedish royal residence with which the objects in the exhibition must be associated. He built a string of castles across Sweden as a part of a necessary effort to secure the country against foreign attack—particularly invasion by the Danes, who challenged his right to the throne. Castles were built or rebuilt in the two principal cities of the realm, Stockholm and Uppsala, as well as on the west coast at Älvsborg, the east coast at Kalmar and Borgholm, and at Vadstena in central Sweden.

The typical Vasa castle consisted of four tremendous round towers joined either by walls or by buildings that could serve for military purposes or lodgings for king and court, with the giant towers built in response to new sixteenth-century firearms and cannons. In Stockholm, even the apse of the Storkyrkan (Great Church) was pulled down to make room for expanded modern fortifications for the castle. Some castles eventually functioned primarily as administrative centers and residences and were consequently invested with grand public rooms, such as the Hall of State at Uppsala (now, since a fire in the eighteenth century, hardly more than a vast space to reflect something of the scale of its past glory).

Gripsholm Castle at Mariefred not far from Stockholm on Lake Mälaren is the best preserved of Gustav Vasa's castles and remains even today a royal domain containing important objects from the royal collections.[9] The name of this castle commemorates Bo Jonsson Grip, a nobleman of great wealth who built an early fortress on the spot in the 1380s. In fact, some of the walls of the medieval fortress were incorporated into the present buildings. The profile of Gripsholm seen from the water (fig. 3) is characteristic of Gustav Vasa's architectural achievements. Henrik von Cöllen, who drew up the first plans for this castle in 1537, was both a foreigner, prob-

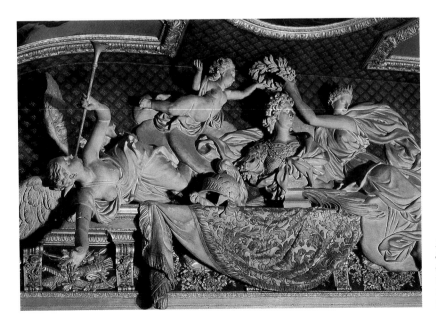

2. *Charles XI Crowned by Fame while Cleo, Muse of History, Records His Actions*, sculptural decoration by René Chauveau and others for the ceiling of the Gallery of Charles XI, executed c. 1699, Royal Palace, courtesy Royal Collections

3. Gripsholm Castle, engraving from *Svecia Antiqua e Hodierna* (Stockholm, 1719), courtesy Nationalmuseum

ably from East Prussia, and a military engineer.[10]

The interior of Gripsholm has not survived, but an idea of its original splendor is conveyed by a ceiling of 1543 by Anders Larsson Målare (reputedly a student of Cranach) for the king's bedroom, now in a different location.[11] It is elegantly coffered in a complex pattern of hexagons and squares, with its ornamental painting in the more or less contemporary German mode. The portraits and half-figures in the coffers are based on sixteenth-century German prints, including one by Heinrich Aldegrever.

Research by Swedish art historians has permitted the reconstruction on paper of the Great Room of Gripsholm,[12] with a state chair at the head of the room. The ceiling was coffered somewhat in the manner of the one mentioned above; and the side walls, lined with built-in benches, were penetrated on one side with small windows. The main feature of the room was a series of large paintings in the upper half called Gustav Vasa's triumph pictures, which may have illustrated, in lifesized figures, events from the king's life. About half of these ambitious compositions are known from eighteenth-century watercolors now in Sweden's Royal Library. This interior resembled a luxurious German princely room of the period.

The major surviving Vasa interior at Gripsholm is a semicircular bedroom in one of the towers known as Duke Charles' Chamber (fig. 4). It is in fact the best-preserved room in Sweden from Vasa times, redecorated

only a decade or so after the death of Gustav Vasa for one of his sons (later Charles IX). This cozy room, with three deep window niches, including one with a bed built into the wall, has walls covered with high paneling. The paneling is articulated with pilasters and arches based on classical Renaissance types, suggesting that the Renaissance had established itself by the 1570s even in the distant north. Motifs in the decorations are based on prints by Cornelis Floris and Vredeman de Vries, Flemish artists. The painted decoration is in tempera directly on the wood and, though not very refined, is a charming combination of flower bouquets, putti, and other ornament.[13]

It was Eric XIV and John III, Gustav Vasa's sons and heirs, who settled down to the business of creating an architectural environment for the Swedish royal family to rival that of the nearer Continental sovereigns, most notably the Danes and the Germans. The standard of the time in this part of the Continent had been set by the courts of the Holy Roman emperors at Vienna and Prague and that of Francis I at Fontainebleau, the latter known mostly at second and third hand through French engravings and the adaptation of their style by some of the German court artists.[14] The influence of the Netherlands, where fine craftsmen and painters were unusually abundant, was particularly important for design developments in Sweden. The recruitment and training of artists abroad makes this clear.[15]

Erik's considerable success in design can be gauged by

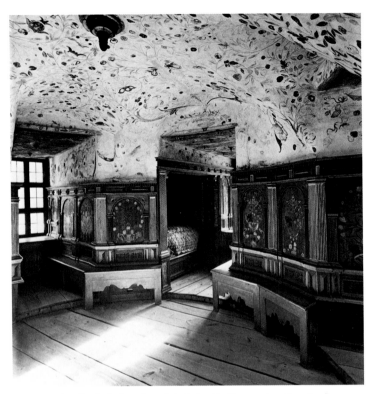

4. Duke Charles' Chamber, Gripsholm Castle, courtesy Royal Collections

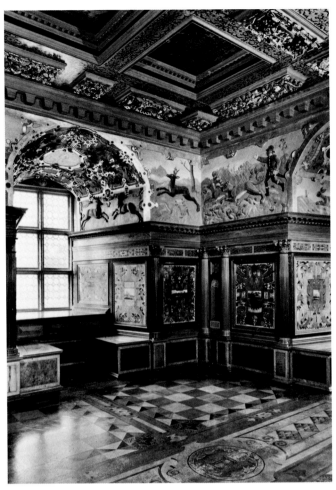

5. King Erik's Chamber, Kalmar Castle, courtesy Kalmar Läns Museum

an important surviving (though much-restored) room at Kalmar Castle, one of Gustav Vasa's great fortresses, which was also the sometime residence of Erik and later of his half-brother John. This room, now known as King Erik's Chamber (fig. 5), is close in time to Duke Charles' Chamber at Gripsholm (fig. 4) (Charles' room, surprisingly, is a bit later), but the two are so different as to suggest different countries and cultures. The rough stone ceiling at Gripsholm has as its counterpart a grandly coffered ceiling, basically of Italian inspiration, with rich wood inlay and gilded sculptural ornament. Though invested with a similarly high wainscoting, Erik's room is lavishly decorated with wood inlay, in contrast to Charles' room, with its simple painted designs. Since Erik, a real Renaissance prince—poet, musician, and artist—is said to have done wood inlay, parts of these decorations have even been ascribed to him.[16] It is the character of the ornament, however, that makes for the greatest difference between these interiors. Geo-

metric shapes and proportions predominate in the decoration at Kalmar, whereas organic motifs distinguish the ornament at Gripsholm. The patterns in Erik's bedroom are elegant and complex, with spatial illusionism shown in the inlay; the principal panel areas are decorated with the mannerist strapwork invented at Fontainebleau.

The reliefs of hunting scenes in Öland that run around the upper part of King Erik's Chamber are in the latest style and recall less the works of the German painters preferred by Gustav Vasa than Flemish tapestries, which they were undoubtedly supposed to imitate. The gold, bright colors, and extravagant complexity of the ornament approaches the contemporary style of the Habsburg emperors, and leaves completely behind most of the local decorative traditions evident at Gripsholm.

Since Erik's reign proved to be a short one—he was deposed for madness in 1568—it fell to his brother and successor, John III, to pursue developments in the arts

he had begun. John continued the work at Kalmar, making it today the greatest surviving Renaissance palace in Sweden. But his most important achievement was the rebuilding of the Three Crowns Castle in Stockholm (fig. 6). Three Crowns stood precisely on the spot where the Royal Palace stands today, and it was, as it had been for centuries, the premier residence of the Swedish kings.

The prestige of Three Crowns dated well back into the medieval period. At its origins, possibly as early as the ninth century, it had been a fortress on the small island in front of the present palace, where the nineteenth-century parliament building stands today.[17] The fort's importance was related to the trade between the large inland waterway, Lake Mälaren, and the Baltic Sea, which afforded the possibility of exporting natural resources such as iron and copper ore. It was on this economic strength that the power of a number of Swedish kings had been based, and the location came to be closely associated with the Swedish crown.

The transition from a small fortress to a great medieval castle was accomplished around 1250, when massive walls were constructed just outside the northern wall of the city of Stockholm by Birger Jarl, regent in Sweden from 1250 to 1266. Parts of Birger Jarl's thick masonry walls (some twenty feet thick and still existing to a height of twenty feet) were incorporated into later versions of the Three Crowns Castle and were used by Tessin to support the great northern front of today's Royal Palace.[18]

The arrangement of Birger Jarl's Stockholm castle was the traditional one. The keep, which contained the residence of the monarch, was surrounded by vast utility courts, used both for the military and for the practical needs of the king (the present palace's north facade marks one side of one of these). At Stockholm the keep was a large round tower that stood on a hill enclosed by the castle walls about thirty feet above the nearby water. Over the years it continued to be regarded as the center of the castle. The name "Three Crowns" that was eventually given to the castle apparently derived from the three gold crowns mounted on the castle tower, which are also represented on the arms of Sweden. These crowns were probably put up during the fourteenth century. They are clearly visible in the Parhelion painting of 1535, on view today in the neighboring Storkyrkan (see also fig. 6). The tower was surrounded by a square building that often housed the actual royal residence and separated the tower from the utility courts that lay to the north and the east.

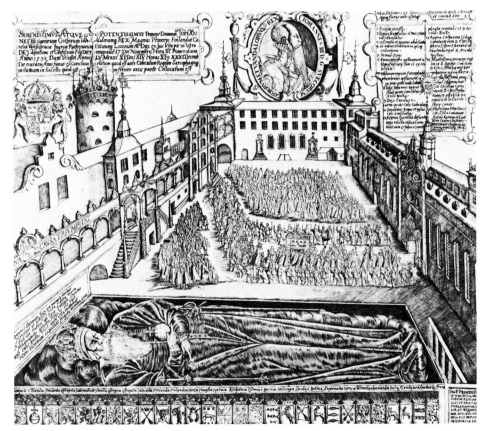

6. John III lying in state in the courtyard of Three Crowns Castle, with funeral procession of 1592 in background, engraving by Hieronymus Nützel, 1593, courtesy Royal Library, Stockholm

It is not clear what state the Three Crowns Castle was in when John III took possession of it. Frequent fires had ravaged the buildings over the years. As recently as 1525 the damage had been so extensive that Gustav Vasa spoke of being left with "but a shirt and a silver tankard to drink from." During Gustav's reign the royal accommodations had at least been restored, no doubt comfortably. The king's apartment was notable for its unusual privacy. Records also speak of a "dancing house" and separate quarters for the royal children, but the character of these is unknown. The relative modesty of Gustav's own apartment is suggested by the fact that King Erik, when he took over Three Crowns, immediately redecorated his father's rooms—though they had recently been refurbished. On the basis of what we know of Erik's taste, we may assume that substantial enrichment of the interiors was achieved. But the castle appears to have changed little otherwise.[19]

John III was apparently not pleased with what Erik had done, and his redecorators moved in immediately. Later, in the 1570s, he decided that more fundamental changes would be necessary to make Three Crowns a suitable residence for a Swedish king. The outstanding problem was the castle's medieval character, its ugly courtyards cluttered with small buildings for military and utilitarian use. Two factors weighed heavily in favor of the preservation of Three Crowns: its size, which was adequate for the court of an important prince; and its history, which gave a sense of the continuity of the Swedish monarchy, something much prized by a new dynasty none too sure of its position.

As a young man, John was well educated and thoroughly familiar with the refinements of the European royal life-style his brother Erik had adopted. His first wife, Katarina Jagellonica, was a Polish princess whose mother, Italian princess Bona Sforza, had made the Polish capital of Cracow into an important outpost of Italian Renaissance culture. Katarina thus had ideas about appropriate lodgings. In 1573 John had revealed his discriminating taste as a patron by bringing three of the north Italian Pahr brothers from Germany to work for him at Kalmar Castle. His intentions rapidly evolved, and the upgrading of the Three Crowns Castle became his central interest. He was aided by the considerable talents of the sculptor and architect from Flanders, Willem Boy.[20]

Under John, the royal residential quarters at Three Crowns expanded out into most of the area covered by the old castle, achieving an unprecedented grandeur. His designers also gave an appearance of fashionable modernity to the whole complex. The roofing was all redone in the same sheet metal. Then the many towers, except for the round tower where the three crowns were displayed, were made more uniform in height,

7. Three Crowns Castle from the southwest, by Govert Camphuysen, 1661, courtesy City Museum, Stockholm

though pleasingly varied in profile. A final coherence was achieved by painting the roofs red and the walls of the building white. The white walls were unchanged as long as the castle stood (fig. 7).

John's transformation of Three Crowns, and the fact that he saw it as one of the major achievements of his life, is expressed in a print issued in connection with his funeral (fig. 6). The old king wears his regalia as he lies in state in the large northern courtyard of the castle. The enclosure is no longer the utility area it had been for centuries but the courtyard of a splendid palace.

John III was a well-read man. He is known to have studied Serlio and other architectural theoreticians of the Renaissance. The great round arcaded court at the royal residence of Svartsjö, built in 1588 toward the end of John's reign, is remarkable in the history of Swedish architecture.[21] This architectural erudition is also reflected in the Three Crowns courtyard shown behind the king's coffin in figure 6. The issues of symmetry and proportion that so concerned Renaissance architectural theorists can be seen, though somewhat superficially, in the new windows in the walls around the court. But it is in the use of columns and arcades and in the creation of certain individual structures—required for reasons of utility and access—that John came closest to creating the impression of a Renaissance building. Swedish art historians have found the architectural models for this court in the great French châteaux of the sixteenth century.[22]

The north courtyard of Three Crowns Castle contains several other structures that should be mentioned among John's architectural achievements at Stockholm. The funeral cortege in the print (fig. 6) wends its way

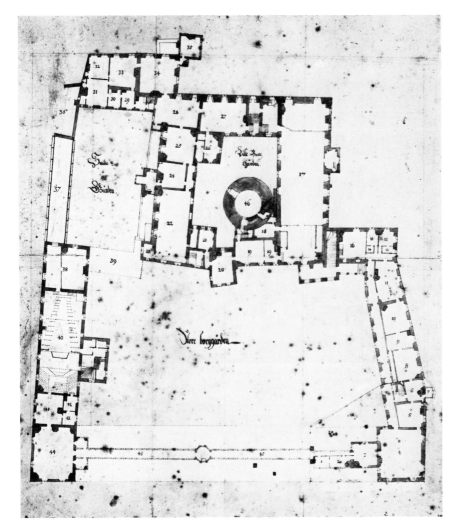

8. Ground plan of Three Crowns Castle, by Jean De la Vallée, 1660, courtesy Office of the Palace Architect, Stockholm

toward the entrance to the new protestant chapel (John also built a small Catholic chapel for his Polish queen). The few surviving fragments from this building suggest that it was elaborately decorated in an original combination of styles, including both northern mannerist and Gothic. It is supposed that John's interior, following from his theology, tried to reconcile the modern reformed church with traditional Catholicism. Today some sense of what the decor of this chapel must have been like can be had from the tomb of Katarina Jagellonica by Willem Boy in Uppsala Cathedral (1588).[23]

At the far end of the court appears a building between two square towers, which included magnificent new apartments on its top floor for the king and queen. Their old rooms, though frequently redecorated, had never pleased them. (It is easy to understand why when one realizes that many of the rooms overlooked the blacksmith's court, while others of greatest prestige had only adequate views of town and the rear of the Stor-

kyrkan.) Part of John's overall palace plan of the 1570s apparently called for new royal lodgings, but work began only in 1584. The death of Queen Katarina in 1583 and the king's courting of the reluctant Gunilla Bielka, a young Swedish noblewoman, as a second wife seem to have spurred the project along. King John's decoration of the rooms was so lavish that they were not ready until 1590. (A contemporary example of John's generosity to his new wife is shown in this exhibition by the splendid orb and scepter made for her coronation [cat. 2].)

Innovative planning increased the living space and the comfort of the royal apartments and at the same time created an unprecedentedly grandiose setting. A broad windowed corridor of great length joined most of the rooms, and even served when necessary as a reception room, enjoying a view of John's new northern courtyard (fig. 8). Many of the rooms were also connected by interior doors, allowing private circulation by the royal couple. A major innovation in design was a

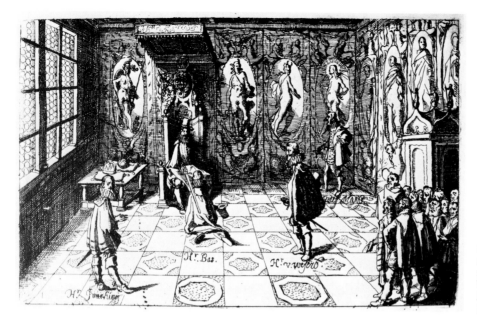

9. John III's audience room, Three Crowns Castle, showing reception of Dutch ambassador by Gustavus Adolphus, engraving by Antonis Goeteris, from *Journael der Legatae ghedaen inde Jahren 1615 ende 1616* (1619), courtesy Royal Library, Stockholm

huge family dining room linking the king's apartment with that of the queen. On occasion the room also served as an enormous guardroom. The tour de force, however, was the small audience room near the north tower of the castle:

> This room which was 12 x 15 meters [c. 39 x 49 feet] was entirely finished with the work of goldsmiths and shone with gold and silver. It had seven large rectangular windows. . . . The walls were divided by pilasters and the areas between them as well as the shutters were covered with silvered copper plate, very likely with engraved decoration. . . . The ceiling was coffered . . . but completely executed in richly chased copper and entirely gilded and silver plated. The floor of the room was made of plates of copper and brass laid in a checkered pattern. The plates had enamel ornament in colors. On the walls over the silvered copper plate hung tapestries richly in-woven with gold and silver.[24]

Though obviously nothing more was needed to overwhelm the visitor, a doorway opened between two fireplaces (gilded?), leading to a long passageway. This connected the king's apartment with the two chapels of the castle. "The Green Passage was used by the king as a library and study and probably as a picture gallery. From the large-paned windows, the king had a fine view [over the water and the castle yard]" (see fig. 8).

Mention should also be made of the renovation of the Hall of State built by King John at Three Crowns, reached by the great ceremonial stairway that led to the new royal apartments.[25] While in no way equal to the room built by Gustav Vasa at Uppsala, it was nonetheless a magnificent interior, serving for more than a cen-

tury as the site of many major royal functions. John's palace, with only minor modifications, accommodated the Swedish monarchs until the 1690s. It was thus he who created the setting in which the Swedish monarchs lived during almost all of the country's time as a great power in Europe. His successor, Charles IX, did almost nothing to change Three Crowns Castle.

Gustavus Adolphus, who ruled Sweden from 1611 to 1632, established a centralized government in Stockholm at Three Crowns Castle. But he appears to have been more interested in organizing the rapid growth of the city than in restoring the elegances of the castle from earlier years. Most of the construction undertaken at Three Crowns during his reign was the enlargement of quarters for the reorganized government—the courts of law, chancery, revenue office, and so on. This hardly changed the character of the castle as a whole.

It would be wrong, however, to underestimate the building achievements of Gustavus Adolphus. In 1624 he signed a contract with a new royal architect, Kaspar Panten, to construct a new wing around the blacksmith's court at Three Crowns. The features of the four-story structure were carefully defined before Panten departed for his native Holland to procure craftsmen and artists. Workers arrived in Sweden in May, and the building was completed in about a year.[26]

Although Gustavus Adolphus did not hesitate to use John III's audience chamber on special occasions (fig. 9), he seems to have preferred a simpler decor of wood inlay. Either he or his minister, Axel Oxenstierna, had forged a relationship with some fine woodworkers from Lübeck (who produced among other works in Sweden a superb baptismal chapel in Västerås cathedral). They

worked for Oxenstierna at Tidö Palace, executing its famous wooden doors, many of which remain in place today (fig. 10). Similarly elaborate inlaid door frames are presumed to have decorated the various rooms at the Three Crowns Castle, which were refurnished by the king for private use during his relatively short reign. Kaspar Panten served as an advisor to the king on all aspects of palace decoration and furnishing. Certainly the standard of luxury had risen to such heights at the end of the sixteenth century that it was inconceivable for a king of Sweden to be less than moderately lavish.

The death of Gustavus Adolphus at the Battle of Lützen in 1632 brought about a near hiatus for almost ten years in important work at Three Crowns Castle. A regency was established for the young Queen Christina led by Axel Oxenstierna, and for him the prestige of the crown was manifested less in building programs than in the smooth administration of the country, its growing territories abroad, and its armies in Germany. Not unexpectedly, the royal residence was changed mainly by the addition of still more space for government offices and some improvements in the water supply system. Even these modest efforts counted for little since many of the new offices were swept by a fire in 1642 shortly after completion and had to be rebuilt.

A description of Christina's apartment (see fig. 8) suggests that some changes were made that related to the remarkable education of the young queen, who during the 1640s gradually gained a reputation as the preemi-

nent humanist among European monarchs.[27] In addition to the queen's bedroom and a "large reception room with stone floor," there was a "study with small tower" and an anteroom, a music chamber, and an area for musicians in her dining room. The music facilities recall the extraordinary court ballets on the French model that were so much a part of Christina's life, though they were probably staged in the large reception room. A theater was added in the 1650s (fig. 8).

Another fire broke out in 1648, and in the process of rebuilding the blacksmith's court, which had been severely damaged, Christina's apartment, which was nearby, was completely transformed.[28] The queen must have been particularly pleased by the addition of a library connected to her bedroom. The library had bookcases reaching all the way to the ceiling, the upper shelves being reached by balconies supported by metal rods suspended from the ceiling.

Christina's new apartment seems to have been decorated not with the old elegance of Germany, Holland, and the Holy Roman Empire, typical of so much that was done by her predecessors, but in the French style. Her bedchamber was furnished with a great French bed of state, which she used in the French manner for audiences, either reclining or, more often, receiving important figures in a special area in the bed niche. The names of other rooms in her suite—the Red Chamber and the Blue Chamber—also suggest contemporary French ideas. Some years before, Madame de Rambouil-

10. Vestibule doorway, dated 1639, Tidö Castle, courtesy Atlantis

let had started a revolution in interior decoration when she received her guests in a room where blue was the predominant color and all of the elements in the room were in harmony. It is not clear whether Christina followed these new aesthetic ideas fully or whether she simply adopted the fashionable names of modern Parisian rooms.

In 1648 Christina invited André Mollet, a prominent member of an acclaimed family of French gardeners, to join her court. Magnus Gabriel De la Gardie, the queen's favorite, had met him in Paris in 1646 and negotiated his entering the queen's service. Mollet brought with him to the royal gardens twenty orange and lemon trees, four grenadines, four myrtles, ten Spanish jasmines, seven laurel bushes, as well as tulips and anemones. Since Three Crowns Castle had room for only a few small gardens, Mollet concentrated his efforts on Kungsträdgården (the king's yard), a well-known public park in Stockholm across from today's Royal Palace. An elaborately structured French formal garden with shaped and trimmed walls of trees surrounding parterres and walks was developed during Mollet's five years in Sweden.

Mollet has also been given credit for Magnus Gabriel De la Gardie's beautiful garden at Jacobsdal (see fig. 15), which impressed Queen Christina enough that she purchased the entire palace. Mollet and his son also found time to transform the gardens of other noble residences, the most famous being the great garden at Kungsholm to the west of the city, made for Governor-General Schering Rosenhane. Sweden's new status as a center of the modern European art of gardening was established when André Mollet published in Stockholm, possibly in connection with Queen Christina's coronation, his renowned treatise on gardening, *Le Jardin de Plaisir* (1651).[29] French garden design developed so quickly that when Erik Dahlberg published Sweden's achievements in architecture a decade later in his splendid *Svecia Antiqua e Hodierna*, numerous formal gardens of a high international standard were engraved.[30]

With the arrival of loot from the Swedish capture of the imperial collections in Prague in 1649, Three Crowns was again transformed. But these valuable objects presented Christina with something of a dilemma. Beyond the books, which she was most anxious to acquire, the Prague treasures were in the grand Germanic style so appreciated by her ancestors, but mostly not to her taste (see cat. 31). Her own account of 1653 reads: "There is an infinite range of items, but apart from thirty or forty Italian originals, I discount them all. There are works by Albrecht Dürer and other German masters . . . which would arouse profound admiration of anyone apart from myself. But I do declare that I would change them all for two Raphaels, and I think this

would be doing them too much honor.''[31] Her opinion of the precious objects was undoubtedly the same. If they were of use, it was only as symbols of Swedish power; and apart from the books, most must have been displayed in parts of the palace other than her personal quarters. There can be no doubt, however, that Three Crowns Castle suddenly became home to a world-class art collection rivaling those of the greatest European monarchs.

This windfall of booty had a modest impact on the architecture of the castle. The major work prompted by the arrival of the spoils from Prague was the construction of a building to house the lions. Though Christina ruled for only five years after the capture of Prague, and left with most of the collection when she abdicated, she enhanced the idea of regal living surrounded by treasures, already well established in the previous century.

In the last years of Queen Christina's reign, she sponsored an extravagant scheme for completely rebuilding Three Crowns. The reasons were primarily that she now favored a style based more on classical, Italian, and French models; and the etiquette of her court had become more refined as she adopted the strict rituals and protocol of the Spanish kings. Already on 30 May 1649 Christina spoke to her council about plans for a new castle. One of these proposals, by Nicodemus Tessin the Elder, recommended the destruction of most of the old castle—the queen's new quarters appear to have been destined to survive, at least for a while—and a far more regular if rather boring organization of many interior spaces and the courtyards.

This project apparently failed to win support, but in 1651 the queen engaged Jean De la Vallée, just back from Italy, as palace architect.[32] He seems to have carefully reflected on the problems, producing an overall plan in 1654. He then proposed a highly regular, generally symmetrical plan, stressing outdoor amenities, particularly terraces and formal gardens. His radical changes included the suppression of the ramparts and moats, and the removal of walls that blocked the views toward both the city and the water. This would have completed the transformation of the medieval castle into a modern palace.

Charles X, who was crowned king on the day of Christina's abdication in 1654, has on the whole received rather bad press on the subject of his support for the arts. This is difficult to understand, considering his known architectural activity. He was widely traveled and well educated, and he appears to have been eager to continue Christina's enthusiastic patronage (see cat. 36). He also seems to have been willing to undertake major building projects, to enhance either his image or his life-style. He found Gripsholm outdated, but rather than remodel, he asked Tessin the Elder to draw up

plans for a new pleasure palace nearby.[33] He also pressed for the rebuilding of Three Crowns Castle along the ambitious lines proposed by De la Vallée in 1654. Two alternative designs were presented to the king in 1656, and the decision was made to establish one basic program and proceed piece by piece with construction.[34] Charles was personally involved in this process, reviewing plans while on campaign in Poland in 1657. The next year the architect traveled to Gothenburg to discuss the same matter with the king. A final decision was made, but by the time measured drawings were completed for part of the new work in 1660, the king was dead.

Through the 1660s Tessin, who replaced De la Vallée as royal architect, continued to draw up new plans for Three Crowns Castle. Some of his elevations are preserved. These are primarily in the French style but with a slight admixture of Italian and German elements. They have been lauded for their originality, which is considerable, but they became seriously dated after the foreign travels of the architect's son during the 1670s and 1680s, when it was decided that something close to the imposing contemporary architecture of Rome or Paris was the appropriate model for Stockholm. The elder Tessin's Old State Bank Building on the Järntorg in the old town of Stockholm (1675–1682) is a remarkably idiomatic design in the style of contemporary Italian palaces, the first sign of a royal architect working in a style that had little to do with Swedish architecture in the immediate past.

Queen Hedvig Eleonora, widow of Charles X, was the daughter of cultured German parents who were generous patrons of the arts. She seems to have retained this interest and advanced both her husband's and Queen Christina's commitment to acquiring works of art and building according to the highest contemporary standards. In a typical gesture, the dowager queen sent Nicodemus Tessin the Younger to Italy to study architecture in 1673.[35] Christina, who was then living in Rome, introduced Tessin to the pope's architect and sculptor, Gian Lorenzo Bernini, and arranged for him to study with Carlo Fontana. In 1677 Tessin made another trip, primarily to France, to refine his knowledge of garden design at Versailles. The conviction was that the Swedish royal architects should be trained in the best traditions rather than recruited from available talent.

However transformed Three Crowns Castle might eventually become, it appears that the dowager queen preferred life in the country, and in 1661 she bought the palace and property of Drottningholm from the De la Gardie family. The ''Drottning'' (queen) in the name refers to John III's wife Katarina Jagellonica, who planned the palace in 1579 but did not live to see it completed. The character of this building is not known, however, for it burned to the ground on 30 December 1661.

Preparations for construction of a new Drottningholm Palace began promptly, and Tessin the Elder worked on it for the remaining twenty years of his life, collaborating with his son.[36] Two factors stand out about the planning of Drottningholm. The whole, executed so soon after the queen was widowed, was seen by her as a memorial to her husband and an homage to the Swedish crown. Since the aim was no less than to create a great Swedish monument, only the best in everything would suffice. The Tessins offered her their conception of the highest modern architectural standard.

Drottningholm's outline against the sky suggests very different style preferences from those that shaped Three Crowns (compare figs. 7 and 11). The picturesquely

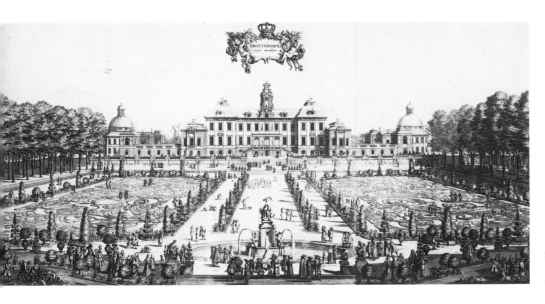

11. Drottningholm Palace, engraving by Willem Swidde after Erik Dahlberg, 1692, from *Svecia Antiqua e Hodierna*, courtesy Nationalmuseum

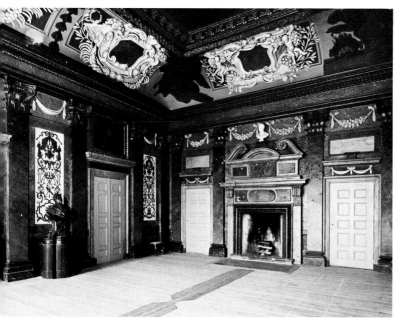

12. Upper floor guardroom of Drottningholm Palace, stuccoes by Giovanni Carove, 1672, courtesy Atlantis. The portrait bust of Gustavus Adolphus by Georg Petel in this exhibition (cat. 25) was on display on the left in this photograph

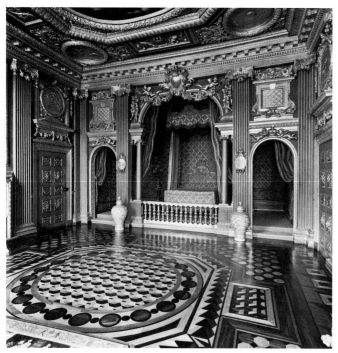

13. State bedroom of Hedvig Eleonora, Drottningholm Palace, 1668–1672, courtesy Royal Collections

curved metal roofs topped by spires or cupolas and the irregular towerlike features of the Stockholm castle disappeared at Drottningholm. Symmetry reigned, and simple copper roofs penetrated with mansard windows covered most of a building that had but one tower. The enrichment of the silhouette was limited to this tower and the pair of domes that appeared at either end. Drottningholm was unfortified and in fact was arranged to take advantage of its views of Lake Mälaren and the palace gardens, conceived in a correlative symmetry. This was a house in which to enjoy the pleasures of country life. It had similarities to the slightly earlier château of Vaux le Vicomte in France, even if a certain Swedish flavor was not completely absent.

In the interiors at Drottningholm, stone replaced much of the elaborate inlaid wood characteristic of Swedish castles and palaces for nearly a century, even on the walls; and the wooden dados below pictures and tapestries were kept low and painted in feigned marble. Most distinctive in the new palace was the use of plaster for ceilings and cornices (fig. 12). An Italian stuccoer Giovanni Carove and his son Carlo were responsible for many of the principal rooms, while the same stucco style was rendered in other rooms by means of illusionistic painting. The look of marble rooms in an Italian palace was thus somewhat heavy-handedly suggested. Ceiling paintings with figures also made their appearance here. One or two were booty from Charles X's Danish war, and the rest provided some of the commissions that caused the rise in the fortunes of German-born court painter David Klöcker (ennobled later as von Ehrenstrahl).

The most remarkable room in the palace demonstrates that French taste, as well as Italian, was very much in the ascendant (fig. 13). Tessin designed a state bedroom that is almost a rendering of the interiors engraved by Jean Le Pautre in Paris. This spectacular room, now blue and gold and so painted by the queen shortly after 1700, was originally rendered in black and gold for mourning. It contains allegorical paintings by Ehrenstrahl relating to the history of the royal family and is certainly the most sumptuous room to survive from seventeenth-century Sweden.

When his father died in 1681, Tessin the Younger was left to complete major parts of Drottningholm Palace on his own, including a pair of galleries that, following the original theme laid down by Queen Hedvig Eleonora, represent the battles won by her husband and son. In the great palace stairway, after a design by his father, Tessin celebrated classical art in the style of the statues, while figures in court dress looked down from the paintings. The motif of foreign onlookers was well known from the ambassador's room at the Quirinal Palace in Rome and from Louis XIV's Ambassador's Stair-

way at Versailles. But the use of figures in court dress originated in the ceiling of the Queen's Guardroom at Versailles and was much remarked upon by contemporary critics at the time. Word about such innovations in the major centers of European art clearly traveled to Sweden with utmost speed.

The younger Tessin excelled in his Drottningholm garden design. In fact, he was pleased enough with what he had done that he found no reason to change it when the greatest gardener of that century (and perhaps any other), André Le Nôtre, sent along an overdue project. Tessin's garden so elevated Drottningholm that it is often called the Swedish Versailles.[37] But that is too simple. The garden was of course a good approximation of the best contemporary French standard, but it was also designed to follow the theme of the whole palace, namely, the glorification of the queen's husband and family. The thirty-odd pieces of sculpture in the garden were by Adriaan de Vries and most came from a monumental fountain looted by Charles X at Frederiksborg in Denmark (fig. 14).[38] The queen's interest in using works from the previous century, which were clearly not in fashion and would have been more at home in a palace of John III's time, is explained by their provenance and its reference to the victories of her husband.

In 1669 the queen bought another country palace, Jacobsdal, which had reverted to the De la Gardie family when Christina forgot to pay for her purchase of it (fig. 15). Hedvig Eleonora made a number of changes, but little remains of her palace except a Carove ceiling and an orangerie rebuilt by Tessin the Younger in c. 1700.

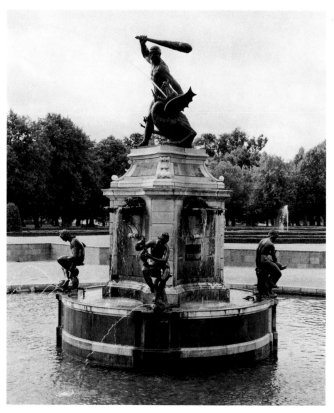

14. Adriaan de Vries, *Hercules Fountain*, 1602, reassembled (in part) in Drottningholm Palace garden, courtesy Nationalmuseum

15. Ulriksdal (earlier Jacobsdal), engraving by Erik Dahlberg, from *Svecia Antiqua e Hodierna*, courtesy Nationalmuseum

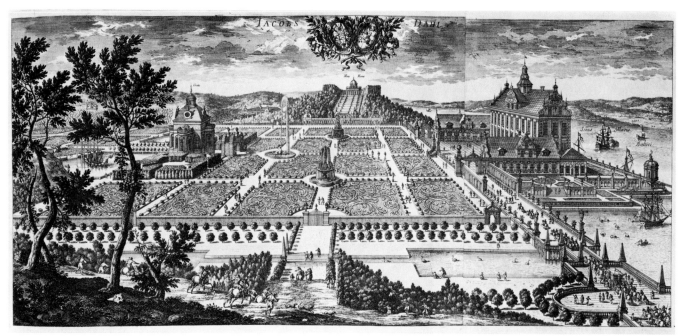

She changed the name of the property to Ulriksdal in 1687 and gave it to her grandson (after whom it was named); it returned to her when he died shortly afterward. At Ulriksdal, in a spot we cannot identify today, the queen had her treasure cabinet, inspired apparently by the treasure collections of Christina's time. In it, she kept her collection of elegant decorative arts objects and jewelry (cats. 55–60), including miniature animals made of gold and jewels. Other splendid works in her collection were displayed on tables, in cabinets, and on chimneys at Drottningholm, where inventories indicate that there were 350 pieces of faience and porcelain from Italy, Delft, and the Orient.[39] The sparsely furnished palaces of today rarely convey what they must have been like in the seventeenth century, crowded with treasure, musical instruments, even oddities such as wax sculptures with real human hair.

Charles XI, son of the lavish Queen Hedvig Eleonora, grew into an important patron of the arts in his own right. When he was young, the French ambassador suggested to Louis XIV that a gift of horses was most likely to please him (cat. 51), but he learned to take great pride in his court painter and decorator, Ehrenstrahl. And the younger Tessin finally convinced him to begin rebuilding the Three Crowns Castle.[40] Charles' interest was in creating an architectural statement absolutely original for Sweden—an architectural wonder on a scale that would rival what was being done at the court of Louis XIV in France.

It was in 1686 that new life was breathed into the idea of modernizing Three Crowns. When a great fire destroyed part of the city of Stockholm, the question of a bridge from north Stockholm to the north side of the castle was discussed. This led to the decision to rebuild the north side, which was finally undertaken in 1692. Unprecedented efforts were made to attract the very best contemporary artists to work on the renovation. Daniel Cronström, a permanent representative of the Swedish king and his architect, was stationed in Paris in 1693 to recruit artists, commission some designs, acquire objects that could not be made in Sweden, and send prints and drawings to Stockholm of current developments in the visual arts.[41] Cronström was eventually to play a major role in the reconstruction of the Stockholm castle and in many other royal projects during Charles' reign and that of his son.

Tessin's north facade can be seen today as part of the Royal Palace (fig. 1). It is as strikingly different from Drottningholm as the latter was from Three Crowns; and it was an important statement of a new architectural aesthetic. Tessin might have based his design on one of those developed by his father in the 1660s or 1670s, but what rose had nothing whatever to do with them. Instead he began with the proposals of Jean De la

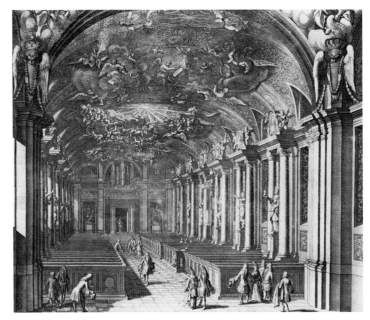

16. Royal Chapel, Royal Palace (burned 1697), by Nicodemus Tessin the Younger, engraving of 1702, from *Svecia Antiqua e Hodierna*, courtesy Nationalmuseum

Vallée from the 1650s, carefully studying and criticizing them. Their precise influence is difficult to evaluate since all of De la Vallée's elevations are lost, but Tessin disagreed with some features while praising others. Another forerunner was Tessin's own unexecuted design of 1680 for the rebuilding of the castle of Settin across the Baltic in Swedish Pomerania, which embraced the style of the Italian baroque.[42] But the clearest influence on what evolved in the planning of the new Stockholm palace was the great model left by Gian Lorenzo Bernini for a new palace for the Louvre, which Tessin had studied closely while in Paris in 1687.

By his own account, Tessin began work on his design for Stockholm's palace immediately after returning from Paris. And the surviving drawings of Bernini's elevations for the Louvre are very like what was built in Stockholm, but with an essential difference: Bernini had worked with a far easier site. The archeological remains under Tessin's north wall make it clear that he was directed to preserve medieval walls as his foundations. Since he had embraced an aesthetic that stressed simple rectangular forms and derived its beauty from the various proportions of elements of the structure, including the overall outline and the placement of the rectangular portal and windows, the design problem was difficult. The base was established, and Tessin had to struggle with the awkward length of the north front. In that context, his solution shows considerable skill, though architectural critics have expressed reservations about

the result. His use of ramps leading up to the main portal substantially enhances the austere facade, which beyond the main door is ornamented principally by simple windows and a relatively narrow cornice. Tessin himself seems to have recognized a problem, and he slightly elaborated an original project by suppressing a conventional sloping roof and introducing a balustrade and a wider cornice in his final plan.

Between 1692 and 1694 the old north wing was pulled down and a new one rose. Contemporaries were amazed by the rapidity of the work, accomplished through the professional expertise of Tessin.

As the plans for the grand exterior of the palace were accepted, Tessin moved toward the redesign of the interior. On leap year 1692 he produced a plan for the interior of John III's chapel, which had been largely preserved behind the new facade. A new decorative investment of it was complete by Christmas 1694 (fig. 16), and the transformation was radical. Though identical in size and basic structure, the room no longer combined Gothic and mannerist styles; instead Tessin produced a one-aisled baroque church, with an illusion of great spaciousness.[43]

A long gallery on the third floor of the palace also occupied the architect's particular attention at this period. Though an early drawing suggests that the original conception included architectural ornament and large sculptures, by the time the wing was actually built, the presence in Stockholm of two French artists—the painter and designer Jacques Foucquet and the sculptor René Chauveau—led Tessin to imagine a decorative scheme in which elaborate paintings and sculpted frames and ornament would serve as a monument to the achievements of Charles XI (fig. 2), just as the Hall of Mirrors at Versailles had commemorated the victories of King Louis XIV in his Dutch wars of the 1670s.

Work was still underway on the gallery and on the other interiors when disaster struck. First, Charles XI died of cancer, and then, on 6 May 1697, while the king was still lying in state in the new chapel, a fire destroyed the old castle completely, and even damaged the new wing. In the chapel, only the huge paintings by Ehrenstrahl (now in the Storkyrkan) and the pews (in the palace chapel today) were saved. The gallery of Charles XI seems to have fared better, though it is hard to know how much was finished at the time.[44] In any event, the fire was a tragic loss. A small schnapps glass still in the royal collections was mounted in enamel and inscribed, noting it to be a rare survivor of the great fire. Much in the royal collections must have been lost, though fortunately many of the best objects were certainly among Hedvig Eleonora's collections at Drottningholm and Ulriksdal. Pieces from the dowager queen's collection are most appropriately displayed today in vitrines in the Gallery of Charles XI (fig. 17).

Following the fire, the young Charles XII moved into the Wrangel Palace on Riddarholmen nearby with his family and court. This relatively small building served as the Swedish royal family's residence for more than fifty years, though it was always seen as a temporary measure. In fact the building was in the distinctly outmoded style of midcentury palaces of the nobility, far from the modern vision embraced by Charles XI.

The day after the fire Tessin was asked to discuss the repair of the castle with the royal council. Since in connection with his reconstruction of the north wing he had already designed a general plan for rebuilding the entire castle, it is not surprising that he proposed drawing up a new master plan. This was completed and accepted on 21 June 1697.[45] The breathtaking speed with which Tessin was able to work was due to two factors: the existence of his earlier plan; and a project with which he was deeply involved at precisely that time,

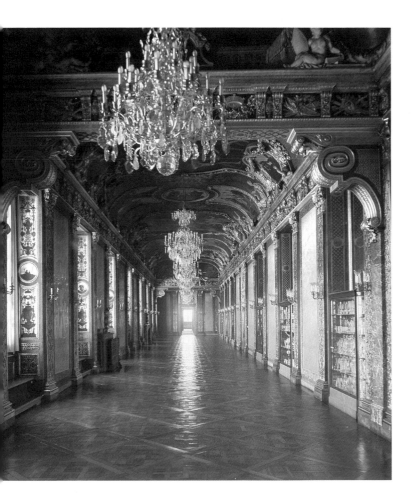

17. Gallery of Charles XI, Royal Palace, courtesy Royal Collections

namely, the design of a palace in Copenhagen for the king of Denmark. Ideas in the Danish plans were extensively pillaged.

Since the Royal Palace was completed only after the death of Charles XII and the end of the period surveyed by this exhibition, it does not seem necessary to review that complicated story here. But one point must be emphasized: the grandiosity of Tessin's conception. Though the area of the new palace was not much greater than that of the old castle the regularized profile of the whole provided considerable additional interior space. Tessin's design included a vast Hall of State and a chapel several times the size of the one just destroyed. Even an opera was proposed, though never built. This era of great architectural ambitions is also suggested by the equestrian statue of Charles XI included in this exhibition (cat. 64). Cast from the model for a full-scale work that was to have stood in the central courtyard of the new palace, it is closely based on a famous monument to Louis XIV.

Tessin's position in Sweden became so exalted that he even built a small palace for himself facing the projected south facade of the new royal residence (fig. 18). It proved to be in miniature what the king's house was in grand.[46] Italian palaces are suggested in the design of the exterior, while inside on the third floor he built a small state apartment that has been called the best surviving example of French taste in interior design of the 1690s. The ceilings of these rooms are one of their most remarkable features (see cat. 65), some of them based on drawings of Parisian hôtels by Jean Berain. Berain, who was King Louis XIV's own designer of the royal chamber, had established an excellent relationship with Tessin during the architect's visit to Paris in 1687, and after Tessin returned to Stockholm, Berain continued to send him drawings of ornament, theater designs, and so on (see cat. 63). The cutting edge of innovative French interior decoration was well represented in Stockholm.

The imperial ambition that led to Charles XII's military adventures in Russia also made itself felt in Swedish architecture. While Charles languished for years at Bender in Turkey, Tessin continued to send him increasingly stupendous architectural projects.[47] These began with projects to rebuild Stockholm (or at least Norrmalm) into a magnificent capital city. Plans were prepared for a new domed burial church for the Swedish kings on axis with the palace. When these were discussed, Tessin then turned to designs for a tremendous garden palace for the king that would have dwarfed Drottningholm and come close to rivaling Versailles. But all of this was to prove as chimeric as Charles' dreams of conquering Russia and Peter the Great.

Even so, Tessin not only served his monarch brilliantly but became a major European figure as well. Berlin and Copenhagen sought his advice,[48] and he successfully presented himself as one of the foremost experts on royal building. He was hardly modest. In 1706 he dared to send Louis XIV designs and had a model built in Paris that presented his solution to problems raised by the completion of the Louvre. While Louis' careful study of the model may be seen as a polite gesture to the minister of an important ally, Tessin was in fact well regarded even in France. He had the exceptional opportunity to be asked to design a château for a member of the French nobility in Roissy-en-France (destroyed, it was on the site of de Gaulle Airport today). With Tessin, the arts in Sweden under royal patronage achieved near parity with those of the greatest cultural centers of Europe, and to his contemporaries, Sweden seemed to have added the laurels of artistic achievement to those of the military fame achieved earlier in the century.

18. Garden facade of Nicodemus Tessin's Palace in Stockholm, engraving by J.V.D. Avelin, 1702, courtesy Nationalmuseum

1. Ingemund Bengtson, et al., *Riksdagens Hus* (Stockholm, 1983).

2. Göran Axel-Nilsson, *Makalös* (Stockholm, 1984).

3. Björn Kommer, *Nicodemus Tessin und das Stockholmer Schloss* (Heidelberg, 1974); Martin Olsson, *Det Tessinska Slottet*, vol. 2 of *Stockholm Slotts Historia* (Stockholm, 1940) (English summaries); and Andreas Lindblom, et al., *Från Fredrik I Till Gustaf V*, vol. 3 (Stockholm, 1941) (English summaries).

4. Sketches by Tiepolo, Piazzetta, and others, acquired by Carl Gustav Tessin as work samples to determine the suitability of candidates for the decoration of the palace, are to be found in Stockholm's Nationalmuseum. French artists provided most of the palace decorations. Works were acquired from Boucher and Oudry. Taraval traveled to Stockholm to paint ceilings, while Jacques-Philippe Bouchardon and Charles Guillaume Cousin did sculptural decorations.

5. Kommer 1974, 29–31, 74–79.

6. This idea was expressed by Louis XIV's buildings superintendent, Jean-Baptiste Colbert. See Pierre Clément, ed., *Lettres, Instructions et Mémoires de Colbert*, vol. 5 (Paris, 1868).

7. Ragnar Josephson, *Nicodemus Tessin d.y.*, vol. 2 (Stockholm, 1931).

8. Stig Fogelmarck, "Den svenska skattkammarsamlingen," *En Värld i miniatyr* (Stockholm, 1982), 51–84; and *Ur den kungliga Skattkammaren* [exh. cat., Royal Treasury] (Stockholm, 1930).

9. Boo von Malmborg, "Gripsholm," *De Kungliga Slotten*, vol. 2 (Malmö, 1972).

10. A. Hahr, "Henrik von Cöllen," *Svenskt biografiskt lexikon* 9 (Stockholm, 1931).

11. Malmborg 1972, 27, illustrated.

12. P. O. Westlund, *Gripsholm under Vasatiden* (Stockholm, 1949). Illustrated in Malmborg 1972, 19.

13. The paintings are probably by Hans Eriksson. On this room, its art, and its historical associations, see Malmborg 1972, 21–26.

14. Karl Chytil, *Die Kunst in Prag zur Zeit Rudolf II* (Prague, 1904).

15. See Birgitta Sandström, in Mereth Lindgren, et al., *Svensk Konsthistoria* (Uddevalla, 1986), 130–154. An abridged version has been published in English entitled, *A History of Swedish Art* (Uddevalla, 1987), see 92–99.

16. Martin Olsson, *Slottets Historia Intill År 1600*, vol. 1 of *Stockholm Slotts Historia* (Stockholm, 1940), 86–102, pl. 13, 14; Bengt Söderberg, *Manor Houses and Castles in Sweden* (Malmö, 1975), 43.

17. A new Medieval Museum has been established at the site, which allows visitors to see the results of a recent archeological excavation.

18. The old north wall may be viewed today in the Castle Museum, which incorporates most of the excavations of the 1930s. The publication of the excavation is found in Olsson 1940, 1:31–60 (English summary).

19. Olsson 1940, 1:87–94, and 95–102.

20. Boy was active in Sweden from 1558 to 1592.

21. Svartsjö burned in 1687, but the appearance of the round court is preserved by an engraving in *Svecia Antiqua e Hodierna* (Stockholm, 1719). Reproduced in Sandström 1986, 144.

22. Olsson 1940, 1:154–156.

23. Sandström 1986, 148; Olsson 1940, 1:187–197, presents a full discussion and reconstruction of the chapel.

24. Olsson 1940, 1:183, 184. Olsson gives the full history of the new apartments; the quotes used here are from his English summary.

25. Olsson 1940, 1:185–198. Its appearance is known from a print showing the coming of age ceremony of Charles XI in 1692.

26. Olsson 1940, 1:229–243.

27. Olsson 1940, 1:252.

28. Olsson 1940, 1:255.

29. André Mollet, *Le Jardin de Plaisir* (Stockholm, 1651; republished with a postface by Michel Conan [Editions du Moniteur], Paris, 1981).

30. *Svecia Antiqua e Hodierna*, a large book of engravings was begun in 1660. The project was proposed to Queen Hedvig Eleonora by De la Gardie, and the principal artist was the soldier/draftsman Erik Dahlberg. Some of the plates were made by French engravers, the later ones by a Dutch artist, Willem Swidde, working in Stockholm. The book may be seen as an attempt to gain international respect for Sweden's architectural heritage and recent achievements in building.

31. This remark is published by C. Nordenfalk, "Queen Christina and Art," in *Christina, Queen of Sweden* [exh. cat., Nationalmuseum] (Stockholm, 1966).

32. Tord Olsson Nordberg, "Jean de la Vallées och Nikodemus Tessin D. Ä.:s Stora Ombyggnadsprojekt," in Olsson 1940, 1:272–273.

33. See Malmborg 1972, 2:43.

34. Nordberg, in Olsson 1940, 1:274.

35. Osvald Sirén, *Nicodemus Tessin D. Y:s Studieresor* (Stockholm, 1914).

36. See Boo von Malmborg, "Drottningholm," *De Kungliga Slotten*, vol. 1 (Malmö, 1972), 135–172.

37. Ragnar Josephson, *Nicodemus Tessin d.y.*, vol. 1 (Stockholm, 1930).

38. John Böttiger, *Bronsarbeten af Adrien de Fries i Sverige* (Stockholm, 1884).

39. John Böttiger, *Hedvig Eleonoras Drottningholm* (Stockholm, 1897).

40. Ragnar Josephson, "Byggnaden," in Olsson 1940, 2:24–56.

41. R.-A. Weigert and C. Hernmarck, *Les Relations Artistiques entre la France et la Suède 1693–1718: Correspondence (extraits) Nicodème Tessin le Jeune et Daniel Cronström* (Stockholm, 1964).

42. Josephson 1930.

43. Gunnar Maseoll Silverstolpe, in Olsson 1940, 2:229–243.

44. Kommer 1974, 151–154, 164–165, catalogues the few surviving drawings for the gallery and adjoining salons and publishes Tessin's own description of the gallery from his "Traité de la Décoration intérieure." See also John Böttiger, "Inkallandet av de Franska Konstnärerna," Olsson 1940, 2:193–228. René Chauveau worked on the gallery in 1696, but Foucquet's paintings were done after the fire. Foucquet began the ceilings of the adjoining salons, "Spring" and "Summer," while Chauveau was at work on the gallery. Work on both areas continued after the fire.

45. Kommer 1974, 25–69, and Josephson in Olsson 1940, 2:69–112.

46. Josephson 1931. On the interior decoration, see Agneta Laine, "Invention och imitation: Studier i den dekorativa utsmyckningen av det Tessinska palatsets paradvåning" (diss., Stockholm, 1972).

47. C. Hernmarck, "N. Tessin d.y:s projekt till lustslott för Carl XII," *Svenska kungaslott i skisser och ritninger, Ur Nationalmusei handteckningssamling*, vol. 6 (Malmö, 1952). And Ragnar Josephson, "Stadsbyggnadskonst i Stockholm intill år 1800," *Samfundet Sit Erik* (Stockholm, 1918).

48. On Tessin's influence in Europe, see Ragnar Josephson, *L'Architecte de Charles XII Nicodème Tessin à la cour de Louis XIV* (Paris-Brussels, 1930); and Kommer 1974, 86–97.

List of Abbreviations

Andrén 1963
> Andrén, Erik, et al. *Guld- och silverstamplar: Svenskt silversmide 1520–1850*. Stockholm, 1963.

Cavalli-Björkman 1972
> Cavalli-Björkman, Görel. *Pierre Signac: En studie i svenskt emalj- och miniatyrmåleri under 1600 talet* (Stockholm, 1972).

Cavalli-Björkman 1982
> Cavalli-Björkman, Görel. *Svenskt miniatyrmåleri*. Stockholm, 1982.

Cederström 1942
> Cederström, Rudolf. *De svenska riksregalierna och kungliga värdighetstecknen*. Stockholm, 1942.

Cederström and Malmborg 1930
> Cederström, Rudolf, and Gösta Malmborg. *Den äldre Livrustkammaren*. Stockholm, 1930.

Ekstrand 1956
> Ekstrand, Gudrun. *Karl X Gustavs dräkter i Kgl. Livrustkammaren*. Stockholm, 1956.

Ekstrand 1957
> Ekstrand, Gudrun. "Karl X Gustavs dräkter i Kgl. Livrustkammaren." Diss., Stockholm, 1957.

Fogelmarck 1970
> Fogelmarck, Stig. *The Treasury*. Exh. cat., Royal Palace. Strängnäs, 1970.

Fogelmarck 1982
> Fogelmarck, Stig. "Den svenska skattkammarsamlingen." *En Värld i miniatyr*. Stockholm, 1982.

Hayward 1962
> Hayward, John F. *The Art of the Gunmaker*. 2 vols. London, 1962.

Heer 1978
> Heer, Eugèn. *Der Neue Støckel*. 3 vols. Schwäbish-Hall, 1978.

Historiska bilder
> Kraft, Salomon, Heribert Seitz, Torsten Lenk, eds. *Historiska bilder*. 2 vols. Stockholm, 1948–1949.

Hoff 1969
 Hoff, Arne. *Feuerwaffen*. 2 vols. Brunswick, 1969.
JKSW
 Jahrbuch der Kunsthistorischen Sammlungen in Wien
Laking 1921
 Laking, Sir Guy F. *A Record of European Armour and Arms Through Seven Centuries*. London, 1920–1922.
Lenk 1939
 Lenk, Torsten. *Flintlåset*. Stockholm, 1939.
Lenk 1949
 Lenk, Torsten. "En storpolitisk gåva." *Historiska bilder*, vol. 2. Stockholm, 1949.
Meyerson and Rangström 1984
 Meyerson, Åke, and Lena Rangström, *Wrangel's Armoury*. Uddevalla, 1984.
Nordström 1984
 Nordström, Lena. *White Arms of the Royal Armoury*. Uddevalla, 1984.
Seitz 1943
 Seitz, Heribert. *Bardisanen som svenskt drabant- och befälsvapen*. Stockholm, 1943.
Seitz 1948
 Seitz, Heribert. "Gustav Vasa: Svärdet och värjan." *Historiska bilder*, vol. 1. Stockholm, 1948.
Seitz 1955
 Seitz, Heribert. *Svärdet och värjan som armévapen*. Stockholm, 1955.
Seitz 1965–1968
 Seitz, Heribert. *Blankwaffen*. 2 vols. Brunswick, 1965–1968.
Steingräber 1969
 Steingräber, Erich, ed. *Royal Treasures*. Translated by Stefan de Haan. New York, 1969.
Stockholm 1930–1931
 Den Kungliga Skattkammaren och Andra Samlingar. Exh. cat., Nationalmuseum. Stockholm, 1930–1931.

Stockholm 1932
 Gustav II Adolf. Exh. cat., Royal Armory. Stockholm, 1932.
Stockholm 1966
 Christina, Drottning av Sverige: en europeisk kulturpersonlighet. Exh. cat., Nationalmuseum. Stockholm, 1966.
 NOTE: an English edition of this catalogue was published simultaneously.
Stockholm 1982
 Gustav II Adolf: 350 år efter Lützen. Exh. cat., Royal Armory. Stockholm, 1982.
Stockholm 1986
 Kung Sol i Sverige. Exh. cat., Nationalmuseum. Stockholm, 1986.
Twining 1967
 Lord Twining. *European Regalia*. London, 1967.
Tydén-Jordan 1984
 Tydén-Jordan, Astrid. "Karl XI's kröningsvagn: fransk lyximport med förhinder." *Livrustkammaren* 16. Stockholm, 1984 (English summary: "King Charles XI's Coronation Coach: A French Luxury Import with Impediments").
Tydén-Jordan 1985
 Tydén-Jordan, Astrid. *Kröningvagnen: Konstverk och riksklenod*. Stockholm, 1985 (English summary: "The Coronation Coach: Work of Art and National Heirloom").
Tydén-Jordan 1987
 Tydén-Jordan, Astrid, ed. *Kungligt klädd, Kungligt mode*. Stockholm, 1987.
Uppsala 1921
 Livrustkammaren. Vägledning. Uppsala, 1921.

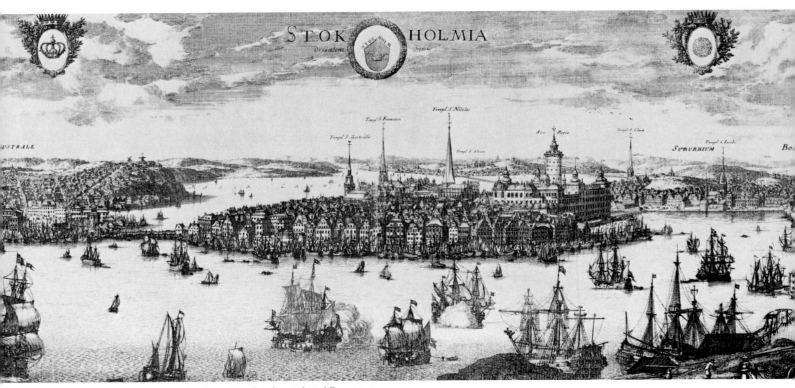

View of Stockholm, engraving by A. Perelle after Erik Dahlberg, last
quarter of the seventeenth century, from *Svecia Antiqua e Hodierna*
(Stockholm, 1719), courtesy Nationalmuseum

Catalogue

Note to the Reader

Dimensions are in centimeters, followed by inches in parentheses. Height precedes width precedes depth.

Contributors to the Catalogue

G.A.	Göran Alm, Royal Collections
G.C.-B.	Görel Cavalli-Björkman, Nationalmuseum
M.C.	Michael Conforti, The Minneapolis Institute of Arts
N.D.	Nils Drejholt, Royal Armory
G.E.	Gudrun Ekstrand, Royal Armory (retired)
S.F.	Stig Fogelmarck, Royal Collections (retired)
A.H.	Adam Heymowski, Librarian to His Majesty the King
B.H.	Barbro Hovstadius, Nationalmuseum
U.G.J.	Ulf G. Johnsson, Royal Castles Collections (Gripsholm)
U.L.	Ulla Landergren, Royal Treasury
A.L.	Arne Losman, Skokloster Castle
B.M.	Börje Magnusson, Nationalmuseum
L.N.	Lena Nordström, Royal Armory
L.R.	Lena Rangström, Royal Armory
A.T.-J.	Astrid Tydén-Jordan, Royal Armory
G.W.	Guy Walton, New York University

The Royal Regalia

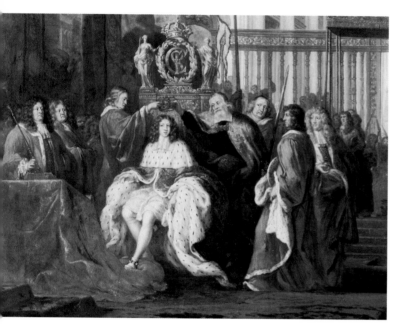

The Coronation of Charles XI in Uppsala Cathedral by David Klöcker von Ehrenstrahl, 1675, courtesy Nationalmuseum. The king is seated on Queen Christina's throne, and the crown, scepter, orb, and sword of state are held by the archbishop and ministers of the realm

THE SWEDISH CROWN JEWELS are artistically and historically among the most important in Europe and include a number of unusual objects with unique functions. Swedish coronation rites originated in the medieval period, but it was only with the accession of Gustav Vasa in 1523 that firm traditions regarding coronation ceremonies and regalia were established. Gustav Vasa was crowned in Uppsala in 1528, but none of the regalia used on that occasion—crown, scepter, or orb—has survived. Two extant swords of state from later in Vasa's reign are thus the oldest items in the Swedish collection of regalia.

Mindful of the need to strengthen the national and international prestige of his house, Gustav's son and successor, Erik XIV, took great pains over the outward trappings of his coronation. In planning the ceremony he no doubt followed an ancient Swedish tradition. But at the same time, eager to add luster to the bare fabric of Swedish ritual, he focused on more ancient and powerful kingdoms elsewhere in Europe. We know, for example, that he derived inspiration from English coronation ceremonies. These were particularly appropriate for a Protestant country like Sweden, having evolved with reference to a non-papal liturgy.

Erik discarded all of his father's regalia, except for the swords of state, and ordered new tokens of regal dignity from Antwerp, which at that time was the center of the goldsmith's trade in Europe. For some unknown reason, this order was not received, and in 1561 the new regalia were all completed in Stockholm: crown, scepter, orb, and key of state. Their symbolic meaning, rooted partly in the ancient world, was expounded in detail in the coronation ritual, which itself remained virtually

unaltered until the last Swedish coronation in 1873. The officiating prelate—the archbishop himself—recited a prayer of consecration at the presentation of each item of regalia, which included a characterization of each article. The crown was described as the emblem of royal honor and dignity, the scepter as the symbol of the secular power of the king and his God-given duty of ruling justly and judging his people. The cross-surmounted orb showed, among other things, that God had appointed the king to be his vice-regent in a great and Christian kingdom. The sword alluded to the king's power bravely and manfully to defend good and punish evil. And according to the prayer recited at the coronation of Charles IX, the key symbolized the king's power to exclude evil, harbor good, and open the gates of the kingdom to people in distress. The key is without any counterpart in other European regalia traditions.

For the coronation of Charles IX in 1607 no fewer than three articles were added to the regalia. Two are on display here: a chain of office (cat. 11) and a golden horn for the sacred oil with which the king was anointed during the religious ceremony (cat. 3). The distinctive design and exquisite beauty of the anointing horn have made it one of the most famous items of the Swedish regalia. Interestingly, it was the first item of regalia to have been made by a Swedish goldsmith, Peter Kempe of Stockholm.

The history of the queenly regalia begins with the marriage of Erik XIV and Karin Månsdotter, followed one day later by the coronation of the new queen. For this ceremony Erik commissioned a crown, scepter, and orb (no longer extant). The appearance of an orb in this connection is remarkable, for in the tradition of European regalia the orb symbolized the sole power of the sovereign and accordingly could not be carried by a consort. This, then, marked the beginning of a tradition in Sweden, known also in Poland, that was to be maintained throughout the centuries.

The oldest existing queenly regalia were made in 1585 for the marriage of King John III to a young Swedish noblewoman, Gunilla Bielke. Her crown was melted down subsequently, but the scepter and orb have survived and are in the present exhibition (cat. 2).

The oldest surviving queenly crown was made in 1620 for the marriage of King Gustavus Adolphus and Princess Maria Eleonora of Brandenburg (cat. 1). Over the years it has been variously modified and elevated in dignity. Queen Christina chose to wear this crown for her coronation in 1650 instead of using the crown of Erik XIV, and she had another four gold arches added. The reason for her decision is unclear, but she may have considered this crown more up-to-date and more impressive.

The Swedish regalia include a number of other crowns, swords, badges of royal orders, scepters, and orbs, which belong to the nation and still play a part as symbols of the monarchy. The present King Carl XVI Gustaf, like his immediate predecessors, Gustav V and Gustav VI Adolph, did not have a coronation, but during royal baptisms, weddings, and funeral services, the regalia are displayed for their symbolic significance. At the king's wedding in 1976, for example, the king's and queen's crowns were placed on either side of the altar in the Storkyrkan, Stockholm's great cathedral. S.F.

1

Crown of Maria Eleonora 1620

Ruprecht Miller, fl. in Stockholm 1606–1623; reworked by Jürgen Dargeman, fl. in Stockholm 1646–1688, and Frantz Bergs, fl. in Stockholm 1725–1777

gold set with diamonds and rubies; orb of blue translucent enamel with gold and diamonds; cap of reddish purple, gold-embroidered satin, encrusted with stone settings held by gold wires in compressed spirals

18.4 (7¼) high; circlet, 17.8 x 21.4 (7 x 8⅜) inner diam., 3.7 (1½) high

The Treasury, Royal Palace

When twenty-six-year-old Gustavus Adolphus chose Maria Eleonora of Brandenburg to be his bride, he did so partly for political reasons. Three days after the wedding, in 1620, she was crowned queen of Sweden in the Storkyrkan, Stockholm. Dowager Queen Kristina, the mother of Gustavus Adolphus, was still living and thus in possession of the existing queenly regalia. Therefore, preparations for the coronation included the ordering of a new crown. The commission was given to Ruprecht Miller, a goldsmith of German origin then working in Stockholm who had outstanding artistic ability. Miller had previously worked for both Charles IX and Gustavus Adolphus, and his accounts for the years between 1606 and 1620 record an immense number of assignments, beginning with the queenly crown of Kristina (no longer extant).

The crown of Maria Eleonora was of the "closed" type, with four arches supporting an orb at their intersection (fig. 1a). Its basic decorative theme was of rich, thistlelike foliage worked on several levels, and its finely balanced color scheme was a characteristic detail. The choice of gold, black enamel, and white and red stones probably had heraldic implications: gold and black for Gustavus Adolphus (Vasa), red and white for Maria Eleonora (Brandenburg). The blue-enameled orb has an astronomical design, featuring sun, moon, and stars. This crown, with its dynamic, stylized foliage ornamentation, deviates from previous regalia and also from earlier work by Miller.

This crown was altered several times over the years. The first and most substantial reworking took place in connection with the coronation of Queen Christina in 1650. In the royal treasury on 1 February that year, Jürgen Dargeman, a goldsmith hailing from Wolgast in Pomerania, signed for jewels to be used for improvements to the crown. The changes commissioned by Christina, which involved adding four new gold arches, were doubtless intended to elevate the dignity of her

mother's crown, now that it was to be worn by a sovereign. The additional arches were of simpler design, and they were less neatly chased and less delicately punched than the original ones. The earlier stone settings were also more elegantly executed. Each of the new arches was set with nine diamonds, and six diamonds were added to each of the original arches.

The second major alteration to the crown was made in 1751, for the coronation of Adolph Frederick. Frantz Bergs, one of the foremost Swedish goldsmiths of the eighteenth century, was commissioned for this work. The additions he made are easily distinguishable by their less careful workmanship and by the use of a yellower gold. To the circlet, which had already been enlarged for the coronation of Ulrika Eleonora the Younger in 1719, Bergs now added eight diamond rosettes, and to each arch he added an ornament consisting of three small diamonds with a larger diamond on the point. The original cap was replaced by a new one of gold-embroidered reddish purple satin, adorned with seventy rose diamonds and fifty-nine table-cut diamonds.

The crown of Maria Eleonora was the crown most frequently used in the eighteenth century. Frederick I wore it, and under the Holstein-Gottorp dynasty it continued to be used as a regal crown from the coronation of Adolph Frederick in 1751 until the death of Charles XIII in 1818. U.L.

BIBLIOGRAPHY: Cederström 1942; Fogelmarck 1970.

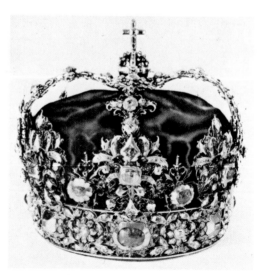

1a. Crown of Maria Eleonora before 1650

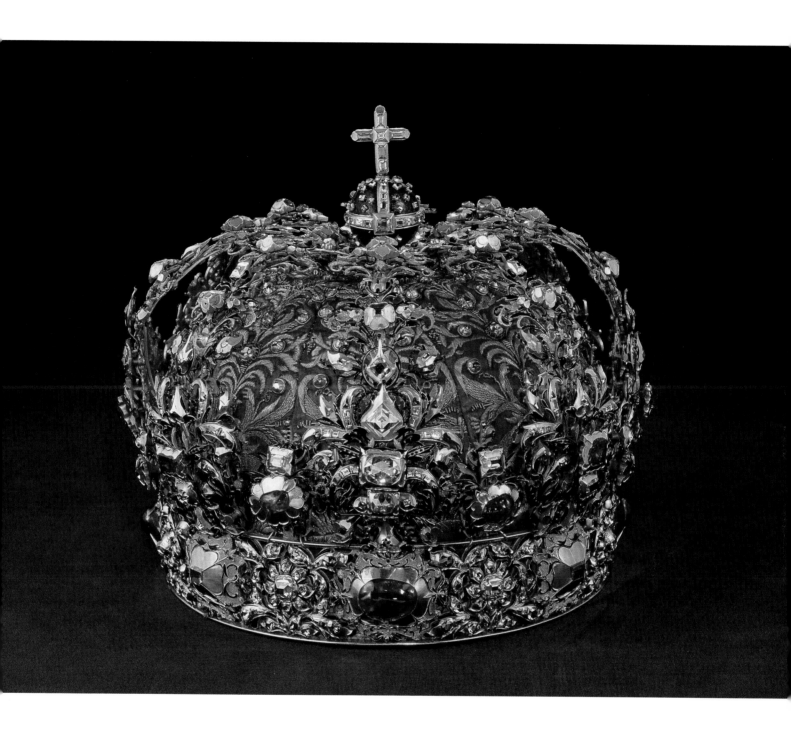

2

Scepter and Orb of Gunilla Bielke 1585

scepter probably by Antonius de Croeck, fl. in Stockholm
1568–1611; orb by Franz Beijer, fl. 1570–1596

gold, enamel, pearls, and diamonds

scepter, 68 (26¾) long; orb, 17.9 x 13.1 (7 x 5⅛), and globe,
12 (4¾) diam.

The Treasury, Royal Palace

The oldest surviving Swedish queenly regalia date from
the reign of John III and comprise the scepter and orb
of Gunilla Bielke, rather curiously referred to by John as
"reginalia." The crown that the king had ordered for
the occasion was destroyed before 1592, but the scepter
and orb are shown in this exhibition.

Gunilla Bielke was born in 1568, the daughter of the
privy councillor and governor of Östergötland Johan
Axelsson Bielke and his wife Margareta Posse. She was
educated at the court of John III and Queen Katarina
Jagellonica, where she served as the queen's maid-in-
waiting. After Katarina died in 1583, John decided to
remarry and chose sixteen-year-old Gunilla Bielke as his
new bride. She was none too pleased, but in the end
she was persuaded to accept the fifty-year-old king as
her suitor. The wedding festivities took place at Västerås
Castle in February 1585, and in connection with her
marriage, Gunilla Bielke was crowned queen of
Sweden.

The making of Gunilla Bielke's regalia was entrusted
to Gillis Coyet the Elder, a Netherlander who had re-
cently settled in Stockholm and had been appointed
John III's goldsmith in 1571 and master of his mint a
few years later. The regalia, however, were not all Coy-
et's work. Accounts show that several goldsmiths were
employed on the assignment under Coyet's supervision,
and he was responsible for the entire delivery. Several
years later Coyet was charged with failing to give a
proper account of the materials and with making a
"clumsy, rough job" of the queenly crown. In his de-
fense, Coyet pleaded that shortage of time had pre-
vented him from making the crown "lighter and bet-
ter." Records of the subsequent questioning of Coyet in
court show that Antonius de Croeck had made the
scepter, and Franz Beijer, a Swiss goldsmith, the orb.
When Duke Charles had an inventory made of the re-
galia a few days after the death of John III in 1592, the
queen declared that "the crown was broken before."

Gunilla's scepter and orb stayed together for more
than one hundred years as queenly insignia. In Duke
Charles' inventory of 1592 they are referred to as "the
scepter and orb used by Queen Gunnil at her corona-
tion." They next passed to Queen Kristina, consort of
Charles IX, and they were probably altered for the coro-
nation in 1607. The pearls on the scepter are original,
but the diamonds were added, replacing an earlier set-
ting of emeralds and "karelian rubies" (garnets from the
Finnish province of Karelia). In 1620, when the regalia
were taken over by Maria Eleonora, the orb is said to
have included only twenty-six pearls; one pearl had
been lost but has since been replaced.

Prayers from sixteenth- and seventeenth-century cor-
onations that explain the symbolism of the queenly re-
galia have not survived, but there is reason to suppose
that their meaning is reflected in the ritual known from
coronations of the eighteenth and nineteenth centuries.
The queenly crown is referred to there as a symbol
of honor and dignity, and the scepter as a symbol of
the queen's God-given duty to further virtue and jus-
tice and to combat ungodly living. The orb, surmounted
by a cross, was meant to show that God in his mercy
had bestowed on the queen the right of watching over
the prosperity and development of the kingdom for the
benefit of the people of Sweden.

It was probably on account of its size that Gunilla
Bielke's orb was elevated to the rank of the king's orb
of state under the Holstein-Gottorp dynasty. It was thus
used by King Adolph Frederick at his coronation in
1751, by Gustav III in 1772, and by Charles XIII in
1809. U.L.

BIBLIOGRAPHY: Cederström 1942; Fogelmarck 1970.

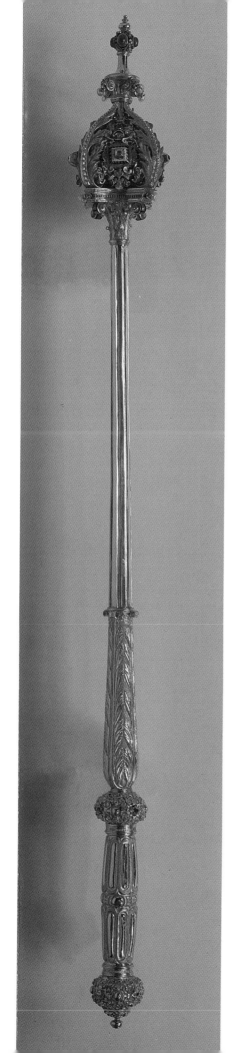
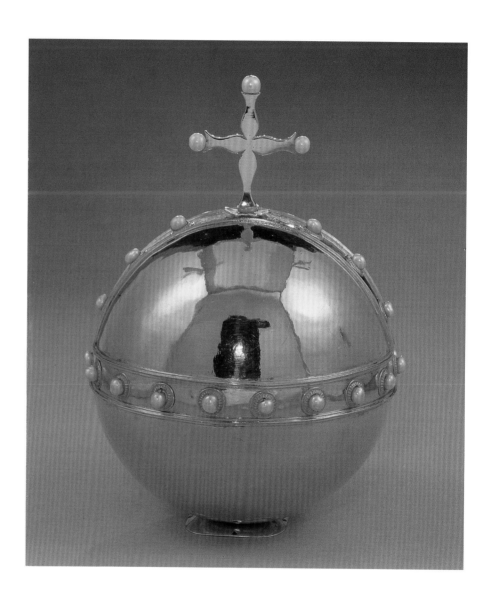

3

Anointing Horn of Charles IX 1607

Peter Kempe, fl. in Stockholm 1589–1621

gold with multicolored opaque and translucent enamel, diamonds, rubies, and garnets from Finnish Karelia

15.5 x 12 (6⅛ x 4¾)

The Treasury, Royal Palace

For his coronation in 1607, Gustav Vasa's youngest son, Charles IX, ordered a precious vessel for the consecrated oil to be used in the anointing ritual. This new regalia object was given the form of a small, well-proportioned, lidded horn mounted on a baluster-shaped foot. The inspiration for this design may possibly derive from a passage in I Kings 1:39: "And Zadok the priest took an horn of oil out of the tabernacle and anointed Solomon." Charles IX wanted his coronation ceremony to recall Old Testament as well as Old Norse traditions as a way of giving the young Vasa dynasty an air of venerable legitimacy.

Coronation ceremonies and anointing had been a practice in various northern European states since at least the second half of the twelfth century. Valdemar the Great was anointed king of Denmark in 1157, and Magnus Erlingsson, king of Norway in 1164. The first king of Sweden definitely known to have been anointed as king was Erik Knutsson, who acceded in 1210. The coronation ceremony took place in Uppsala and was performed by the archbishop assisted by all the bishops in the presence of the magnates of the realm. Six years later Pope Innocent III issued a Latin manifesto confirming Erik's assumption of power in Sweden. The ceremony of anointing seems to have been prompted by a desire on the part of pretenders to secure the valuable support of the Church.

The order for Charles IX's anointing horn went to the Stockholm goldsmith Peter Kempe, who had previously worked for John III and in 1606 had been commissioned to make a princely crown of gold adorned with rubies, diamonds, and pearls. Kempe also engraved the left pauldron of Charles IX's funeral armor, erected over the king's tomb in Strängnäs Cathedral, and was entrusted with making the scepter and orb for the same king's funeral regalia (cat. 12). Like the burial regalia, the anointing horn shows that Kempe was a skilled enamelist. The ornamentation on its foot and on its two detachable plates features a hairline pattern of gold open work against the enamel, an ornamentation typical of the time. In decorating the horn, Kempe also used garnets of rare beauty from a deposit in Finnish Karelia. Charles IX was keenly interested in finds of precious stones in his kingdom (which included Finland) and was probably at special pains to incorporate these stones in his new regalia. The figure at the apex of the anointing horn is Justitia, goddess of justice, with her traditional attributes of sword and scales (the intricately wrought scales are made up of twelve separate pieces). The elegant shape of the anointing horn and its balanced combination of polished gold and enameled relief ornamentation make it one of the most beautiful items in the Swedish regalia.

Erik XIV's coronation service in 1561 set the pattern for Swedish coronations right down to that of Oscar II in 1873. At the coronation of Charles IX, the regalia were carried in solemn procession to the church. They were carried in front of the king by the senior officers of the realm, in ranking order. Nearest to the king went the sword of state, and in front of it the crown, scepter, orb, and key. The religious part of the coronation ceremony began at the church door, where the archbishop, assisted by the bishops, greeted the king with the words "Blessed be He that cometh in the name of the Lord." The anointing horn, carried at the head of the procession, was deposited on the altar together with the regalia. After the king had recited his prayers and, in the presence of the archbishop, pledged himself to defend the true faith, the coronation oath was taken. This was followed by the anointing, the sacred oil being applied to the king's forehead and wrists. The ceremony then continued with the archbishop removing the crown from the altar, putting it on the king's bare head, and pronouncing the blessing. The king was similarly invested with other regalia. This part of the ceremony over, the king sat on the throne in full majesty, displaying the sword, scepter, and orb. The herald then proclaimed three times over: "Our most illustrious, noble prince and lord, His Majesty Charles IX, is now anointed and called the king of Sweden," to which the congregation responded: "God send our king fortune and happiness, may his reign be long and glorious." The colorful ceremony was then vigorously ended with a fanfare of trumpets and an artillery salute. U.L.

BIBLIOGRAPHY: Cederström 1942; Twining 1967; Fogelmarck 1970.

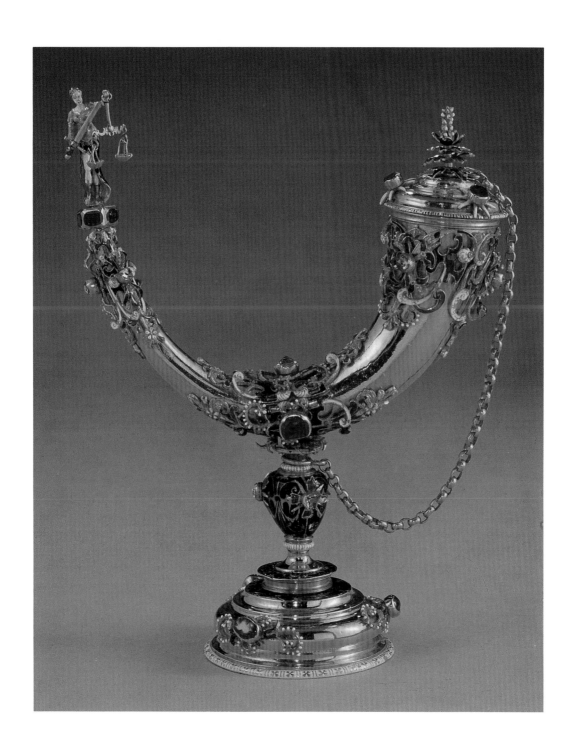

Gustav Vasa c. 1494–1560

SINCE THE 1390s Denmark, Norway, and Sweden had been joined together in what is known as the Union of Kalmar, after the city in Sweden where the union treaty was signed. But this meant that the Swedes were often governed from Denmark, and occasionally they rebelled against this "foreign rule." Nothing changed fundamentally until the 1520s, however, when Gustav Eriksson of the house of Vasa finally succeeded in "lifting the Danish yoke from the shoulders of the Swedish people." By then King Christian II of Denmark and Norway had laid claim to the Swedish crown by virtue of the union treaty, and the Vasas had been among the noble families cut down in Christian's treachery. Gustav Vasa himself was imprisoned without cause, and his father was beheaded together with about a hundred other unsuspecting guests at Christian's coronation in Stockholm. Gustav's mother and sister were taken to Denmark and died there in captivity.

Gustav Vasa rallied the Swedish people against the Danes, and after a number of important victories, he was elected king of Sweden on 6 June 1523. More than twenty years passed before he was able to feel secure on the throne, however. His position was challenged in various quarters domestically, and on the Continent he was regarded as an upstart ruler with little claim to the monarchy. But he was equal to the situation. Rebellions or uprisings were beaten down, disobedient subjects

were executed, blandishments and fair promises alternated with broken agreements and torrents of invective. To create the strong centralized government he envisioned, Gustav personally took over every aspect of running what he tended to regard more and more as his own property. And in the end, it must be said, he succeeded.

Gustav Vasa introduced the Reformation to Sweden mainly for economic reasons, but also as a means of uprooting the secular power of the Church. He had little interest in whether the Mass was read one way or another, but if the country became Protestant, he would be able to dissolve the monasteries, seize their wealth, and forbid obstreperous bishops from keeping fortified palaces and private armies.

In 1544 Gustav Vasa secured the proclamation of Sweden as a hereditary kingdom with the royal title descending through the male line of the Vasas. A son Erik was the only child of the king's first marriage. Eight children survived from the second marriage, including three sons: John, Magnus, and Charles. When Gustav Vasa died in 1560, he left a reformed and united Sweden, but curiously, his legacy allowed a division of his kingdom into fiefdoms for each of his sons. Three of the princes eventually became kings of Sweden: Erik XIV, John III, and Charles IX. U.G.J.

4

Close Helmet with Grotesque Visor of Gustav Vasa c. 1540

German
etched and gilded steel
26 x 22 x 33 (10¼ x 8⅝ x 13)
Royal Armory, LRK 11441

This helmet is part of a suit of armor that belonged to King Gustav Vasa. The armor, dated 1540 in three places, was bought by the king's merchant Claus Heijder in Augsburg or Nuremberg and registered in the Royal Wardrobe in 1548 as "a polished suit of armor for man and horse, with two extra helmets, one with a crown, all with etched and gilt decorations." It is very similar to works by the Augsburg masters Desiderius Colman and Matthias Frauenpreis.

The visor and helmet, though of the same period and workshop, did not originally belong together. Their decorative borders do not quite match, and the upper edge of the visor was cut to fit the helmet, possibly before the armor was delivered to Sweden. The helmet has a hollow rim around the lower edge so that it could lock and rotate on the roped top of the gorget.

The fashion for masked visors was introduced in the beginning of the sixteenth century with the fluted "Maximilian" armors, at a time when armor was often used for ceremonial functions at festivals. Many of these visors present an even more grotesque appearance than the one exhibited here. The so-called Will Somers helmet at the Tower of London includes spectacles and ramshorns, and a helmet in the Imperial Armory in Vienna by Seusenhofer has a visor in the form of a wolf's or fox's head. One convenience of such helmets was that the protruding visors made the interior of the helmets more spacious, so it was easier to breathe in them. N.D.

BIBLIOGRAPHY: Heribert Seitz, "Rustningen från 1540," *Gustav Vasa-minnen* (Stockholm, 1928), 103–108, 113 (plate); Karl Erik Steneberg, "Harnesksmide i Gustav II Adolfs rustkammare," *Livrustkammaren* 9 (1961–1963), 162–165; Laking 1920–1921, 95–102 (on grotesque helmets).

5

Sword of Gustav Vasa 1550s

German; blade possibly Swedish
steel and gilded silver
108.8 x 25.2 (42¾ x 9⅞); blade, 95.2 x 3.4 (37½ x 1⅜)
Royal Armory, LRK 13502

The Royal Armory's inventory of 1654 refers to this sword as having belonged to Gustav Vasa and describes it as "One sword with gilt-silver mounts and artful work, and a chape and upper mount of silver and gilt, similarly worked. A mount on one quillon lost in a fire; scabbard of black velvet, but old and worn."

Although the sword may seem heavy and unwieldy, its design bears witness to the appearance of modern Mediterranean fencing in Sweden at this time. Fencing had not yet acquired strict rules: for instance, both thrusting and cutting strokes could be delivered with the same weapon; the technique depended on the nature of the blade. The blade of Gustav Vasa's sword is typical of the early Italian style of fencing sword, which became widespread on the Continent toward the middle of the sixteenth century. It is straight and two-edged, with an arrowlike stamp on the outside at the ricasso. It may have been made in Arboga, Sweden, for the stamp is reminiscent of the Diefstatter family's, and Markus Diefstatter was one of the leading swordsmiths at the factory founded there in 1551. But the stamp also resembles that used by Wolfgang Stantler in Munich, who was active during the same period.

The hilt, of dark annealed steel with engraved mounts of gilded silver, is an early example of an elaborate system of bars and rings to protect the hand, which on this hilt are below the cross-guard to allow the "Italian" grip, which involved curling the index finger around the quillon in order to achieve closer control of the weapon. The quillons have square ends, decorated with arabesques and with cast lions' masks. The rear mount of the quillon is a replacement, the original having been destroyed in the castle fire of 1642. The grip is covered with silver wire, alternately twisted and smooth.

On the quillon center and the ricasso of the blade a socket of gilt silver is engraved with a mythological figure—a genius rising among birds and foliage—probably intended to match the mounts of the lost scabbard. L.N.

BIBLIOGRAPHY: Åke Meyerson, *Svärdet och värjan, Gustav Vasa-minnen* (Stockholm, 1928), 145, 146, 153, 159, 161; Seitz 1955, 72–76 (summary, 367–368); Seitz 1948, 94–101; Seitz 1965, 1:308–309; Hans Stochlein, "Münchener Klingenschmiede," *Zeitschrift für Historische Waffen- und Kostümkunst*, vol. 5 (1909–1911), 286, nn. 16–17.

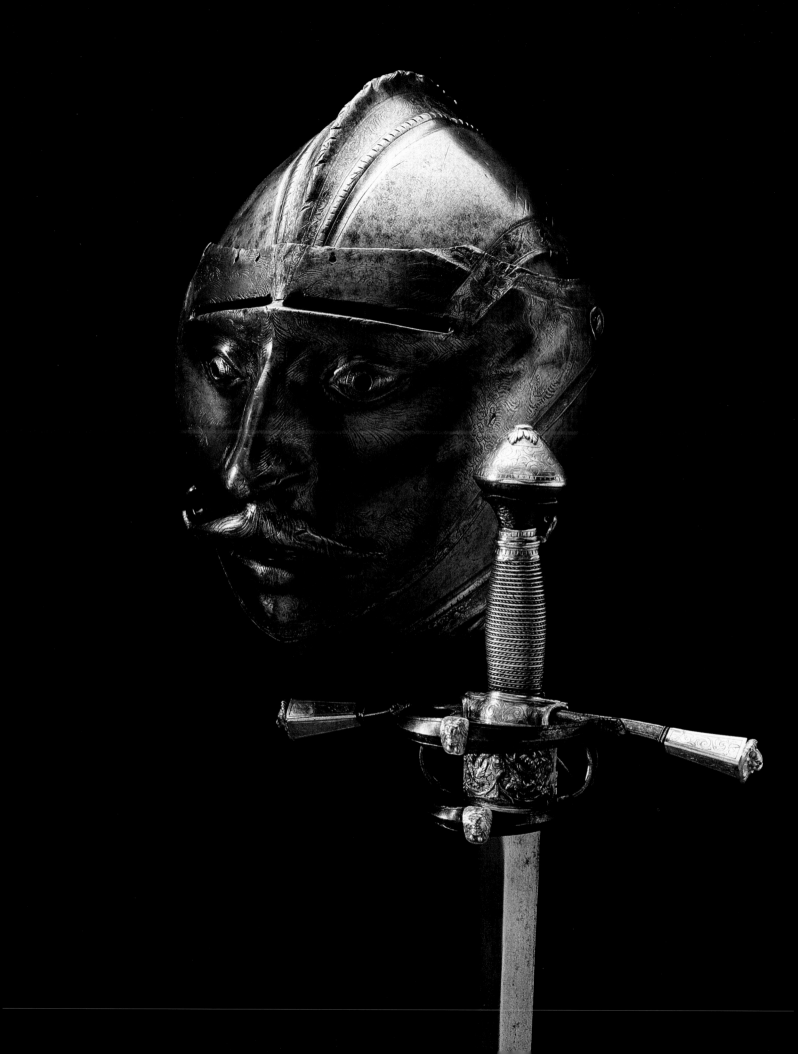

Detail, cat. 7

Erik XIV 1533–1577

BORN IN 1533, Erik was less than two years old when his mother, Katarina of Saxony-Lauenburg, died. He received a thorough education in keeping with the contemporary ideals of a Renaissance prince: he was well-versed in different subjects and could draw, paint, and play the lute. His education also included learning to exercise power unflinchingly toward his own ends, putting sudden, brute force before negotiations, and not being too particular about keeping his promises.

From the beginning of his reign, Erik had trouble with his younger half-brother John, who was exercising independent control in his duchy of Finland. Erik therefore took John prisoner in 1563 and incarcerated him for four years at Gripsholm Castle to keep him out of harm's way. But the king evidently saw his royal status threatened from many quarters, and when pressed, he was capable of acting with unpremeditated fury. A situation of this kind developed in 1567, when he had imprisoned several members of the powerful Sture family

in Uppsala Castle. Erik himself sparked the murder of Nils, Svante, and Erik Sture by stabbing Nils in a sudden fit of mental confusion, after which his mercenaries did the rest.

The following year the king married a seventeen-year-old commoner, Karin Månsdotter, who had been one of his concubines for several years, and had her crowned queen in a provocatively extravagant coronation ceremony. This touched off a rebellion and Erik was deposed and put in prison by his two half-brothers. He was succeeded on the throne by one of them, who would reign as John III. Erik's troubled life came to an end in 1577, presumably by poison. He was buried in Västerås Cathedral but did not acquire a proper tomb until two hundred years later. From the beginning, however, an appropriate Old Testament text (I Kings 2:15) was displayed at the grave: "Howbeit the kingdom is turned about, and is become my brother's: for it was his from the LORD." U.G.J.

Detail, cat. 6

6

Parade Armor of Erik XIV c. 1560–1563

probably Swedish; decorated by Eliseus Libaerts, fl. in Antwerp 1557–1564 (chanfron made separately)

steel and gold

armor, 170 (67) high; close helmet, 29 x 35 x 27 (11⅜ x 13¾ x 10⅝); saddle, 46 x 57 x 69 (18 x 22½ x 27⅛); shield, 56 (22) diam.; chanfron, 51 x 29 (20 x 11⅜)

Royal Armory, 2605, 2902, 2930, 22/9

Eric XIV was well apprised of the forms and accessories of princely splendor. He owned a copy of Castiglione's "Book of the Courtier" in which he could read, for example, that beautiful weapons caught the eye of the people. For ceremonial purposes, magnificent armor like that shown here could be worn by the king himself or by his squire. Its embossed high-relief figures and borders damascened with gold stand out against a punched, originally blackened steel ground. The decoration features female jinns, prisoners in chains, battle scenes, trailing acanthus, trophies, and fruit groups. It also includes themes directly alluding to the owner—the Swedish Vasa emblem, the Three Crowns, and the Folkung Lion.

The chanfron, with its etched and gilded ground, departs from the design of the rest of the armor. It was ordered by Erik as part of a second garniture, which was intercepted and seized by the Danes en route to Sweden, subsequently finding its way to Dresden. The chanfron was delivered to Erik in 1563.

This parade armor was doubtlessly used for one of the many festive processions—both martial and peaceable—that King Erik organized. One was staged during the war with Denmark between 1563 and 1570, when Erik returned to Stockholm in 1564 "in great triumph," bringing with him trophies and prisoners in chains—a living illustration of the decoration on his armor.

Ornaments and figures embossed and chiseled in relief became an essential part of the armorer's art during the sixteenth century. Armor had developed into a kind of ceremonial dress for tournaments and other gala occasions, at the same time the growing power of firearms was depriving armor of its protective usefulness. The field was thus free for decorative elaboration. The scenes depicted on this garniture of King Erik's were to a great extent inspired by the triumphs in ancient Greece and Rome, a reflection of the Renaissance fascination with the life and art of the classical world. Erik XIV, ever receptive to developments in the ceremonial arts, introduced this new means of exalting his royal status. The heroes, chained prisoners, and trophy groups of the pa-rade armor made a readily intelligible symbol of the heroic grandeur of the owner.

This type of armor resulted from the combined efforts of three master craftsmen: armorer, designer, and goldsmith. For a long time Erik XIV's parade armor was believed to have been the work of French, Italian, or south German masters. But surviving accounts reveal that it came from Antwerp. During the early years following Erik's accession in 1560, many large purchases were made and orders placed in Antwerp for jewelry, silver, costumes, other textiles, and arms. Receipts indicate that a goldsmith named Eliseus Libaerts in Antwerp was paid for parade armor completed and delivered to King Erik in 1562. Libaerts, not previously known to scholars, is mentioned in the guild rolls of Antwerp between 1557 and 1564.

Libaerts planned to deliver a second suit of armor to King Erik in person in 1564, but a war was on, and he was taken prisoner in Denmark while traveling to Sweden. Erik tried unsuccessfully to secure the release of Libaerts and the armor. After a couple of years, Libaerts was freed, but he stayed in Denmark in the service of Frederick II, where his duties included the production of medals. Also at the Danish court was the German goldsmith David Cnoep, who acquired the armor that Libaerts had decorated for Erik XIV. This armor was sold in 1606 by Cnoep's son in Nuremberg to the elector Christian II of Saxony. That armor, decorated with the Swedish Vasa crest and Three Crowns, is still in Dresden, together with another suit of similar design by the same master. Closely related specimens exist in Vienna, Dresden, Paris, New York, Copenhagen, Stockholm (Skokloster shield, cat. 7), and London.

Surviving correspondence between Erik XIV and Libaerts makes clear that the king had the second suit of armor forged in Sweden and then sent to Antwerp for decoration. It is not certain, but quite probable, that Erik did the same with the armor on display here. The only workshop that could possibly have handled this kind of assignment in the Vasa period was the Arboga factory, founded in 1551 by Erik's father, Gustav Vasa. A large number of German master craftsmen were employed there—gunsmiths, swordsmiths, and armorers—and their work was very highly regarded. But no goldsmithing was done in the Arboga factory as a rule; this work was usually done in Stockholm or abroad.

It is not known who drew the designs of the decorations for the Stockholm garniture. Some designs are extant in the Staatliche Graphische Sammlung, Munich, and have been attributed to the French artist Etienne Delaune. This would make King Erik's parade armor a combination of Swedish manufacture, French design, and Netherlandish craftsmanship. L.R.

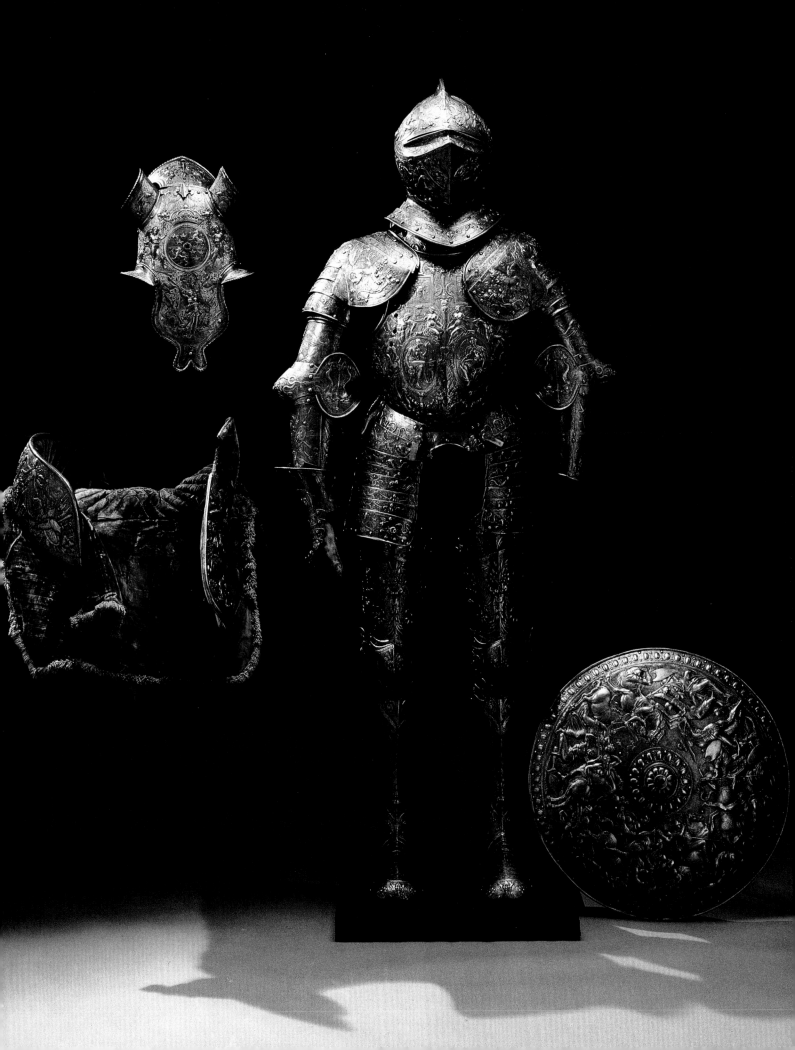

BIBLIOGRAPHY: Rudolf Cederström and Karl Erik Steneberg, *Skokloster Skölden* (Stockholm, 1945); Bruno Thomas, "Neues zum Werk des Eliseus Libaerts," *Livrustkammaren* 4 (1948); Bruno Thomas, "Die Münchner Harnischvorzeichnungen im Stil François Ier," *JKSW* 55 (1959), 31–74; Bruno Thomas, "Die Münchner Waffenvorzeichnungen des Etienne Delaune und die Prunkschilde Heinrichs II von Frankreich," *JKSW* 58 (1962), 101–168 (esp. 146–165); Bruno Thomas, "Die Münchner Harnischvorzeichnungen des Etienne Delaune für die Emblem- und die Schlangen-Garnitur Heinrichs II von Frankreich," *JKSW* 56 (1960), 7–62; Bruno Thomas, "Die Münchner Harnischvorzeichnungen mit Rankendekor des Etienne Delaune," *JKSW* 61 (1965), 41–90; Stephen V. Grancsay, "The Armor of Henry II from the Louvre Museum," *The Metropolitan Museum of Art Bulletin* (Oct. 1952), 68–80; Stephen V. Grancsay, "Royal Armorers: Antwerp or Paris," *The Metropolitan Museum of Art Bulletin* (summer 1959), 1–7; Helmut Nickel, "The Battle of the Crescent," *The Metropolitan Museum of Art Bulletin* (Nov. 1965), 110–127; Laking 1920–1921, 3:342–358, 4:246–259; Sir James Mann, *European Arms and Armor* (Wallace Collection catalogues), 2 vols. (London, 1962), nos. A320 and 321; J. Schöbel, *Ein Prunkharnisch* (Dresden, 1966); *L'Ecole de Fontainebleau* [exh. cat., Grand Palais] (Paris, 1972), 419, nos. 80, 252–258, 580–585; Claude Blair, *Arms, Armour, and Base-Metalwork*, The James A. Rothschild Collection at Waddesdon Manor (Aylesbury, 1974), cat. 9; Meyerson and Rangström 1984, 30–33, 333–334.

7

Skokloster Shield c. 1560

Eliseus Libaerts, fl. in Antwerp, 1557–1564
steel with gold and silver
71.9 x 49.2 x 3.8 (28¼ x 19⅜ x 1½)
Skokloster Castle Museum, 7133

Skokloster was built during the second half of the seventeenth century by constable of the realm Count Carl Gustav Wrangel (1613–1676). The castle, just over 40 miles northwest of Stockholm, is a monument on the grand scale to the integration of Swedish culture with that of mainstream Europe of the time, and one of the most famous objects in its collections is the Skokloster Shield, a European masterpiece of the highest order. This shield represents the beginning of the "Europeanization" of Sweden during the reign of Erik XIV.

Erik XIV, although perhaps more "European" than any of his brothers or his father, Gustav Vasa, never actually traveled abroad. The foremost expert on his reign, Ingvar Andersson, has shown how this was offset by a well-stocked library and by personal contacts with soldiers, physicians, artists, and musicians from France, Italy, England, and other countries. Erik established both a political and a cultural intelligence system, and in this way was a forerunner of Axel Oxenstierna, Queen Christina, Wrangel, and other seventeenth-century personalities.

For centuries now the shield has fascinated visitors to Skokloster, and it has inspired many imaginative attributions, such as "shield of the Emperor Charles V, made by Benvenuto Cellini." It is of chased and embossed steel damascened with gold and silver, and its main decoration is a triumphal theme in the mannerist style (ten figures in chains and heroic scenes). A large number of punches were used for the chasing. The borders are damascened with gold on the blued steel ground, with the brightly polished figurative scenes in striking contrast.

A detailed study of the Skokloster Shield was published in 1945 by Karl Erik Steneberg, drawing on comprehensive, unpublished preparatory studies by Rudolf Cederström (from 1924 onward). Cederström and Steneberg show that although the Skokloster Shield—like an almost identical shield in Vienna—bears neither signature nor stamp, its workmanship is very close to that of the parade armor of Erik XIV in the Royal Armory (cat. 6). Since written records link that garniture with Eliseus Libaerts of Antwerp, this shield is also attributed to him. The design for a shield with four masks in the Staatliche Graphische Sammlung, Munich, which closely corresponds to the Skokloster Shield, is attributed, on stylistic grounds, to Etienne Delaune.

Cederström and Steneberg put forward the hypothesis that the Skokloster Shield could be the same shield listed in Erik XIV's inventory of March 1562 and not included in the above-mentioned armor. That shield recurs in an inventory of the royal collections in 1628 but not in a list from January 1630. Gustavus Adolphus is supposed to have given it to field marshal Herman Wrangel, which would account for its subsequent appearance in the armory of Wrangel's son, Carl Gustav. If Erik was indeed the shield's first owner, then—in view of its triumphal theme—it may possibly have been carried in one of the king's triumphal processions.

Another hypothesis maintains that the shield did not belong to Erik XIV but was intended for him, that Libaerts had it with him when he was arrested in Denmark on his way to Sweden in 1564. The two countries were then at war, and the shield may have been confiscated, finding its way into the imperial collections in

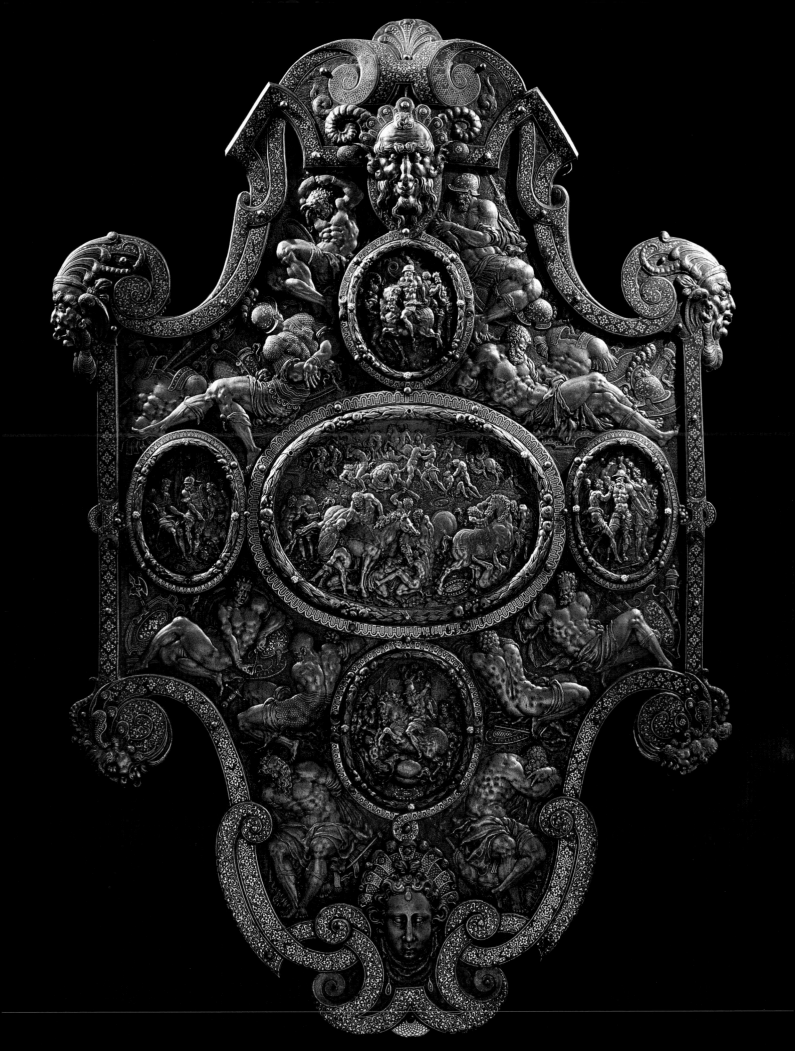

John III 1537–1592
and Sigismund III 1566–1632

Prague (the possibility of the shield's coming from Prague was discussed by the Czech scholar B. Dudík after a visit to Skokloster in 1851).

Åke Meyerson has published several studies on the questions surrounding the provenance of the Skokloster Shield and has advanced the possibility that the shield was made for the coronation of Emperor Maximilian in 1564 (see Meyerson and Rangström 1984). Meyerson recovered a 1651 inventory of Wrangel's armory at the Castle of Wolgast in Swedish Pomerania, where Wrangel was Swedish governor-general at the time. The list includes the shield but does not give its previous history. Meyerson is inclined to believe that Wrangel acquired the shield during the closing stages of the Thirty Years War rather than inheriting it from his father through the generosity of Gustavus Adolphus. A.L.

BIBLIOGRAPHY: Rudolf Cederström and Karl Erik Steneberg, *Skokloster Skölden* (Stockholm, 1945); Meyerson and Rangström 1984; B. Dudík, *Schweden in Böhmen und Mähren* (Vienna, 1879); Ingvar Andersson, *Svenskt och europeiskt femtonhundratal* (Lund, 1943).

JOHN (JOHAN) WAS BORN in 1537, the eldest son of Gustav Vasa by his second wife, Margareta Leijonhufvud. He was given the duchy of Finland by his father, and as an adult began to pursue his own foreign policy, with particular emphasis on Livonia and Poland—much to the displeasure of his elder half-brother Erik XIV. In 1562, defying Erik's wishes, twenty-five-year-old John married the sister of the king of Poland, Katarina Jagellonica, who was eleven years his senior. John and Katarina were imprisoned by Erik the following year at Gripsholm Castle, where they remained for four years. On being released, John made common cause with his younger brother Charles, and took up arms against the now mentally disturbed Erik XIV, deposing him and putting him in prison in 1568.

John succeeded Erik on the throne but soon found himself reigning less securely than he might have hoped. His kingdom was at war on several fronts, the nobility were becoming increasingly disaffected, and the rate of inflation was out of control. In addition, the Swedish Lutherans, headed by John's younger brother

Charles, were increasingly suspicious of John III's sympathies toward the Church of Rome. John had hoped to unite Sweden and Poland under a single crown, which in his belief could be more readily achieved if Sweden reverted to the old faith.

Unification became a possibility when John's son Sigismund was elected king of Poland in 1587, fifteen years after the death of his uncle, Sigismund August II. When John died in 1592, however, Sigismund had to struggle to obtain the Swedish throne. He was crowned king of Sweden in 1593, but his uncle Charles used religious and other issues to finally depose him in 1598. Sigismund remained in Poland for the rest of his life, but he never renounced his claim to the Swedish throne, and constantly conspired to win back the kingdom. U.G.J.

Detail, cat. 9

8

Parade Armor of Sigismund August II of Poland 1550s

Kunz (Konrad) Lochner the Younger, 1510–1567

etched steel, gilt and enameled

194 x 230 x 110 (76⅜ x 90½ x 43¼)

Royal Armory, LRK 2603 (old no.)

Shown in Minneapolis only

This armor was made for Sigismund August II of Poland (1520–1572), the last king of the Jagellonica dynasty. According to a description of the king by the nuncio Ruggiero in 1568, he was of medium height and lean, corresponding well to the measure of the armor.

In his will King Sigismund divided his possessions among his sisters, but because only one of them, Princess Anne (1524–1596), was still living in Poland, the will was contested, for it gave foreign princesses possessions that should have reverted to the Polish state at the extinction of the dynasty. This caused an international problem unresolved for many years, to which was added the need to elect a new king of Poland. One candidate was Prince Sigismund, the seven-year-old son of the late king's younger sister Katarina (1526–1583), married to Duke John, later King John III, of Sweden. But the Polish electorate preferred a French prince, twenty-two-year-old Henry of Valois, provided that he marry the fifty-one-year-old Princess Anne. His reign was short, as he left Poland when his brother, King Charles IX of France, died in 1574; and he never married the princess. A second electoral parliament was convened in Warsaw on 15 December 1575, when Princess Anne herself was elected queen of Poland.

In a letter to John III dated 28 September 1574, Princess Anne informed him of the electoral process. To mollify him regarding the inheritance, and to secure Swedish support, she offered him one of her brother's suits of armor as a gift. In inventories of the Swedish Royal Armory the suit of armor is said to have belonged to John's son Sigismund. But when Sigismund was dethroned as king of Sweden in 1598 by his uncle, Charles IX Vasa, the armor was retained in the Royal Armory.

The armor has a pointed median ridge on the breastplate, dating the suit to the 1550s. The horse armor has a steel-plated bridle and saddle of black velvet, embroidered with gold and silver; and the chanfron is provided with two scrolled ramshorns in similar taste to the grotesque masked visors. The entire surface of the pieces is adorned with etched and gilt strapwork decoration, partly painted with black and white color known as "cold enamel." The armor is mounted on a seventeenth-century mannequin.

The armor was made by Kunz (Konrad) Lochner the Younger, from the Nuremberg family of armorers. It bears the mark of the Lochner coat of arms—a lion together with the city mark of Nuremberg—on the neckpiece and pectoral of the horse armor. Lochner was appointed armorer to Grand Duke Maximilian II in 1544 and later worked for Sigismund August II of Poland; he went to Poland in person in 1559 to collect payments. He was the best embosser in sixteenth-century Nuremberg, and etched and enameled decorations were frequently used on his armors. The name of the etcher is unknown.

In the late seventeenth century this armor was displayed in Stockholm as the armor of King Christian II of Denmark and Sweden (1451–1559) in one of the earliest European museums. The kings of Sweden were represented there by the exhibition of armor from the Royal Armory, though not necessarily by pieces that had actually belonged to the kings named. N.D.

BIBLIOGRAPHY: Wendelin Boeheim, "Meister der Waffenschmiedkunst," *Zeitschrift für Historische Waffen- und Kostümkunde,* vol. 1 (Berlin, 1897), 9–10; F. Pulaski, *Inventarz Zbrojowni Ordynacyi Krasinskich* (Warsaw, 1909); Hans Stocklein, "Lochner, Kunz d. J.," in *Allgemeines Lexikon der bildenden Küstler* (Thieme-Becker), vol. 23 (1929), 306; Josef Alm, *Blanka vapen och skyddsvapen* (Stockholm, 1932), 212–214; Renaud Przezdziecki, "Sigismund Augusts av Polen rustning i Livrustkammaren," *Livrustkammaren* 2 (1942), 115–130 (English summary); Karl Erik Steneberg, "Livrustkammarens Lochnerrustning," *Svenska Vapenhistoriska Sällskapets årsskrift* (Stockholm, 1940–1941), 67–77; Karl Erik Steneberg, "Zur Geschichte des Stockholmer Lochnerharnisches," *Zeitschrift für Historische Waffen- und Kostümkunde,* vol. 17 (Berlin, 1944), 31–36; Karl Erik Steneberg, "Harensksmide i Gustav II Adolfs rustkammare," *Livrustkammaren* 9 (1961–1963), 166–170.

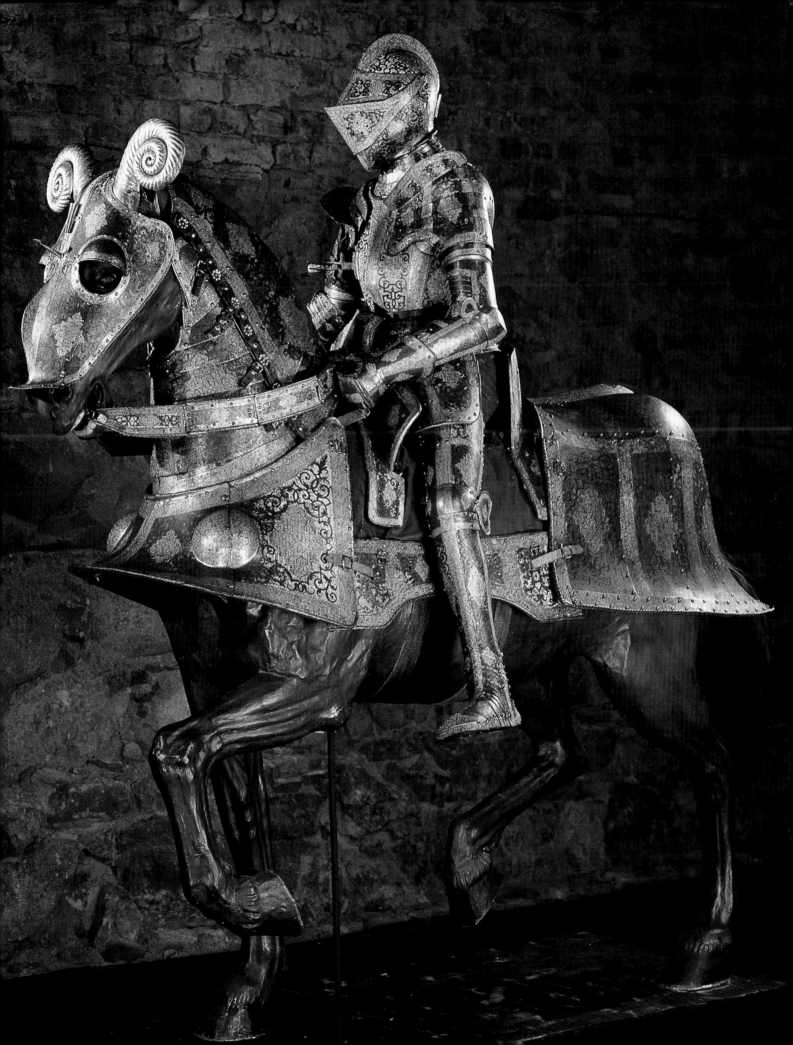

9

Parade Helmet and Round Shield

c. 1560–1570

Italian

chased, embossed, blued, and gilt steel

helmet, 30 x 21 x 37.5 (11¾ x 8¼ x 14¾); shield, 58 (22¾) diam.

Royal Armory, LRK 17989–17990

This helmet and shield, possibly of Milanese workmanship, may have come to Sweden through the royal family's connection with Poland, since John III's consort Katarina was the daughter of Queen Bona Sforza (1537–1592), the Milanese princess who married Sigismund I of Poland. The objects are first mentioned in the inventories of the Royal Armory in 1655, perhaps also in an inventory of the armory of Charles X at Gripsholm Castle a year before. But they may have been part of the booty from Warsaw or Cracow in 1655. An unverified note suggests that they were bought by then-Prince Charles' emissaries in Nuremberg in the 1640s.

The two pieces are made in the classical style of the sixteenth century. The helmet, a burgonet—open-face with a peak, cheek pieces, and a neck defense—is wrought from a single sheet of dark-hued steel, with a high comb and hinged cheek pieces, one with the remains of an armored chin strap. Its embossed and chased decoration, with gilded details, is devoted to themes of victory, the central figure on both sides being Hercules.

The etched and embossed decoration of the round shield features a legendary scene from the Roman-Etruscan war of 508 B.C. Roman citizen Gaius Mucius Cordus had been caught in the Etruscan camp trying to kill the king and here burns his right hand on a sacrificial fire in front of King Porsenna as a demonstration of Roman fortitude. The Etruscan king was duly impressed and released him, and Cordus was afterward given the honorary name "Scaevola," or left-handed, which was also used by his descendants. The inside of the shield has a lining of red velvet with braces, or enarmes, for the left forearm and hand.

A similar helmet and shield are in the Capodimonte Museum in Naples. Another set is in the Dresden Collection.

Many masters have been put forth for the helmet and shield shown here. Viennese scholars have suggested Giovanni Battista Serabaglio; Seitz proposed the Negroli workshop in Milan; and lately it has been said that the helmet and shield do not belong together, the former being possibly Lombardian, and the shield made in the Italian style in France or the Netherlands. N.D.

BIBLIOGRAPHY: Heribert Seitz, "Two Milanese Masterpieces," *Livrustkammaren* 14 (1978), 269–274, pls. 1–3; John F. Hayward, "The Revival of Roman Armour in the Renaissance," in Held 1979, 1:160, pls. 31–32 (Capodimonte pieces); Brynolf Hellner, "Stålets dekorering inom vapensmidet," *Livrustkammaren* 9 (1964), 7, pl. 4; G. Giorgetti, *Le armi antiche*, vol. 1, *Le armi bianche* (Milan, 1961), 90, 103; E. Häenel, *Kostbare Waffen aus der Dresdner Rüstkammer*, vol. 27; R. Wenger, "Rundschild und Sturmhaube, ein Meisterwerk von Lucas Piccinino," *Dresdener Kunstblätter* 8 (1960), 129.

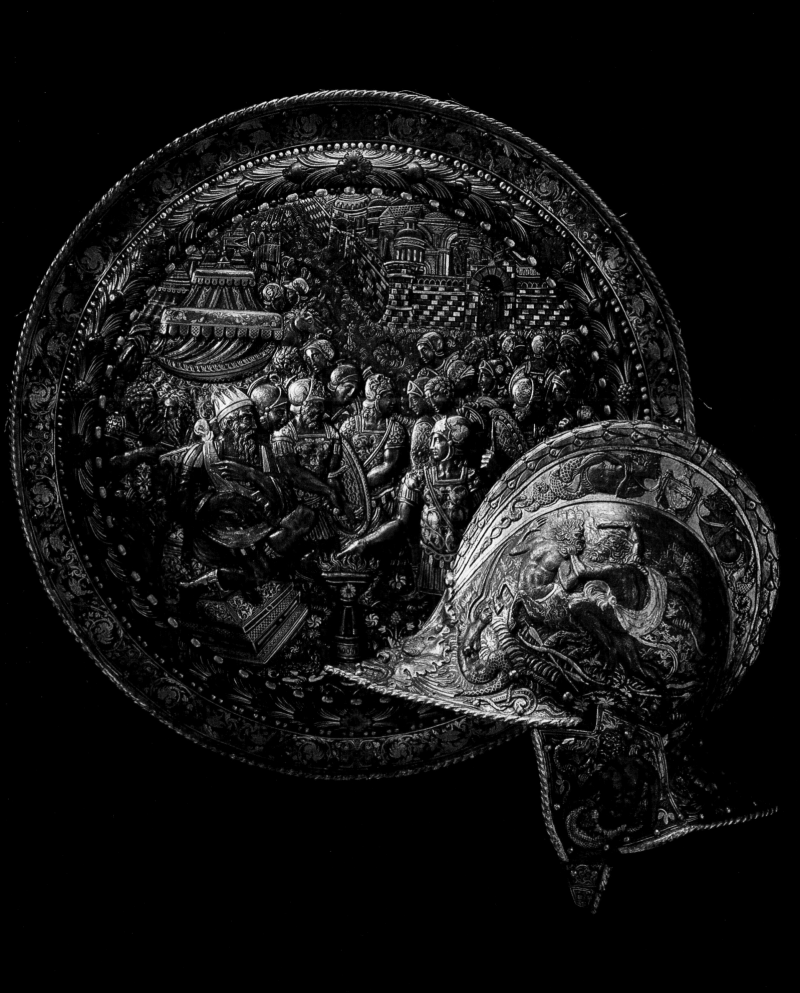

Detail, cat. 10

Charles IX 1550–1611

OF ALL THE SONS of Gustav Vasa, it was Charles IX who bore the closest resemblance to his father. He had the same appetite for power, the same implacability, the same callousness and fierce temper, and the same capacity for ruthlessly pleading his cause. Indeed, he looked upon himself as the true executor of his father's political testament and the only true guardian of his work of religious reformation. These were in fact the causes for which Charles waged an unceasing struggle, not least because they matched his own purposes.

Gustav Vasa had first allotted Charles the duchy of Södermanland southwest of Stockholm, and in his last will and testament had given him extensive powers of self-determination in his miniature kingdom. This allowed Charles unusual independence under the reigns of his two elder brothers, Erik XIV and John III. When Erik XIV's mental health began to fail a few years after his accession, Charles joined John in rebellion and deposed him. John assumed the throne in 1569, and for a time, Charles gladly made his Gripsholm Castle available as a place of custody for the royal prisoner. Erik died there in captivity in 1577.

John III's eldest son Sigismund was elected king of Catholic Poland in 1587 and by hereditary right would become king of Sweden at his father's death. When John died in 1592, however, Sigismund was out-maneuvered by Charles, who realized that sternly Protestant Sweden would never accept a papist heretic as king. So as not to appear over eager, Charles refrained from immediately proclaiming himself king, but eventually he submitted to entreaty and was crowned in 1607.

Charles IX made numerous appearances in the theater of war, intermittently juggling three wars simultaneously. His rivalry with Sigismund in Poland precipitated hostilities time and time again, and when Charles IX carried the war into Russia (where Swedish troops under Jacob De la Gardie captured Moscow in 1610), the Danes saw their chance and declared war on Sweden. At Charles' death in 1611, conflicts had not been settled in any quarter and were inherited by his son and successor Gustavus Adolphus, who at the time was not even seventeen years old. U.G.J.

10

Fittings for Coronation Saddle of Charles IX
1607

Ruprecht Miller, fl. in Stockholm 1606–1623

gilt silver, gold, enamel, precious stones

cantle, 30 x 54 (11¾ x 21¼); left pommel, 12 x 22.4 (4¾ x 8¾); aigrettes, 29 x 10 (11⅛ x 4), and 26.5 x 10 (10⅜ x 4)

Royal Armory, 3341, 3342, 3358, 3359

Charles IX, the youngest son of Gustav Vasa, was eager to demonstrate the powerful position of his branch of the family by commissioning his own symbols of rank and status and by maintaining a distinctive splendor at his coronation ceremony in 1607. Next to the regalia (see cat. 3), the ornaments for the coronation horse were the most important of the cornation properties.

It is thought that the crescent-shaped cantle plate and corresponding left front plate exhibited here were intended to decorate Charles IX's coronation saddle, but the commissioned suite was never completed. Documents show that the extant fittings were delivered in 1631 by the widow of the German goldsmith, Ruprecht Miller, who had originally worked in Hamburg but was called to Sweden for Charles' coronation. The crown of Charles' consort Kristina and the coronation saddle were among Miller's first assignments in Sweden. He also made Maria Eleonora's crown in 1620 (cat. 1).

The decoration of large sections of saddles with goldsmithwork is a tradition that originated in the East and featured art of the sixteenth and seventeenth centuries. Another example of this type is the coronation saddle of Gustavus Adolphus in 1617, which has plates of gilt silver with precious stones and purplish red velvet starred with—surprisingly on a Swedish royal saddle—German imperial eagles.

These saddle mounts are superb examples of the late Renaissance goldsmith's art, with open-work decoration and grotesques of a Triton, Nereid, and two armored knights on white horses, as well as a cornucopia, trophies, and dolphins. In the middle of the cantle, a sheaf—emblem of the Vasa dynasty—is supported by two lions. Topaz, rock crystal, smoky quartz, and garnets are mounted in high box settings.

The aigrettes, or plume holders, consist of a shaft, an open-work plate with lavish grotesque ornamentation, and three octagonal pipes above. Three loops are fashioned on the reverse side of each shaft. The aigrettes were made for the coronation horse of Charles IX and were to have been placed on the bridle at the forehead and on the crupper at the horse's tail. They were used at the coronation of Gustavus Adolphus in 1617, and one may have been used by Colonel von Ungern Sternberg when acting as host at Stockholm's Royal Palace in 1692. A.T.-J.

BIBLIOGRAPHY: Andrén 1963, 53; Stockholm 1932, 11; Y. Hackenbroch, *Renaissance Jewellery* (London, Munich, 1979), 216, fig. 592a-b; Carl Hernmarck, *Hamburg und der Schwedische Hof während des 17. Jahrhunderts*, Festschrift Erich Meyer (Hamburg, 1957), 273–275; Bruno Thomas, *Die schönsten Waffen und Rüstungen* (Munich, 1963), no. 64; John F. Hayward, ''The Revival of Roman Armour in the Renaissance,'' in Held 1979, 1:160 n. 2; Cederström and Malmborg 1930, no. 120e; Historiska bilder, 201.

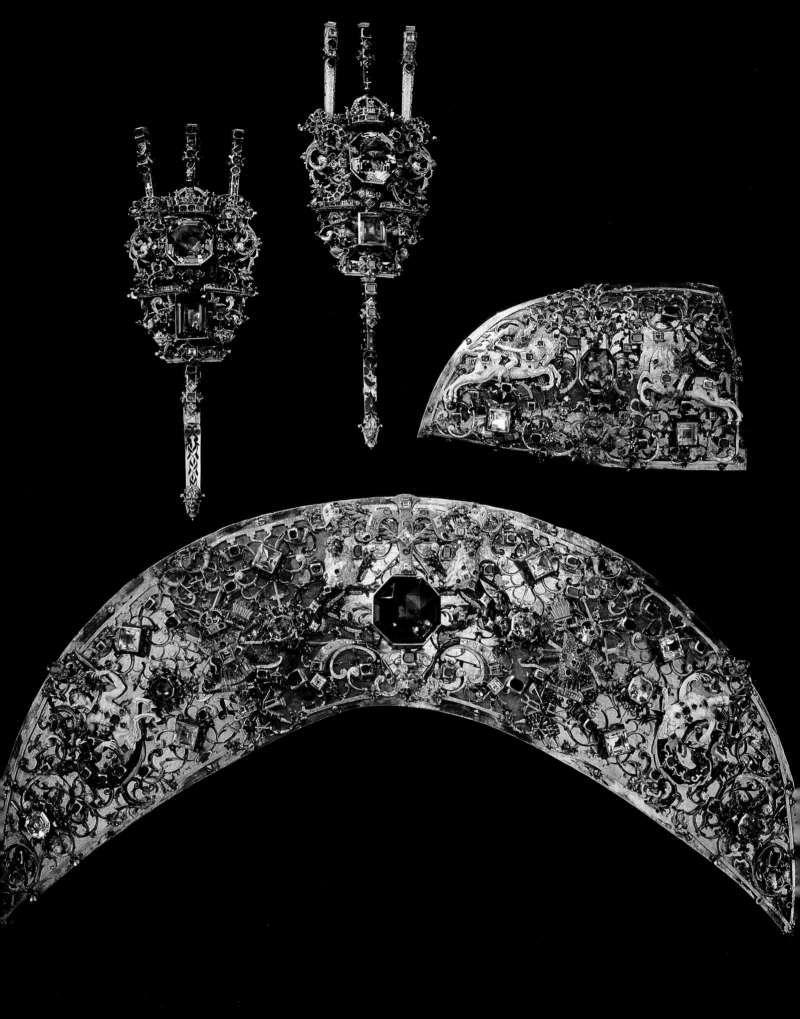

11

Chain and Badge of the Royal Order of Jehova 1606

Antonij Groot the Elder, 1585–1614

gold, enamel, rock crystal, and garnets

chain, 132 (52) long; badge, 7 (2¾) diam.

Royal Armory, LRK 31/21-2

Each of the early Vasa kings created an order identified by a symbolic emblem, but these were probably not orders of chivalry in the normal sense. No statutes are left to clarify their meaning, and we do not know how the orders were awarded or to whom. The titles indicate that they had strong religious associations, probably parallel to the religious justification of the reign embodied in the coronation ritual itself. The Royal Order of Jehova was created by Charles IX in 1606, as his older brothers had created theirs: Erik XIV the Royal Order of the Savior, and John III the Royal Order of Agnus Dei.

Four gold chains and four badges of the Order of Jehova were delivered to Charles IX in 1606 by master of the mint Antonij Groot the Elder, who had supervised the work of other goldsmiths. Among these four were the chain and badge exhibited here. The chain had twenty-four (now twenty-three) links, alternatively oval with table-cut rock crystals and garnets, and "handshakes" holding the Vasa crest of green-enameled gold. The rock crystal badge, in the form of an eight-pointed star, bears the Hebrew word JEHOVA in the center, engraved and gilt. A ring of garnets encircles the whole, and a crystal drop-form pendant hangs below the badge.

Three of the enameled badges were made by the Stockholm goldsmith Ruprecht Miller: for Gustavus Adolphus (1594–1632) and Charles Philip (1601–1622), both sons of the king, and for Duke John of Östergötland (1589–1618), the youngest son of John III. The orders were carried at the coronation of Charles IX in the Uppsala Cathedral on 15 March 1607. They were counted among the Swedish regalia in the Royal Treasury until 1828, and on the dissolution of that institution came to the National Historical Collections. In 1932 the remaining ones were included in the collections of orders and medals in the Royal Armory. Only one enameled badge is still preserved. N.D.

BIBLIOGRAPHY: Cederström 1942, 165–173 (plate); Andrén 1963, 4:45, 48, 53 (goldsmiths' biographies); Arvid Berghman, *Nordiska ordnar och dekorationer* (Malmö, 1949), 18–19, 152 (plate); Karl Löfström, *Sveriges riddarordnar* (Stockholm, 1948), 146–147; Stockholm 1930-1931, cat. 491.

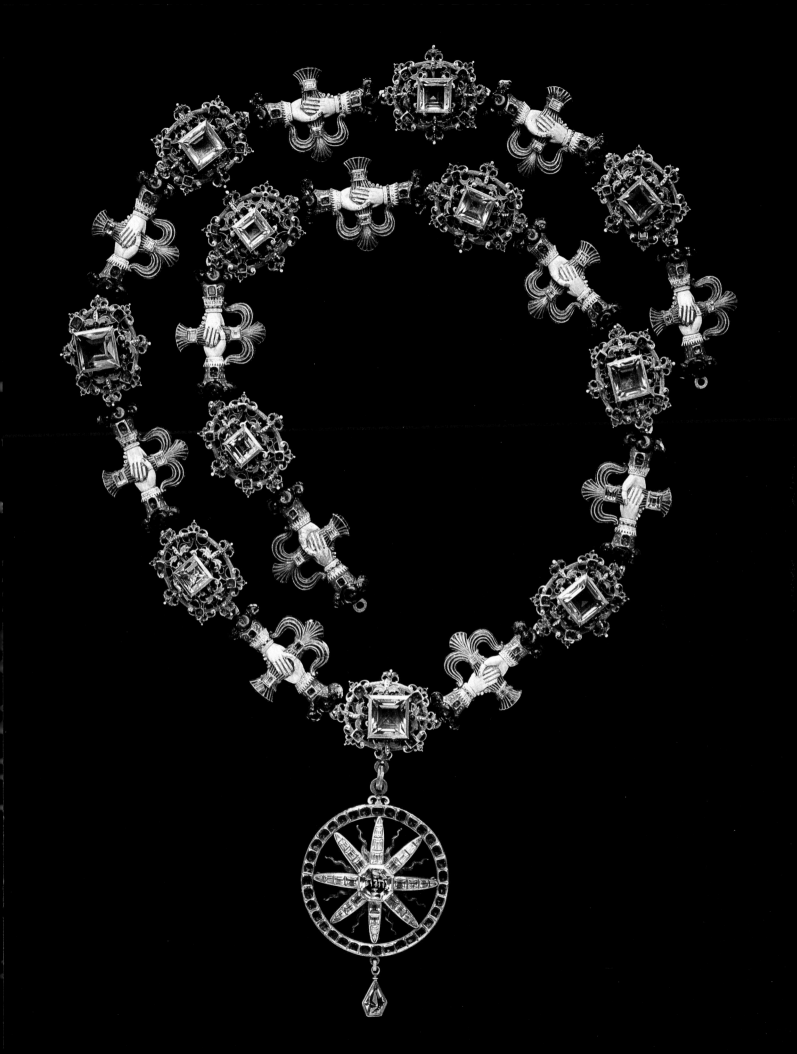

12

Burial Regalia of Charles IX 1611

crown by Antoni Grott, d. 1613; scepter and orb by Peter Kempe, fl. in Stockholm 1589–1612

gold with black and white enamel, rock crystals, and pearls

crown, 25 (9⅞) high, 19.5 (7⅝) diam.; scepter, 71 (28) long; orb, 17 (6⅝) high

property of Strängnäs Cathedral, deposited since 1980 in the Royal Armory

On the death of a monarch, it is still the custom in much of the world for the body to lie in state. This tradition is rooted in the ancient need to prove to all that the king is dead. By the Middle Ages it had also become the practice for European royalty to be buried with their regalia, no doubt inspired by the Christian belief in the resurrection. The earliest burial regalia have been found in the eleventh-century Franconian imperial graves in Speyer Cathedral. Crowns are the most frequent type of insignia found in graves opened in recent times, accompanied in some cases by an orb, scepter, ring, or sword. Some crowns were clearly made for burial, being simplified versions of existing ornaments; others may have been worn in the deceased person's lifetime.

In the second half of the sixteenth century less significance was attached to the sanctity of body, and regalia were usually carried in the funeral procession or placed on the coffin but not buried. The spread of this innovation was associated with the consolidation of Europe's kingdoms and the acceptance of royal ornaments as state regalia. Previously the insignia had been considered the personal property of the kings and queens. In Sweden the burial of regalia continued through the seventeenth century, but special works were made for this to substitute for the national regalia.

The burial regalia of Charles IX and his consort, Kristina, display outstanding workmanship and the finest materials, suggestive of regalia used in life. The kingly regalia are made of gold and decorated with black and white enamel, alternating on the crown with a fine pattern of punched dots and stars. Table-cut rock crystals are mounted in raised box settings, which produce a grayish black shimmer in the stones; and pearls in rosettes or atop standards on the crown contribute to the black-and-white effect. These works mark the culmination of a tradition of magnificent burial regalia that started with Gustav Vasa in 1560. When Gustavus Adolphus died in 1632, no burial regalia were used, partly because those commissioned in Germany by his consort, Maria Eleonora, were rejected as being too simple. At the death of Charles X in 1660, the regalia

made hastily in Gothenburg were of gold but were not elaborately decorated.

Charles IX died on 13 October 1611 at Nyköping Castle in his former royal duchy of Södermanland. In a letter of 12 November the dowager queen Kristina commanded goldsmith Antoni Grott to make a crown "Our Beloved Dear deceased Lord and Husband can have on his head in the coffin." She also instructed the master of the household to supply Grott with gold. She added that since she was unable to procure oriental diamonds and since the king in his lifetime had prized Swedish diamonds (rock crystals) just as highly, Grott should find out from the master of the household whether there was a sufficient number of these; if not, she would supply them. Grott purchased thirty large and ninety-six small pearls for the crown as well. Peter Kempe secured from Grott the gold he needed to make the scepter and orb, and he used large rock crystals and twenty-eight pearls to adorn them.

The burial regalia were deposited in the coffin before it was closed. Then the coffin was brought in a three-day ceremonial procession from Nyköping Castle to the cathedral at Strängnäs, where the king was buried in great state on 21 April 1612. The regalia were removed from the coffin in 1830.

We know very little about Antoni Grott. He is mentioned in 1599, and in 1603 he became master of the mint, which he remained until his death in 1613. During this time he also worked as a jeweler for the Swedish court. His origin is not known, since a notation that he came from the Brabant has proved to be erroneous. The preserved jewelry from his hand shows that he was a highly skilled craftsman. A brilliant example is Charles IX's burial crown, where large rock crystals heighten the impression of pomp and dignity as they stand out against the sweeping detail of the decorative components. The prominence given to precious stones in the late sixteenth century highlighted refinements in gem-cutting on the Continent. Peter Kempe was active as a goldsmith in Stockholm between 1589 and 1621 and had several assignments for the court during this time (see cat. 3). B.H.

BIBLIOGRAPHY: Andrén 1963, 4:50; Hans Gillingstam, "Myntmästaren Antoni Grott och guldsmeden Antonius de Croeck," *Nordisk numismatisk årsskrift 1968* (Lund, 1969), 88–93; Martin Olsson, *Vasagraven i Uppsala Domkyrka 2* (Uppsala, 1956), 58; C. A. Ossbahr, "Ett minne fran Gustaf II Adolfs likbegängelse," *Ord och bild* (1894); K. Schmidt, *Anteckningar om Rone härad* (Nyköping, 1896), 120; Twining 1967; Riksarkivet, Kungl, arkiv, Strödda kamerala handlingar, vol. 54.

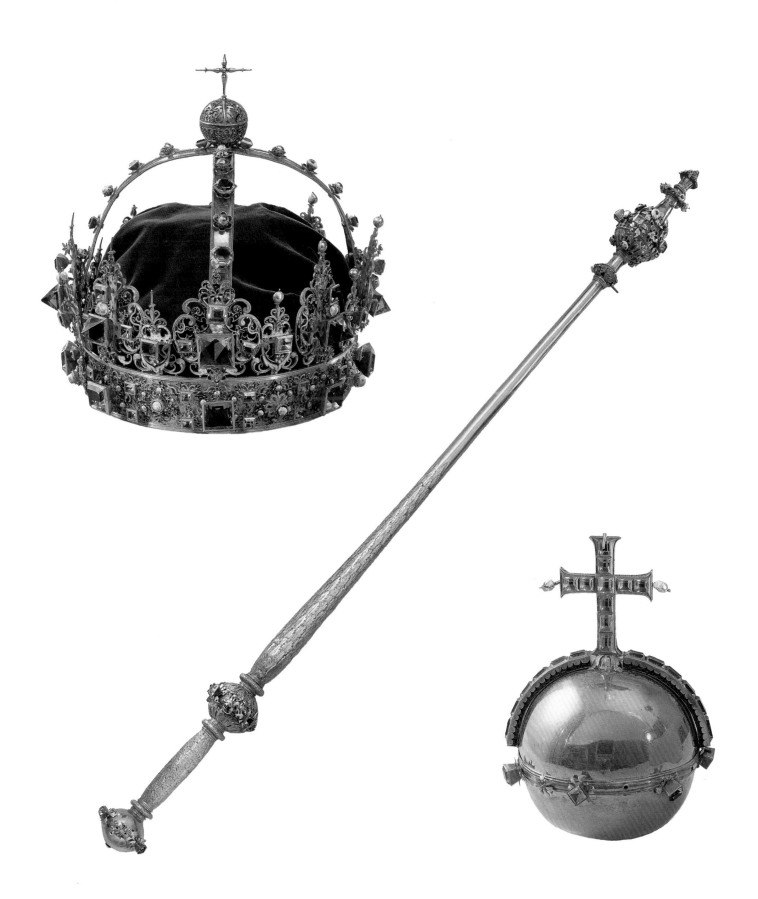

13

Burial Regalia of Queen Kristina 1626

possibly Ruprecht Miller, fl. in Stockholm 1606–1623, or Gillis Coyet the Younger, fl. 1614–1629

gold with black enamel

crown, 12.5 (4⅞) high; scepter, 51 (20) long; orb, 12.5 (4⅞) high

property of Strängnäs Cathedral, deposited since 1980 in the Royal Armory

Queen Kristina of Holstein-Gottorp (1573–1625), second consort of Charles IX, died at Nyköping Castle in December 1625, and her son, King Gustavus Adolphus, ordered a crown, scepter, and orb to be made for her burial. He specified that they were to be of gold, decorated with black enamel, with no precious stones.

The predominance of black is a notable feature of these regalia. The crown is decorated with a pattern of flowers and scrollwork in black enamel and worked gold, while the scepter and orb are entirely covered with an elegant tendril pattern in gold against the surrounding black enamel. Lord Twining has suggested that the reason black was used is that Kristina died a widow, but black was also widely used for coronation regalia at this time. It may have been in fashion generally, and accordingly, found its way onto royal insignia.

The maker of these regalia is not known, but Ruprecht Miller is a possible name. He came from Hamburg to work for Kristina in 1606 and made, among other things, the coronation regalia for Queen Maria Eleonora in 1620 (see cat. 1). It would also have been natural for the commission to go to the master of the mint, Gillis Coyet the Younger.

Queen Kristina was buried at Strängnäs Cathedral beside her husband. Her regalia were removed from the coffin in 1830. B.H.

BIBLIOGRAPHY: Andrén 1963, 4:50; Twining 1967, 308; Riksarkivet, Kungl, arkiv, Strodda kamerala handlingar, K. 79.

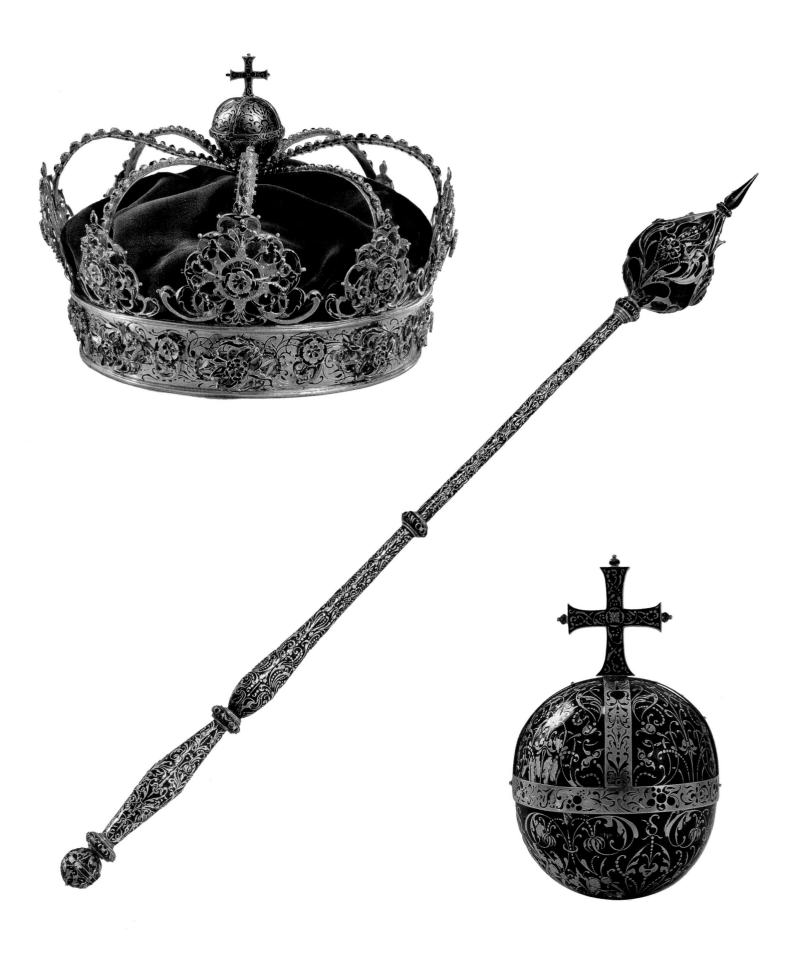

Gustavus Adolphus 1594–1632

THERE IS ONE YEAR in Swedish history that every school-child knows, namely 1632—and many could add to it the exact day and month, 6 November. That date marks the death of Gustavus Adolphus (Gustav II Adolf). Why, of all the many kings of Sweden, should his death still be such a living memory after 350 years? First and foremost, because he died a hero, fighting for what Swedes believe to have been a just cause: the survival of Protestantism and the position achieved by Lutheranism under his grandfather, Gustav Vasa, a hundred years earlier. In actual fact, Gustavus Adolphus was also looking for territorial gains for Sweden and a Swedish empire around the Baltic. There is no denying his great success at war. Moreover, he was a good-looking man with a remarkable gift for oratory and impressing everyone he met.

Gustavus Adolphus was not quite seventeen when he became king of Sweden following the death of his father, Charles IX, in 1611. His inheritance included three ongoing wars: against Russia, Poland, and Denmark. Thus he immediately went off on campaign, and spent most of the rest of his life on the battlefield. The Swedish Riksdag in its wisdom had granted Gustavus Adolphus permission to wage war as much as he liked, except on Swedish soil.

A number of truly enduring initiatives on behalf of Swedish culture were taken by Gustavus Adolphus. He donated a large number of estates to Uppsala University, thereby restoring the health and vigor of that ailing academy. Today his gift is of vast importance to the university finances. The king also gave orders for the addition of a splendid warship named *Vasa* to the Swedish navy. Although it capsized and sank in Stockholm while putting out on its maiden voyage in August 1628, it has been salvaged in our own time and found to be in surprisingly good condition. Since then, it has been exhibited in a specially constructed museum and has attracted millions of visitors from all over the world.

Maria Eleonora of Brandenburg (1599–1655) lived for twelve years as the consort of Gustavus Adolphus and for almost twice that long as his widow. Dynastic marriages in those days could be as significant as military alliances, and Maria Eleonora's brother, the elector of Brandenburg, had at first refused to release her, afraid that her marriage might disrupt his relations with Poland. At the last minute, however, her mother had Maria Eleonora secretly conveyed to Wismar, where Swedish ships were waiting. In November 1620 she was married to Gustavus Adolphus in Stockholm, and three days later she was crowned queen of Sweden.

In 1630 Gustavus Adolphus decided to intervene in the war that had been raging on the Continent for twelve years—the Thirty Years War, as it is commonly known—and made his way to Germany. The queen joined him there the following year, plunging extravagantly into the brilliant life of the Swedish court in its winter quarters in Frankfurt and at Mainz. Maria Eleonora was still in Germany when Gustavus Adolphus fell at the Battle of Lützen in November 1632. Grief for her husband seemed to bring out a streak of insanity in Maria Eleonora, and eventually her daughter Christina was taken to live with her aunt and uncle. After years of living at Gripsholm Castle against her will and then wandering disconsolately from Denmark to Prussia and Brandenburg, she finally returned to Sweden in 1648 and died in 1655, a year after her daughter's abdication. She was buried beside her husband in Riddarholm Church, Stockholm. U.G.J.

14

Gustavus Adolphus c. 1629

attributed to Jacob van Doordt
gouache, capsule of gold with ground glass front
6.2 (2½) high
Royal Collections, ss 247

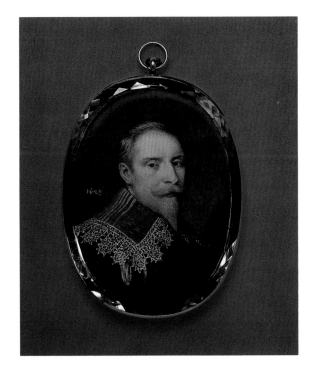

A Dutch embassy to Stockholm in 1616 gave the following description of Gustavus Adolphus: "His Majesty was tall of stature, well-proportioned, with a fair complexion and rather long face, blonde hair and a pointed beard tinged slightly with yellow." The king first had his portrait painted when he was a very young heir apparent. Numerous other portraits appeared in due course, and a real spate of them followed Sweden's intervention in the Thirty Years War, since they were part of the highly successful Protestant propaganda campaign during the conflict. Stories have come down to us of fine ladies of the period wearing brooches with the king of Sweden's portrait, like the image of a saint. In 1932, as part of the tercentenary commemoration of the death of Gustavus Adophus, an inventory was compiled of known contemporary portraits. The list mentioned 276 of them.

Surviving accounts record that Jacob van Doordt painted a succession of portraits of Gustavus Adolphus in 1629. This artist's portraits are generally characterized by strict, almost static composition and minuteness of detail. Stylistic considerations, coupled with knowledge that van Doordt was retained as a court painter in 1629, have made it natural to attribute this portrait to him.

Jacob van Doordt (or van der Doort) came of a Flemish family of artists working as portrait painters and wax carvers at many of the royal courts of Europe. Several sources refer to him as a portrait painter from Hamburg, which has led some scholars to believe that he was a native of that city. A number of his earliest known works were done there, and this, most probably, accounts for the reference to Hamburg. Van Doordt was a traveling court painter, working mainly at the courts of Denmark, Sweden, and north Germany. G.A.

BIBLIOGRAPHY: Stockholm, 1930–1931; Fogelmarck 1982; Stockholm 1966; Boo von Malmborg, *Samtida porträtt av Gustav II: Populär sammanfatting* [exh. cat., Nationalmuseum] (Stockholm, 1944); Sixten Strömbom, *Iconographia Gustavi Adolphi* (Stockholm, 1932).

15

Doublet of Red and Gold Brocade of Gustavus Adolphus c. 1610

Italian brocade, Swedish needlework

gold *lampas broché*: red silk ground with floating weft of gold wire; lining of russet taffeta

43.5 x 46 (17⅛ x 18⅛), with sleeve 66 (26) long

Royal Armory, 3349

This man's front-buttoning doublet—with a pointed front, long, shaped sleeves with shoulder wings, and a stand collar—was worn by the teenage King Gustavus Adolphus. The king was expected to dress in the latest fashion, and a large number of tailors and pearl embroiderers were always employed at the Swedish court. This doublet of costly fabric, presumably from Italy, was probably made to fit the king in Stockholm.

A doublet of this kind was commonly accompanied by knee breeches of fine broadcloth, gathered at the knees, and often decorated with galloon. Such breeches were worn by the king on campaign in Germany in 1627 and are now in the Royal Armory collections (see Fogelmarck figs. 2 and 3). There were no uniforms as we know them today, and the "field dress" of the time was often outstandingly elegant. The accoutrements included a baldric for the sword, a long linen shirt with a more or less elaborate collar, long stockings, extra stockings to be worn with boots, the boots themselves, gloves, and a hat. The reason this doublet still survives may be that it was unusually expensive and not often worn. The stiffeners would have made it such a close fit that the king soon would have grown out of it. G.E.

BIBLIOGRAPHY: Stockholm 1932, no. 24; Stockholm 1982, no. 27.

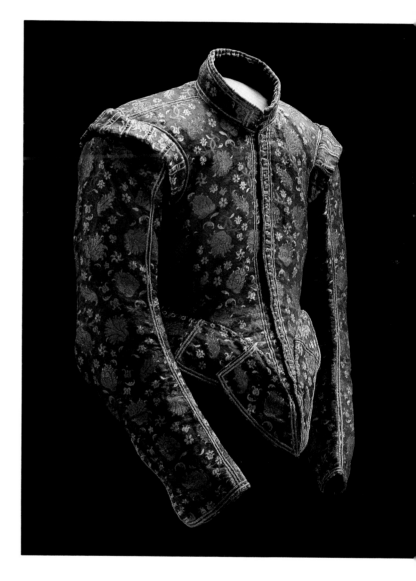

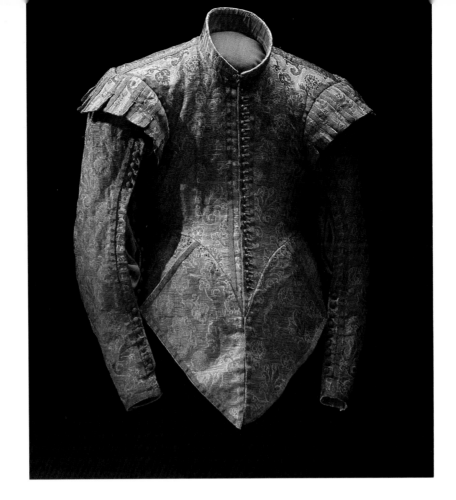

16

Doublet of Gold and Silver Brocade of Gustavus Adolphus 1620s

probably Italian brocade and Swedish needlework

lampas broché: white and silver ground woven in yellow and gold; lining of yellow taffeta

43.5 x 22 (17⅛ x 8⅝) (width at waist), with sleeve 64 (25¼) long

Royal Armory, 3373

This pale brocade doublet may have been worn by Gustavus Adolphus somewhat later in the 1620s than the one of red brocade (cat. 15). This is suggested by the greater length and smaller number of overlapping tabs at the waist and the slits made in the seams of the sleeves to display the fine shirt. One can trace the development toward the satin doublet worn by Gustavus Adolphus in the German War at the storming of the Kleinwerder Bastion near Danzig on 24 May 1627, which he bequeathed, with its appurtenant broadcloth breeches and linen shirt, to the Royal Armory as a perpetual memento (see Fogelmarck fig. 2). G.E.

BIBLIOGRAPHY: Stockholm 1932, no. 27; Stockholm 1982, no. 40.

17

Purple Costume and Cassock of Gustavus Adolphus 1620

Sebastian Lellij; assembled by Baltzar Dinet

purple broadcloth, purple silk satin, blue taffeta, white linen; embroidery of gold

cassock, 59 (23¼) long, with hanging sleeves 68 (26¾) long; breeches, 68 x 53 (26¾ x 20⅞) (at waist); doublet, 42.4 (16⅝) long, with sleeves 60 (23⅝)

Royal Armory, 3347a-b, 3351

This elegant purple costume was included in an order placed with the Hamburg jeweler Sebastian Lellij in 1620, an order prompted by Gustavus Adolphus' marriage to German princess Maria Eleonora of Brandenburg. The costume worn by the king during the actual wedding ceremony is not extant. But three garments survive from the wedding festivities, including the cassock, knee breeches, and tight doublet exhibited here. They were probably combined with a coat, stockings, baldric, gloves, shoes with rosettes, and an elaborate lace collar to make up the complete costume—not to mention jewelry, which was also an important component of the ensemble.

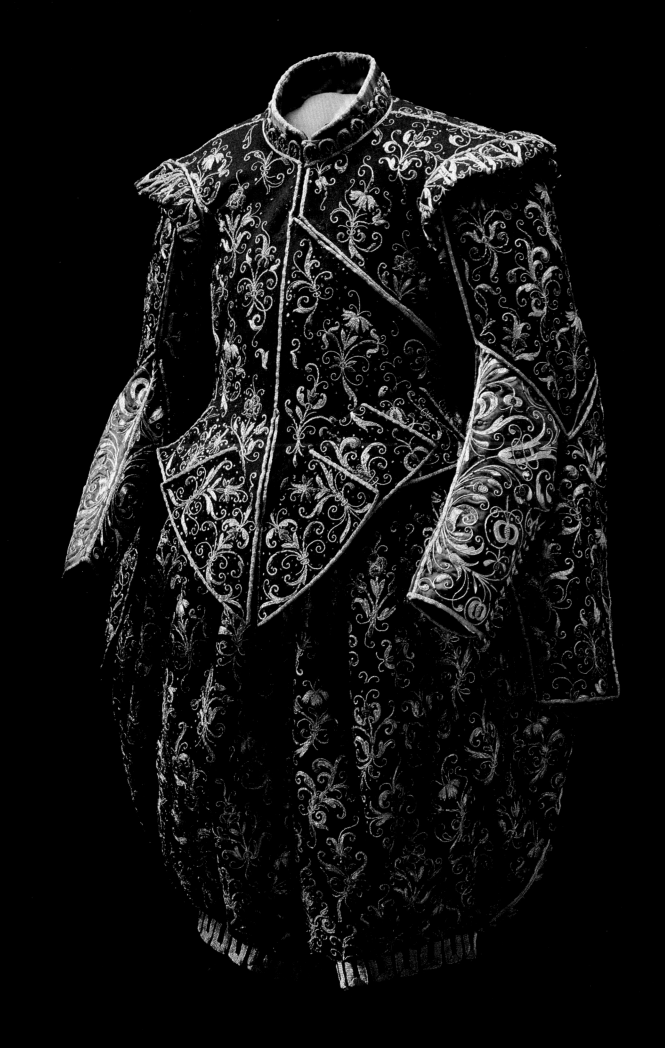

The cassock has a sharply pointed front waist and hanging sleeves with shoulder wings; it buttons diagonally across the left front. The breeches, which are lined in white linen, are very wide and gathered into bands at the waist and knees. Both cassock and breeches are of broadcloth decorated with scattered stylized floral sprigs in gold wire and spangles. The satin doublet is embroidered in gold in a larger-scale floral pattern.

The king's own tailor, Baltzar Dinet, was in charge of sewing the different parts of these garments together, after receiving the embroidered pieces cut to shape from the German workshop. The embroidery on the purple satin doublet resembles the gold embroidery on a large velvet caparison, also in the Royal Armory, which was ordered from Lellij three years earlier for Gustavus Adolphus' coronation. We thus have an indication here of the style that appealed to the king. G.E.

BIBLIOGRAPHY: Karl Erik Steneberg, ''En dräkt med kasak från 1620'' (A Dress with Cassock from 1620), *Livrustkammaren* 1 (1939), 12; Karl Erik Steneberg, ''Dräktmodet under 1600–talet,'' *Svenska folket genom tiderna*, vol. 4 (Malmö, 1939); Tydén-Jordan 1987, 46–48 (fig.).

18

Partisan for Yeomen of the Guard of Gustavus Adolphus 1626

Dutch

steel, chiseled and etched; wood

207 (81½) long; blade, 48 (18⅞) long

Royal Armory, LRK 5675

Partisans and most other pole arms were mainly ceremonial by the seventeenth century. From a functional weapon with simple lines and sharp edges, it had developed into a blade with elaborate contours and blunt edges. These partisans were carried by the yeomen of the guard, the palace guards of Gustavus Adolphus, both in the palace and in ceremonial processions.

Under a contract with the Swedish crown, the Amsterdam merchant Louis de Geer was to deliver partisans, halberds, and drums to Stockholm in 1618. Another shipment of partisans was ordered for the wedding of Gustavus Adolphus and Maria Eleonora of Brandenburg on 25 November 1620. On 23 February 1626 the master of the artillery was told to order another sixty partisans of the same form as those of 1620, to be delivered to Stockholm as soon as the seas were free of ice.

None of the 1620 partisans remains, and of the 1626 shipment, this is the only intact partisan that survives. It has a chiseled and etched decoration on the blade, with the monogram of the king, GARS (Gustavus Adolphus Rex Sveciae), together with the date 1626 and the Swedish coat of arms with lion supporters. The crown on the escutcheon is not a royal crown but similar to an imperial crown. There is a fragmentary blade in the Nordic Museum, Stockholm (inv. no. 115.761), refashioned into a chopper. N.D.

BIBLIOGRAPHY: Heribert Seitz, *Bardisanen som svenskt drabant-och befälsvapen* (Stockholm, 1943), 64, pl. 32 (p. 115, English summary); Stockholm 1932, no. 548; Stockholm 1982.

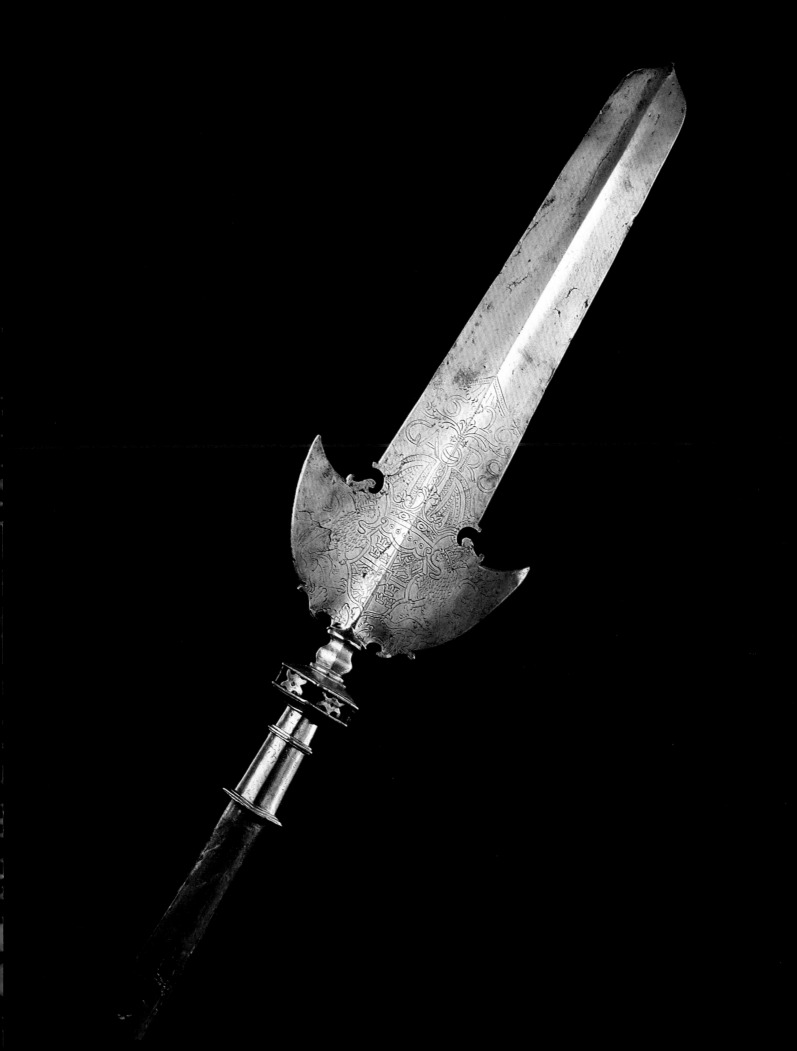

19

Tabard from the Court of Gustavus Adolphus
1617–1632

Swedish

blue velvet, blue silk satin, gold galloon, gold bobbin lace, lining of blue taffeta, gold thread

80 x 110 (31½ x 43¼)

Royal Armory, 3339

Heralds usually walked in pairs at the head of solemn royal processions, carrying heraldic staves as tokens of their dignity. They wore sleeveless, or short-sleeved, outer garments, open at the sides and embroidered both front and back with heraldic shields. Drawings from 1594 depict such heralds in the funeral procession for John III in 1592. The tabard shown here displays the great Swedish coat of arms with the crest of the Vasa dynasty. The coat of arms, which has been inverted, is relief embroidered in gold on blue satin. G.E.

BIBLIOGRAPHY: Cederström and Malmborg 1930, no. 63; Stockholm 1982, no. 76.

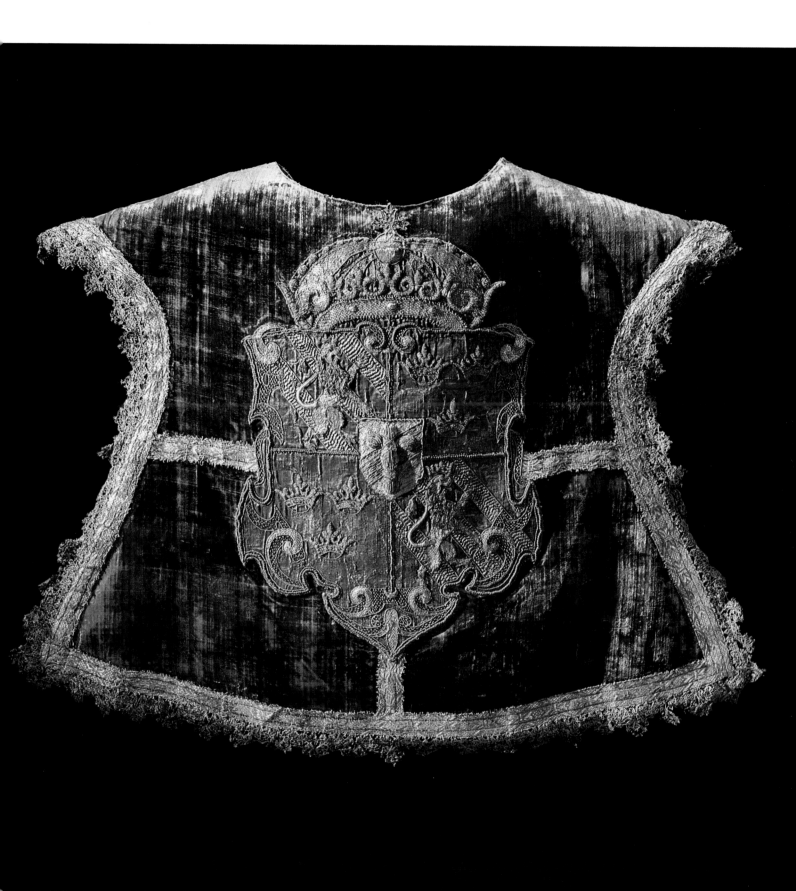

20

Coats of Arms from the Funeral Procession of Gustavus Adolphus 1633–1634

Jörgen Seywollt

silk mounted on paper, embroidery in gold, silver, and colored silks

57.2 x 38.1 (22½ x 15); 55.9 x 38.7 (22 x 15¼); 55.9 x 38.7 (22 x 15¼); 57.2 x 38.7 (22½ x 15¼)

Royal Armory, 3873.10a, 3873.24b, 3763.6b, 3873.9b

Funeral processions have been a part of the Swedish royal ceremonial tradition since the time of Gustav Vasa. These pageants of mourning, some of which are known from contemporary descriptions, drawings, or engravings (fig. 20a), were given a touch of color in the form of heraldic banners that were carried in procession. A number of the banners and caparisons from the funeral of Gustavus Adolphus have been preserved to this day, along with almost all of those from the procession following the death of Charles X (see cat. 40).

No less than sixty-six embroidered arms, representing the duchies, counties, and provinces of the realm, were displayed on horses at Gustavus Adolphus' funeral, 22 June 1634, and four are exhibited here. The arms of Sudermania (Södermanland) are gold with a black griffin. Those from western Bothnia (Västerbotten) are blue with a gold reindeer and "semé" (strewn) with silver stars. The third, from northern Finland (Satakunta), is more complex: it is divided "per fess" (horizontally) blue with two gold stars, and gold with a black bear raising a silver sword. The fourth is from Estonia, one of the overseas Baltic provinces, which is today a part of the Soviet Union: the arms are gold with three blue lions "passant" (walking). All four were embroidered in Hamburg by Jörgen Seywollt. His name and the names of three other embroiderers involved in this project are known from surviving accounts. A.H.

BIBLIOGRAPHY: Stockholm 1932, no. 62; Stockholm 1982.

20a. Anonymous drawing of the funeral procession of Charles IX (detail), 1611, showing the manner in which embroidered shields were used on banners and horse caparisons for royal funerals, courtesy Royal Armory

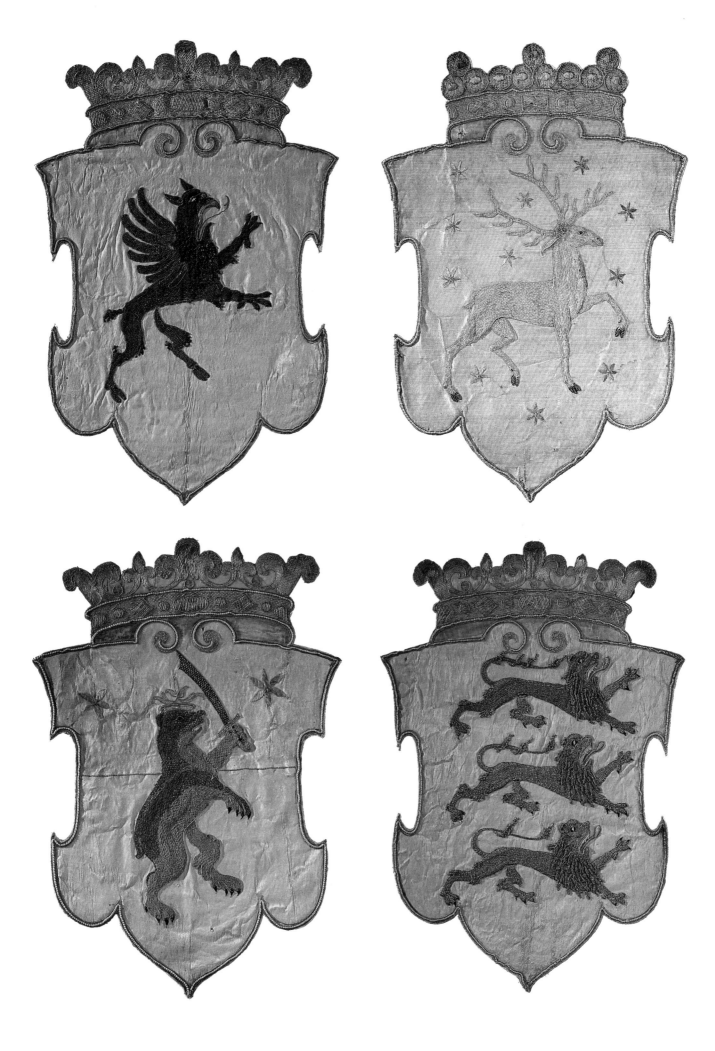

Detail, cat. 21

The Thirty Years War

THE THIRTY YEARS WAR comprised a series of conflicts that lasted from 1618 to 1648, part of an even longer struggle on the part of a number of states aimed at altering the balance of power in Europe. The wars were fought mostly on German soil and pitted the Habsburg powers of Spain and Austria against a number of largely Protestant German principalities fighting against the imperial ambitions of the Habsburgs. There was an important religious dimension to the conflicts in that the elected Habsburg Holy Roman Emperor Ferdinand II wanted to rule as an absolute monarch, and envisioned the recatholicization of German states that had been Protestant since the early sixteenth century. This angered many electors, Catholic as well as Protestant, for in addition to religious rights, each principality's independence in the empire's affairs was in jeopardy.

Although many perceived the survival of Protestantism as an issue in the conflict, the major alliances were not formed on the basis of religious creed alone. The electors and princes were supported by the Dutch, who

at that time were trying to gain independence from Spain, and by Catholic France, who realized that further Habsburg domination in Europe would limit their own territorial ambitions. Poland was closely allied to Austria by religion and tradition and fought for the imperalists. Denmark and later Sweden were encouraged to enter the conflict to lead the military effort for the German princes.

The roots of the conflict notwithstanding, each country that entered the war was interested in improving its own political and territorial position, and few were as successful as Sweden. By leading the allied cause on the battlefield from 1630 to 1635 and continuing in the war until the Peace of Westphalia in 1648, Sweden made significant territorial gains on the southern Baltic coast and acquired priceless works of art as gifts and war booty. This prolonged conflict on the Continent not only internationalized Sweden but also firmly established the country as one of the preeminent powers in Europe. M.C.

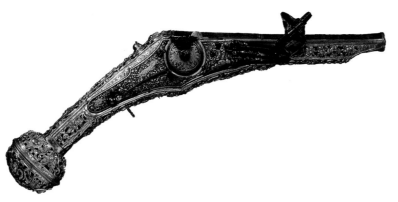

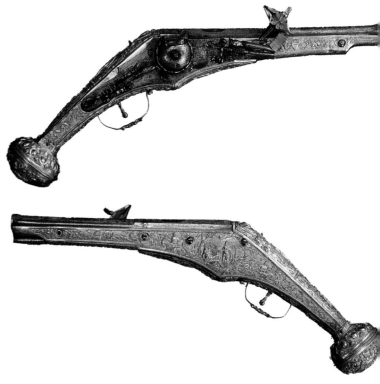

21

Two Pairs of Wheel-Lock Holster Pistols
late sixteenth century

German

etched, blued, and gilt steel, with gilt brass and wood

48.9 (19¼) long, 14.2 mm caliber; 49.9 (19⅝) long, 14.2 mm caliber; 50.9 (20) long, 15.5 mm caliber; 50.2 (19¾) long, 15.4 mm caliber

Royal Armory, LRK 7902–7903, 12722–12723

The duchy of Brunswick (Braunschweig) in Germany was an important center for production of both military and deluxe arms in the sixteenth century. Matchlock and wheel-lock guns and pistols from Brunswick with decorated barrels and stocks made of chased and engraved brass are sometimes called Duke Julius guns after the duke of Brunswick (1528–1589), because some bear his initials, *IH* (Iulius Herzog). The pistols in this exhibition have no initials but belong to the same group.

The barrels of the pistols seen here have etched and gilded decorations in the form of trophies, and imperial German double eagles adorn the wheel covers. The wooden stocks are covered with pierced and gilded brass plates with foliage, fruits, masks, and human faces, while the butt of each pistol depicts a classical warrior on horseback. One pistol shows Pyramis and Thisbe in one scene and Eve in a landscape in another, while another pistol shows Judith with the head of Holofernes in one scene and Adam in another. On a third there is a representation of Justitia.

These pistols were taken as booty by Gustavus Adol-

phus on 2 October 1621 from the armory of the dukes of Courland in Mitau (now Mitov or Jelgava in Lithuania). Of the three wars Gustavus Adolphus inherited from his father, those with Denmark and Russia had by this time been concluded. The third war, with Poland, was perhaps most dangerous for the king, since it was also a war of succession, the Polish king being his uncle Sigismund. The duke of Courland was a vassal of the king of Poland, and Mitau was taken and lost by the Swedish armies many times during the seventeenth century until it was finally surrendered to Russia in 1709.

Of the two pairs of pistols in the exhibition, one was sent in 1803 from the Royal Armory to the Cadet School of the Swedish army to be included in a historic arms collection. After being transferred with this collection to the Artillery (later Army) Museum, it was returned to the Royal Armory in 1907. N.D.

BIBLIOGRAPHY: Cederström and Malmborg 1930, no. 113f; Wolfgang Glage, *Das Kunsthandwerk der Buchsenmacher im Land Braunschweig* (Brunswick, 1983).

22

Rapier c. 1550–1580

German

steel, with silver-gilt mounts

111.5 x 25.3 (43⅞ x 10); blade, 92.2 x 3.6 (36¼ x 1⅜)

Royal Armory, LRK 10024

This rapier was taken, along with the pistols in catalogue 21, as booty from the armory of the dukes of Courland. It has a typical sixteenth-century thrusting blade—long and comparatively narrow—and a hilt with a thumb-ring and a shell-guard on the inside to accommodate a thrusting grip. The steel hilt is partly clad with gilded silverplate and decorated with engravings of foliate patterns against a blackened ground.

In front, a smaller side-ring with a shield is decorated on the inside with flowers and the arms of the Courland house of von Kettler. On the outside, amid flowers, a pelican picking at its breast feeds its young with its own blood. The grip is wound with alternately twisted and smooth silver wire. And the sleeve, of gilt silver, is decorated with a bird looking backward against a background of floral ornament. On the forte of the blade is a punched wolf mark (Passau), while on the left side is a punched orb. L.N.

BIBLIOGRAPHY: Cederström and Malmborg 1930, no. 106a; Rudolf Cederström, "Greve Gabriel Gabrielssons värja," *Livrustkammaren* 3 (1943–1945), 42; Seitz 1955, 76–79; Seitz 1965, 1:335–339.

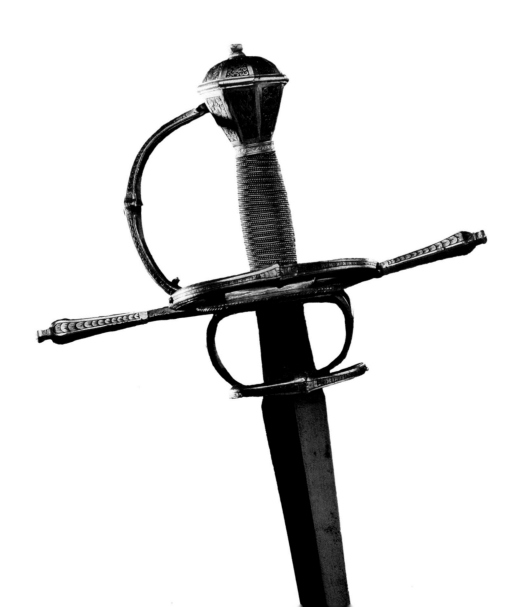

23

Powderhorn Clock c. 1620–1630

German; clock possibly by Andreas Schelhorn, end of sixteenth century

carved ivory, gilt brass, blued steel, and white enamel

20.2 (8⅝) high

Royal Armory, LRK 8997

This powderhorn clock, left to the Royal Armory by Charles XV of Sweden (1826–1872), may have originally been made for Duke Ulrich (1589–1622) or Duke Bogislaw XIV (1580–1637) of Pomerania. The duchy of Pomerania, on the Baltic shore, was important for the Swedish campaigns in the Thirty Years War, both strategically as a base in Germany and economically as it controlled river trade on the Oder. On 10 July 1630 an eternal union was proclaimed between Sweden and Pomerania, with the duchy becoming in fact a Swedish province. When Bogislaw XIV died without issue in 1637, the succession should have gone to Brandenburg, but it was not until 1814 that Pomerania finally returned to German control.

The powderhorn is made of two halves of carved ivory, with the front carved in the form of two wild men with crested helmets, supporting an oval escutcheon crowned with its own crested helmet. The escutcheon also serves as the clock cover. It is of gilt brass, slightly arched and hinged at the lower end, with the lock at the upper end in the form of a catch. The cover is pierced with the coat of arms of the duchy of Pomerania. The back of the powderhorn shows several naturalistic scenes, including two hunters, one on horseback, with a deer captured by the rider.

An astronomical clock in the Grünes Gewölbe Collection in Dresden is signed "Andreas Schelhorn/1571 z Schnebergk in Meisen"; and the clock incorporated in the powderhorn, marked *AS* with a cross, may be the work of the same clockmaker, even though the powderhorn itself is datable some fifty years later. A similar powderhorn is in the Historisches Museum, Dresden (HM X 1255). N.D.

BIBLIOGRAPHY: Hans Bethe, "Neue Funde zur Kunst am Hofe der Pommerschen Herzöge," *Greifswald Stralsund Jahrbuch* (Schwerin, 1961), 167, pl. 11; Jean Louis Sponsel, *Das Grüne Gewölbe II* (Leipzig, 1928), 44, 190, pl. 20 (astronomical clock); G. H. Baillie, *Watchmakers and Clockmakers of the World* (London, 1929), 320; Johann Siebmacher, "Wappen der Deutschen Souveraine und Lande," *Grosses und allgemeines Wappenbuch I:i* (Nuremberg, 1909), 57-78, pl. 79.

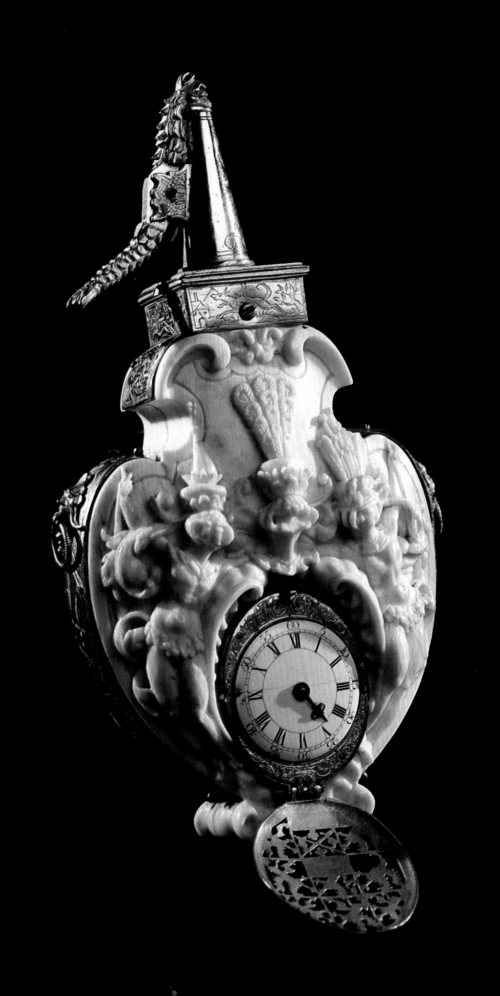

24

Silver Goblets of Gustavus Adolphus 1632

Christoph Jamnitzer, d. 1618; with Jeremias Ritter, d. 1646;
engraved by Johan Hauer

silver, partly gilt

58.2 x 23 x 23; (22⅞ x 9 x 9); 57.8 x 23 x 23 (22¼ x 9 x 9)

Royal Collections, ss 11, ss 10

Nuremberg was one of the most important cities in Germany during the Thirty Years War. Already in 1219 the Holy Roman Emperor Frederick II had issued a charter that made it a free, independent city with no political connection to any of the numerous states of Germany. Then in 1525 the Lutheran Reformation was introduced into the city. Thus when Nuremberg placed itself under the protection of Gustavus Adolphus of Sweden during the Thirty Years War, it became a powerful ally in the contest against the Catholic princes of Germany. On 31 March 1632 Gustavus Adolphus entered the city of Nuremberg at the head of the Swedish army. He was accorded every conceivable honor and presented with marvelous gifts, among them these two silver goblets.

Nuremberg in the sixteenth and seventeenth centuries was also a prominent center of the European silversmith's art, and the Jamnitzer family was perhaps the most renowned of all the dynasties of silversmiths at the time, producing seven notable masters between 1520 and 1620. The most eminent was Wenzel Jamnitzer (1508–1585), and his artistic mantle was taken up by his grandson Christoph (d. 1618). Christoph Jamnitzer, the creator of the two goblets given to Gustavus Adolphus, was an artist with a superb command of elegant, original compositions rooted in the sculptural tradition of the Italian Renaissance. Among his most famous patrons was Emperor Rudolph II.

One of the goblets in this exhibition depicts Atlas standing on an elaborately ornamented base and supporting a celestial globe with a small figure of Minerva on top. The other shows Hercules on a similarly elaborated base supporting a terrestrial globe surmounted by Fama, the goddess of fame. The top of each globe can be raised to reveal a cup for drinking.

The gift book of the city of Nuremberg for 1632 records that work on the goblets was begun by Christoph Jamnitzer and completed by Jeremias Ritter. Since Jamnitzer died in 1618, work had to have begun by that time. Johan Hauer, the engraver, signed his work in 1620. Records indicate, however, that in 1625 the goblets, still unfinished, were in the possession of Jamnitzer's widow. It was not until 31 January 1632, four-teen years after Jamnitzer's death, that the work was completed and the goblets sold to the city. The vendor, Jeremias Ritter, claims payment "for complete fabrication and perfection of the two Jamnitzer globes. . . ."

It is not clear exactly how much of the work was Ritter's, however. Perhaps he executed designs by Jamnitzer. One of Jamnitzer's sketches for the Hercules goblet is known, and we know that the goldsmith derived inspiration from designs by the Italian sculptor Andrea Sansovino. The 1632 account also tells us that the goblets were gilded at the time of their completion, just before 31 January 1632. Jeremias Ritter was elected a city councillor that same year.

The goblets had reached Stockholm by July 1632. They were not regarded as the king's personal property at that time but were added to the inventory of the Chamber of Receipts as part of the national regalia. Presumably they were used as table decorations at important royal banquets, for they were taken out of the Chamber of Receipts for the coronation of Gustav III in 1772. The globes were originally enclosed in cases, one of which, still extant, was made in Nuremberg in 1632 by Lorentz Kellner.

One of the many inscriptions on the terrestrial globe reads: AMERICA SEPTENTRIONALIS AN D 1492 A CHRISTO-PHORO COLOMBO NOMINE REGIS CASTELLE PRIMUM AB AMERIGO VESPUCCIO NOMEN ORITA ANNO DOM 1499. It has not been possible to identify the prototype of the maps on the goblets, but they are obviously modeled on older terrestrial and celestial globes with similar maps.

G.A.

BIBLIOGRAPHY: Stockholm 1930–1931; Steingräber 1969; Fogelmarck 1982; Stockholm 1966; Carl Hernmarck, *The Art of the European Silversmith 1430–1830*, vol. 1 (London, 1977); *Wentzel Jamnitzer und die Nurnberger Goldschmiedekunst 1500–1700* [exh. cat., Germanisches National Museum] (Nuremberg, 1985); Bearbeitet von Hermann Schadt and Ina Schneider, *Kaiserliches Gold und Silber* (Berlin, 1986); *Um Glauben und Reich: Kurfurst Maximilian I* [exh. cat., Ausstellung in der Residenz in München] (Munich, 1980).

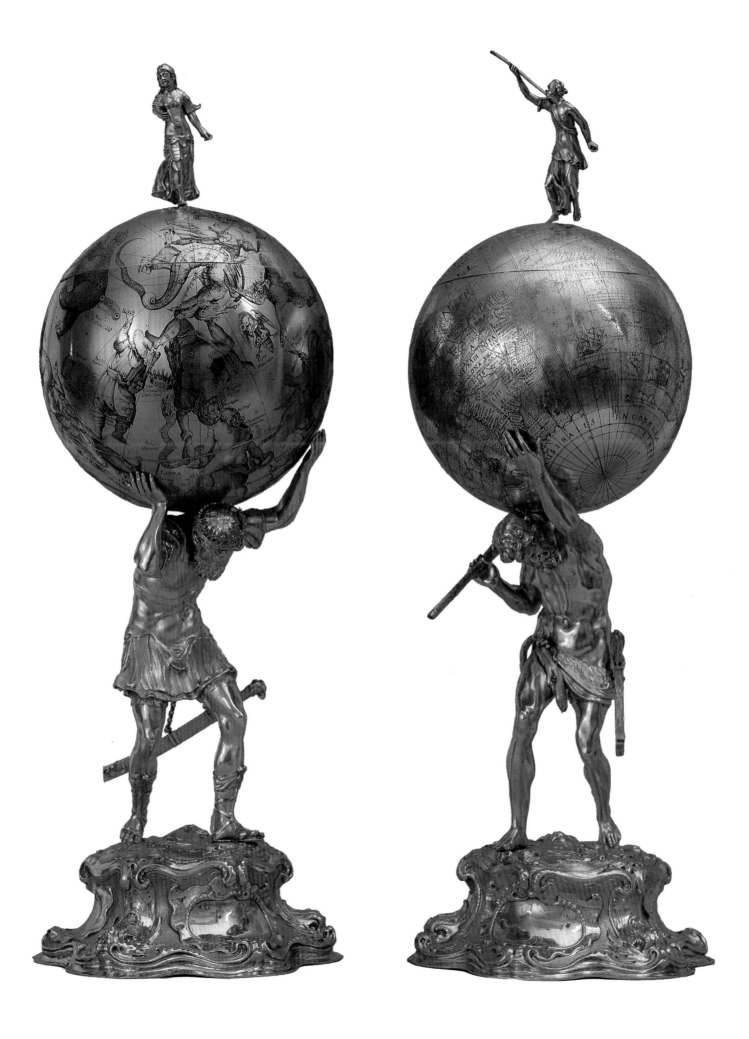

25

Gustavus Adolphus 1632

Georg Petel, 1590–1633

gilt bronze

67 x 66 (26⅜ x 26) (without socle)

signed: GEORG PETEL: AD:VIV:SCULP:1632

CHRISTOF: NEIDHARDT IN AUGSBURG GOS:MICH: 1643

Nationalmuseum, SK 353

Like the fine art cabinet now in Uppsala (see Fogelmarck fig. 4), this portrait bust was a tribute from the occupied city of Augsburg to Gustavus Adolphus. It was modeled from life between 27 May and 2 June 1632 when the Swedish king was staying in that city. Many people have been surprised to learn that the artist was from the Catholic camp. The only possible explanation is that artistic skill meant more in this case than political association, for Petel was the finest artist Augsburg could offer.

Petel, who was of the same generation as Van Dyck, Bernini, and Duquesnoy, was a leading exponent of baroque sculpture in Germany. During his short life—he was only thirty-three when he died—he produced a great number of notable works. He first studied ivory carving in Munich. His style then developed during the years he spent studying in Flanders, France, and Italy. In 1625 Petel settled in Augsburg, becoming a master there the same year. He had a large workshop with a wide-ranging output of sculptures in various materials. He produced large wooden sculpture for churches and monasteries, but he kept up his ivory carving as well. During a visit to Antwerp in 1628, he collaborated with Rubens on the famous salt cellar of the Triumph of Venus now at Stockholm's Royal Palace. He also made several bronze portrait busts, including one of Rubens, the sweeping baroque lines of which are very much influenced by the work of the great painter himself.

This bust of Gustavus Adolphus, which is one of the artist's late works, is more official in character. The king is depicted full face, wearing armor and a mantle loosely knotted over his right shoulder. The meticulous detailing of the lace collar is chased work. Three versions of the bust exist today: the original cast at the Royal Palace, the signed version in the Nationalmuseum, and a replica in Dresden. The wax model originally belonged to Otheinrich Fugger. Both the Swedish busts were originally royal property, but the Nationalmuseum version was transferred in 1865 from Drottningholm Palace, where, according to an inventory of 1744, it had stood in the upper gallery (see also Walton fig. 12). This bronze bust shows little trace of the original gilding. The front of the socle carries the Swedish national coat of arms. G.C.-B.

BIBLIOGRAPHY: O. Granberg, *Svenska Konstsamlingarnas historia Från Gustav Vasas Tid till våra dagar*, vol. 1 (Stockholm, 1929), 53, 55, 183; Karl Feuchmayer, Alfred Schädler, *Georg Petel* (Berlin 1973), 126, 127, 139, cat. 35; Alfred Schädler, *Georg Petel Barockbildhauer zu Augsburg* (Munich/Zürich, 1985), 82–83.

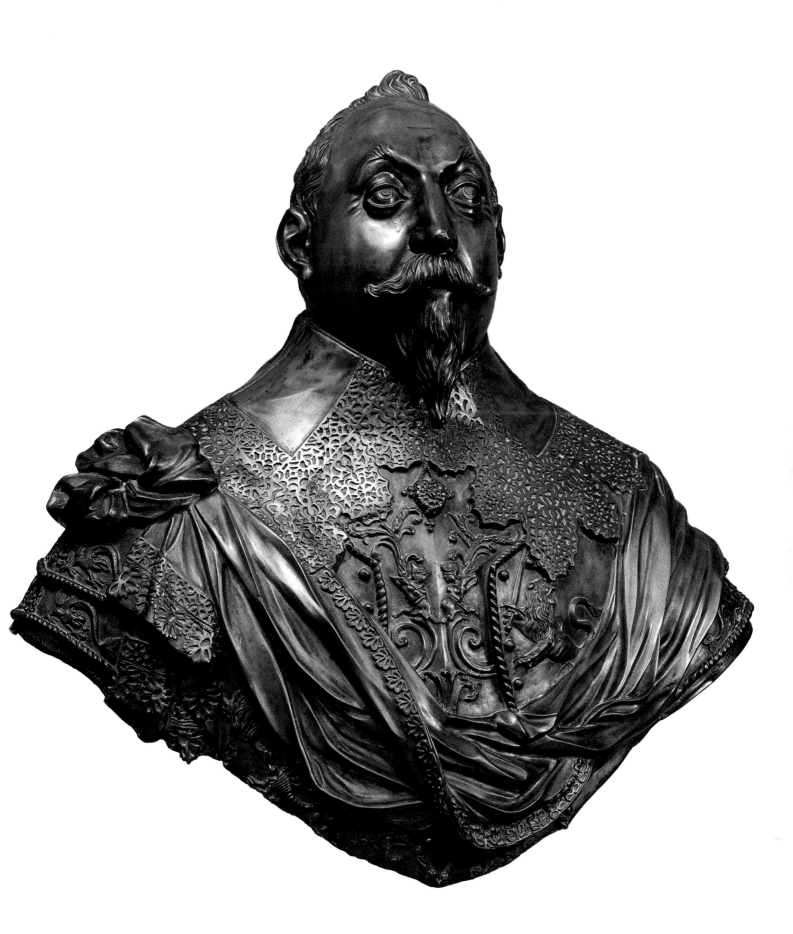

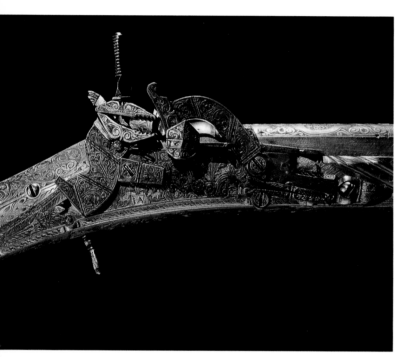

Detail, cat. 26

Axel Oxenstierna 1583–1654

WHERE STATESMANSHIP and diplomacy were concerned, seventeenth-century Sweden produced at least two non-royal personalities who achieved international renown: Magnus Gabriel De la Gardie, famous for his elegance and extravagant service to Christina, Charles X, and Charles XI; and Axel Oxenstierna, known for his intelligence in working with the dynamic Gustavus Adolphus and young Queen Christina. Oxenstierna was from a family of the high aristocracy. He received a thorough education at foreign universities and caught the attention of the rulers of Sweden at an early age. One year after the death of Charles IX, Gustavus Adolphus made Oxenstierna, eleven years his senior, the chancellor of Sweden. They made an extremely successful team, with the king as the spontaneous, hot-tempered, driving force, and Oxenstierna as the reflective, calculating, restraining element.

Oxenstierna became one of the five senior officials of state, his foremost task being to take charge of the royal chancery. He retained this appointment for forty-two years, devoting a great deal of time to the governance of the realm and to constitutional issues such as the status of the monarchy, the powers of the royal advisory council, and the procedures of the Riksdag. He was the effective ruler of Sweden during the minority of Queen Christina, when he headed a regency administration with more than a touch of nepotism: three of its five

members were Oxenstiernas, two of them brothers and the third a cousin. But Axel Oxenstierna's main achievement was in the field of foreign policy. He conducted most of the negotiations following battles waged by Gustavus Adolphus and Sweden's generals; and with his natural dignity and impressive demeanor, he was able to squeeze the utmost advantage out of Sweden's victories and minimize the concessions to be made in defeat.

It was while Oxenstierna was president of the regency council that Sweden acquired its first colony, New Sweden, on the Delaware River. When visiting Holland in 1635, Oxenstierna had broached and devised a scheme for outfitting an expedition to establish a Swedish colony in North America. He was spared knowing the unfortunate outcome of this enterprise, dying one year before the Swedes were forced to abandon New Sweden in 1655.

Oxenstierna's last years were greatly saddened by the caprice of the young Queen Christina; for a long time she preferred the mercurial Magnus Gabriel De la Gardie to stern Oxenstierna. But when De la Gardie fell from grace, Oxenstierna was restored to favor again. Oxenstierna was carried to his last resting place not long after Christina's departure from Sweden—the faithful, dedicated servant of the last rulers of the Vasa dynasty. U.G.J.

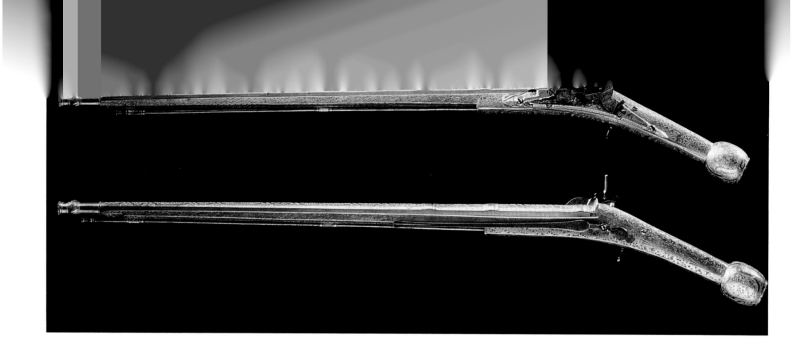

26

Pair of Snaphance Belt Pistols 1613

Scottish; attributed to John Alison (Alysoun), 1587–1613

gilt and engraved brass, with engraved steel

76 (29⅞) long, 9.4 mm caliber; 76.2 (30) long, 9.4 mm caliber

Royal Armory, LRK 4357–4358

Scottish mercenaries formed an important part of the Swedish army in the sixteenth and seventeenth centuries, and many officers of Scottish noble families—such as Forbes, Hamilton, MacDougall (Duwall in Sweden), and Montgomery—received land and titles in Sweden. These pistols, with brass stocks and lemon-shaped pommels, were probably given by one of them to the Swedish chancellor of the realm, Count Axel Oxenstierna. They are engraved with an elegant pattern of Celtic foliage framed by strapwork, and the unusually long barrels are also engraved with the Oxenstierna coat of arms and the count's initials, *AOS*. The locks are of an old Scottish type (with no half-cock), placed on the right side of one, and on the left of the other. Through the centuries, Oxenstierna's Castle Tidö has been bought and sold many times, but the armory—which included these pistols—was kept mostly intact, and in 1859 it was given to the Royal Armory.

Heer's new *Støckel* edition mentions only one John Alison. According to Hoff and Whitelaw, there were two masters by that name working in Dundee, Scotland: one listed in 1587 among master craftsmen in the minute book as a gunmaker, burgess, and guild brother; and another mentioned in 1610, when his son Alexander was apprenticed. The second John Alison was admitted freeman in 1611; the master responsible for these pistols is probably the first. N.D.

BIBLIOGRAPHY: Arne Hoff, "Scottish Pistols in Scandinavian Collections," *Journal of the Arms and Armour Society* 1, no. 12 (London, 1953–1955), 199–214, pl. 32; Torsten Lenk, "Vasarna och eldvapnen," *Historiska bilder* 1: 420 (plate); C. E. Whitelaw, *Scottish Arms Makers* (London, 1977), 48–49; Heer 1978, 12 (John Alison erwähnt 1587–1600); David H. Caldwell, *Scottish Weapons and Fortifications 1100–1800* (Edinburg, 1981), 334 (on Alison).

27

Rapier 1610–1620

French
steel
98.5 x 20.3 (38¾ x 8); blade, 96.3 x 2.9 (37⅞ x 1⅛)
Royal Armory, LRK 18860

This rapier, like the Scottish pistols in catalogue 26, belonged to Axel Oxenstierna and was given to the Royal Armory in 1859 with the armory from Castle Tidö. The hilt is of steel, chiseled in high relief, and the large pommel, long straight quillons, knuckle-bow, and loops of the guard are all decorated with scenes of cavalry fighting. On one side of the blade is an inscription that reads COMBATRE EN FOY.

During the Renaissance and baroque periods the rapier hilt developed an elaborate system of guards to protect the fencer's hand. Sophisticated and elegant hilts of this kind were widespread during the early decades of

the seventeenth century and made their way from Italy across France and Germany to Sweden. A rapier signed by the Munich master Daniel Sadeler and another signed by Frederico Piccinino, the latter presented by Duke Carl Emanual of Savoy to the elector Christian II of Saxony in 1605, are both now in the Historisches Museum, Dresden. Another rapier in the collections of the Swedish Royal Armory is signed Heinrich Pather, Solingen (inv. no. 5669). L.N.

BIBLIOGRAPHY: Seitz 1968, 2:62–64, fig. 59, pl. 3; Nordström 1984, 48–49, no. 48.

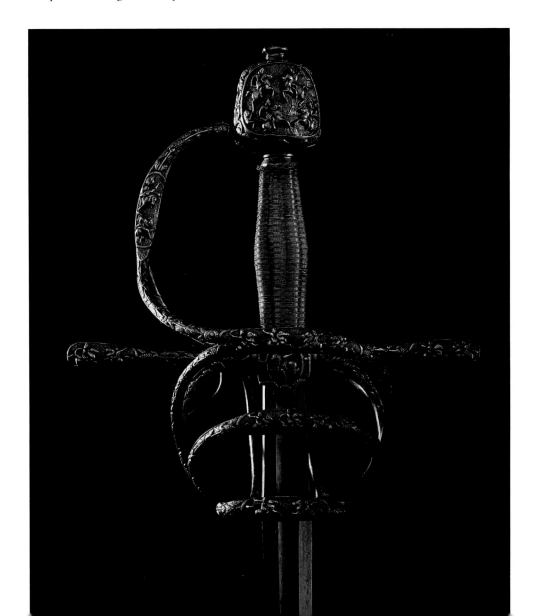

Christina 1626–1689

TOWARD THE END of her life, Queen Christina began writing an autobiography that was never completed. In it she had difficulty condemning Protestantism while praising her father, Gustavus Adolphus, who had in his day been the greatest opponent of Catholicism in Europe. She resolved the dilemma by arguing that in this one respect her otherwise faultless father had been misguided.

When Gustavus Adolphus died in battle against the troops of the Catholic emperor in 1632, Christina, his only child by Maria Eleonora, was not yet six years old. About four months later, in February 1633, the Riksdag paid her homage as queen of Sweden, and appointed a regency administration for the duration of her childhood. Gradually it was realized that her upbringing could not be entrusted to the inconsolable dowager queen, so this duty was assumed by Christina's paternal aunt, Katarina. As a result, Christina grew up with her somewhat older cousin Charles Gustav, who eventually succeeded her on the throne of Sweden.

Christina was an outstandingly gifted, intelligent, and willful child, and these qualities became all the more apparent after she had been declared of age at eighteen and assumed the powers of government. Everyone expected her to marry her cousin Charles, and there was

great consternation when she declared that she intended never to marry at all. But there were more surprises in store. She took issue with the chancellor of the realm, the increasingly patriarchal Axel Oxenstierna, concerning the management of Sweden's affairs, and she began hinting more and more loudly that she was contemplating abdication. All efforts of persuasion by her Council were in vain. In 1654 she abdicated the throne to her cousin Charles Gustav, who had been made heir apparent four years earlier. Most people were aghast when she converted to Catholicism the following year, abandoning the faith of her father.

Christina's actions were based on very clear conviction, however. She was extremely well versed in contemporary ideas concerning morals, religion, and philosophy. In fact, the greatest and most controversial thinker of the day, René Descartes, came to Stockholm in 1649 at her invitation. Unfortunately, the warmth of her reception and the intensity of their talks did not prevent him from catching a chill in the poorly heated palace apartments, and he died of pneumonia only a couple of months after arriving. A number of Jesuits also visited Christina secretly at her invitation, to teach her to be a true follower of Christ.

On leaving Sweden, Christina made no secret about taking with her great numbers of books and works of art from the loot captured for Sweden by her generals in the Thirty Years War, especially the fabulous treasures taken at the storming of Prague in 1648. This failure to distinguish between national and personal property was a habit she shared with other monarchs. Curiously enough, despite her abdication, Christina continued to regard herself as queen, and she maintained hopes of staging a comeback in Sweden. Following the death of Charles X, she traveled all the way to Sweden to attend his funeral, and thought of trying to turn the situation to her advantage by challenging the succession of the young Charles XI. But the Swedes were upset when she had the Catholic Mass celebrated ostentatiously in her rooms at Stockholm's royal castle. Deputations of high officials of state and clergy called on her to protest the enormity of sullying Sweden's Lutheran orthodoxy with such heretical practices. Christina spent the last twenty years of her life in Rome and was buried in St. Peter's, where her resting place is marked by an epitaph bearing her portrait. U.G.J.

28

Christina after 1653

Pierre Signac, 1623–1684

enamel; contemporary frame of gold, enamel, and brilliant diamonds

5.7 x 4.5 (2¼ x 1¾)

Nationalmuseum, NMB 2316

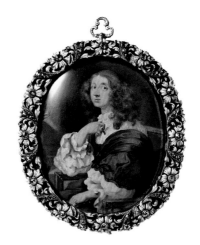

Count Magnus Gabriel De la Gardie, ambassador to Paris in 1646, was responsible for bringing a number of French artists to the Swedish court, among them the enamelist and miniaturist Pierre Signac. During his embassy to Paris, the count had been greatly impressed by the fashions prevailing at the French court. His interest was also captured by minor details of courtly culture, such as personal jewelry. When he noticed that people were wearing small enameled watches and portrait medallions, he recruited Signac as a court painter with the express purpose of establishing this practice in Sweden.

Little is known about Signac's previous activities in France. He was presumably a pupil of the famous enamelist Jean Toutin, whose workshop was the first to combine enameling with an established tradition of goldsmithing and watchmaking. Signac's masterpiece is the enameled watch De la Gardie ordered in Paris as a New Year's present for Queen Christina in 1646 (cat. 33).

Signac, who used both gouache and enamel, produced quite a number of portraits of Christina in the seven years during which he served as her court miniaturist. Most of our knowledge of these portraits is derived from the memorandum of unpaid work he submitted to the Chamber of Receipts in 1660. There he states that he had produced thirty-four enamel portraits of the queen, comprising twenty-five of ordinary size and nine larger ones. Many portraits were painted from life, while others revert to portrait types of David Beck and Sebastien Bourdon. The large enamel portrait recently acquired by Nationalmuseum is most immediately related to Bourdon's waist-length painting of Christina in the Prado.

Signac's portraits of the queen were often set in costly portrait medallions and many of them were presented to foreign envoys and other guests at court. This portrait, acquired through the British art trade, may have been a gift to some high-ranking English guest. G.C.-B.

BIBLIOGRAPHY: *Swedish Portrait Archive*, Index 3 (Stockholm, 1943), 245; Cavalli-Björkman 1972, 88, cat. 5; Cavalli-Björkman 1982, 33.

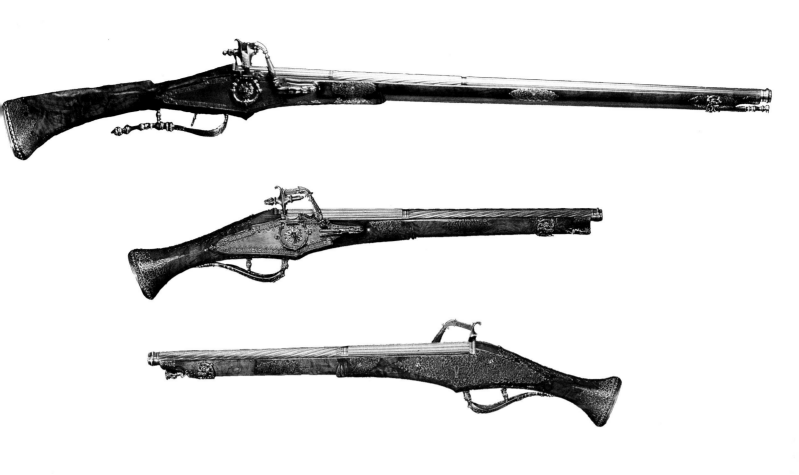

29

Garniture of Wheel-Lock Carbine and Pair of Wheel-Lock Holster Pistols 1638

Italian; barrels signed *Lazarino Cominazzo*, probably Angelo Lazarino Cominazzo, 1563–1646; locks by Giovanni Antonio Gavacciolo, c. 1635–c. 1650; pierced steel inlays on carbine by Giacinto Secardo; steel chiseling and steel inlays on pistols by Antonio and Carlo Francesco Gosi

chiseled and engraved steel, with walnut

carbine, 112.1 (44⅛) long, 15.9 mm caliber; pistols, 56.5 (22¼) long, 15.2 mm caliber; 56.6 (22¼) long, 15.2 mm caliber

Royal Armory LRK 4243–4245

This garniture of firearms was ordered by the senate of Venice on 30 September 1638 and sent from Brescia on 27 April 1639 as a gift to King Louis XIII of France. It exemplifies the highest aesthetic ideals of seventeenth-century Italian gunmaking, using only primary materials of steel and wood in their natural colors.

The provenance of the gift reflects the turmoil in northern Italy in the 1630s. Duke Vicenzo Gonzaga of Mantua died in 1628 without heir, and one pretender with Franco-Venetian backing was Prince Charles of Nevers-Gonzaga. When Charles died in 1637, he left his son Charles under the protection of France and Venice. But in July 1638 the French ambassador suddenly left Mantua, and the Venetian ambassador in Paris was instructed to discuss the matter with the French king. In a letter dated 31 August 1638, he told the Venetian senate about the audience and reported that the king—nicknamed "Louis l'Arquebusier" for his love of firearms—had mentioned a new type of wheel-lock in which the spring was tightened without a key.

The senate ordered two guns and a pair of pistols in Brescia to be made with all possible speed, but not until thirteen months after the French king had expressed his wish was the garniture of arms solemnly presented to him. The weapons were much admired, and the king is reported to have said "all my guns together are not worth one of these."

These guns are cock-spanned, that is, they have an inside mechanism connecting the cock with a pivoted quadrant and gear-rack running along the wheel axis made as a four-toothed cog-wheel. The gear-rack is linked to the mainspring, which is compressed by pull-

121

ing the cock upward and forward. The barrels of these guns are thin smoothbore with chambers of eight facets, the forward part spirally turned. The stocks are made of walnut root, with finely chiseled mounts and pierced steel inlays called "iron lace." The wheel-locks have lockplates with engraved borders and chiseled cocks and wheelcovers. The ornament includes the crown of Louis XIII, his personal monogram *L* and crowned shields with the French three lilies and the chain of Navarre, surrounded by the chain of the Order of St. Michael. The chiseling on the butt plate of the carbine is of poorer quality than that on the pommels of the pistols and is possibly a later replacement.

This garniture of firearms was probably given to Queen Christina of Sweden after the death of Louis XIII in 1643 by the dowager queen, Anne of Austria, or by Cardinal Mazarin. France was anxious to prevent the Swedish queen from negotiating a separate peace with the Holy Roman Emperor in the Thirty Years War, and this was perhaps the reason for the gift. We do not know if the gift sent to Sweden included both of the carbines, but at least one was probably sent, for this one may be presumed to have remained in Sweden and come back to the Royal Armory in 1859 from the collection of Baron Ernst Magnus von Willebrand (1812–1859). N.D.

BIBLIOGRAPHY: Hoff 1969, 68, pl. 130; Hayward 1962, 29, pl. 36c; Torsten Lenk, "Ett internationellt hjullåskriterium," *Livrustkammaren* 4 (1946), 3–13, pl. 1; Agostino Gaibi, *Le armi da fuoco portatili italiane* (Milan, 1962), pl. 36b; Agostino Gaibi, "Recherches biographiques sur les Cominazzi," *Våbenhistoriske Årbøger* 11a (Copenhagen, 1962), 18–23; Marco Morin, "And the King said—All my guns together are not worth one of these," in Held 1979, 1:252–277; Heer 1978, 233–236 (Cominazzo), 424, mark no. 427 (Gavacciolo).

30

Ivory Tankard 1625–1650

German; silver mount by PHD (unidentified)

ivory and partly gilt silver

34 (13⅜) high

Royal Collections, ss 145

Ivory tankards carved in high, often dramatic relief were fashionable royal status symbols in Europe at this time. In fact, ivory objects of all kinds were a substantial part of any royal collection in the seventeenth century. About a fifth of the works in the Swedish Treasury collection today are of ivory, which conveys an idea of its importance.

Ivory as a material was exclusive in itself, and so highly valued that it was frequently used as a manifestation of political power or to mark an important event. The throne of the kings of Denmark at Rosenborg Castle in Copenhagen is made of ivory, as is the speaker's chair in the House of Nobles (Riddarhuset) in Stockholm. Apparently the connection between material and power also applied to smaller objects. Ivory goblets decorated with relief carvings of the martial exploits of kings and princes were not uncommon, and in the seventeenth century it was fashionable for royal personages themselves to shape ivory objects at the lathe. There are several such specimens in the Swedish collection.

Inventories from the reign of Queen Christina mention her ivory collection and the tankards she gave Count Magnus Gabriel De la Gardie. Unfortunately, these descriptions are so abbreviated that they do not allow the identification of pieces now in the Royal Collections. Christina also purchased parts of the ivory collection of Peter Paul Rubens, but only a well-known salt cellar (Royal Collections, ss 143) has been identified.

It is not known for sure where the ivory was carved for the tankard in this exhibition, but the silver mounts were made and stamped in Augsburg. The tankard's relief depicts Apollo playing the cithara in the company of an "orchestra" of muses. The lid is surmounted by a group of putti as musicians. G.A.

BIBLIOGRAPHY: Stockholm 1930–1931; Steingräber 1969; Fogelmarck 1982; Karl Feuchtmayr and Alfred Schädler, *Georg Petel* (Berlin, 1973).

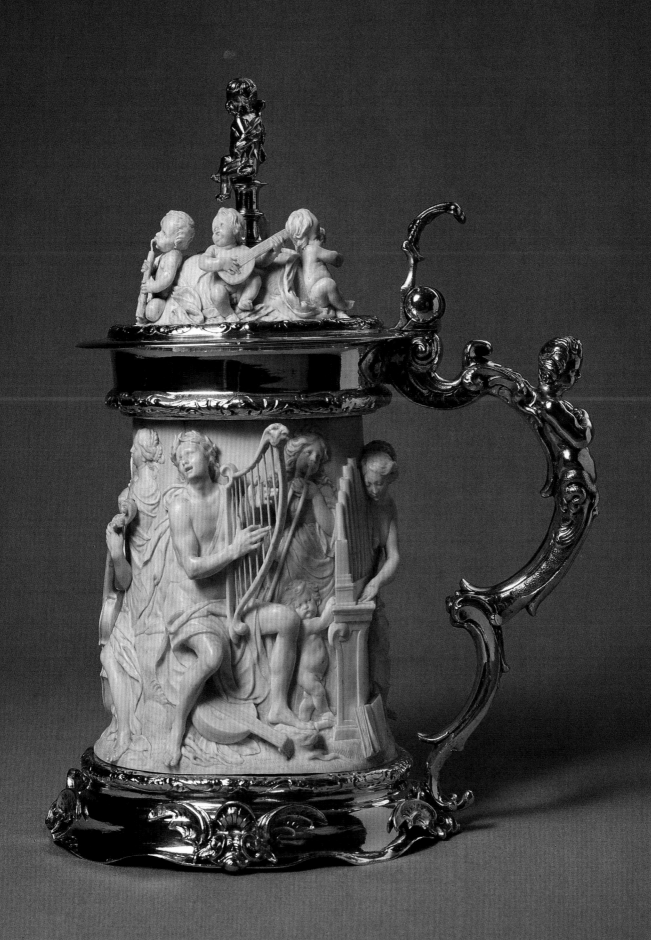

31
Ivory Tankard c. 1650

German; silver mount by Johannes I. Mayr
ivory and partly gilt silver
40.7 (16) high
inscribed: *I.M.* and stamped with the pine cone of Augsburg
Royal Collections, ss 146

This ivory tankard is taken to be an allegory of the Peace of Westphalia of 1648, which concluded the Thirty Years War. The figural composition shows the triumph of Mercury, god of commerce, over Mars, god of war, with Minerva, the goddess of wisdom, on top of the lid, conferring the laurel wreath of victory.

Though Gustavus Adolphus had been responsible for bringing Sweden into this great European war, and his able minister Axel Oxenstierna had guided Sweden during its most important years, the end of the war came during the reign of Christina. She is said to have prolonged fighting in order to capture the treasures of Prague. But she wished to be considered a queen of peace and agreed to delay her coronation until after a treaty was concluded. Thus the subject on the tankard would have been highly appropriate for her collection if it does represent the Peace of Westphalia. Minerva on the cover could well be a reference to Christina, whose intellectual interests were famous throughout Europe. G.A.

BIBLIOGRAPHY: Stockholm 1930–1931; Steingräber 1969; Fogelmarck 1982.

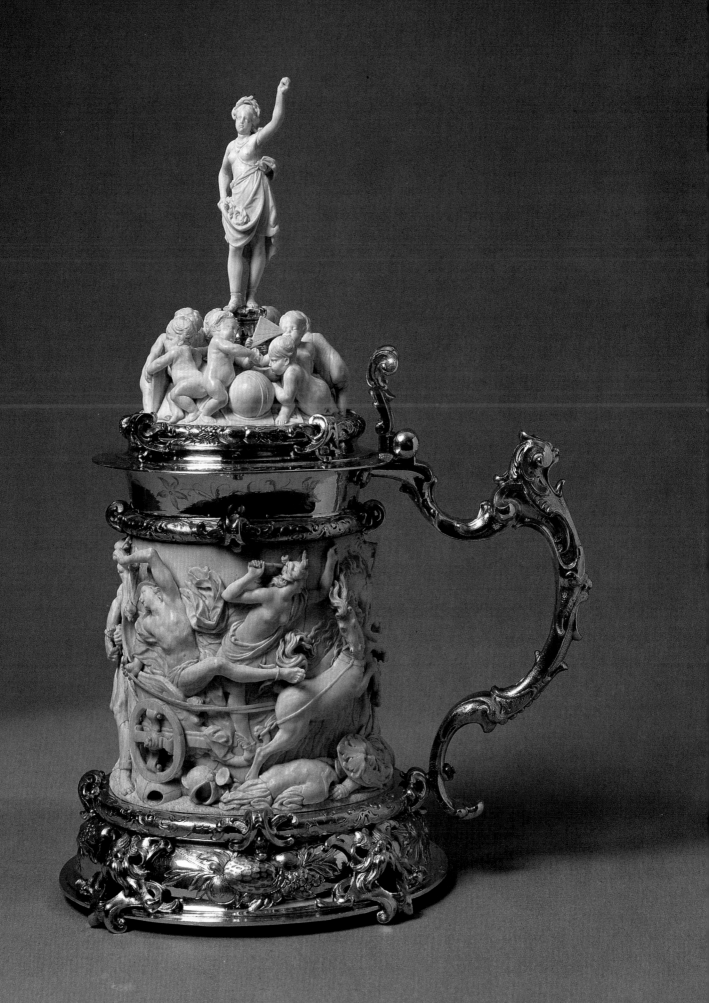

Magnus Gabriel De la Gardie 1622–1686

COUNT MAGNUS GABRIEL DE LA GARDIE was one of the most remarkable figures in seventeenth-century Sweden. He fascinates us today not only by virtue of the tremendous power he wielded during his lifetime but also because of the more human aspects of his career—dramatic reversals between fortune and misfortune, great wealth and poverty—and the final collapse of a carefully constructed way of life.

The education that De la Gardie acquired at foreign universities and the manners that he learned from elite circles in Paris dazzled his unschooled, less-traveled compatriots in Sweden and, more important, secured for this handsome, witty, and well-dressed young count a grand career in the court of Queen Christina. For a number of years he was her special favorite, and she showered him with gifts of all kinds and with one military and civilian appointment after another: colonel, general, field marshal, privy councillor, constable of the realm, lord high treasurer. De la Gardie in turn delighted Christina with carefully chosen gifts—which she made sure he was paid for—and by organizing magnificent festivities in her honor. Needless to say, De la Gardie acquired many rivals and detractors, and it was court intrigue that ultimately felled him. A false accusa-

tion he thoughtlessly uttered prompted the queen to swear never to let "that liar" into her sight again, and she was as good as her word.

After Christina left Sweden following her abdication in 1654, De la Gardie was restored to grace by King Charles X, who was, for good measure, his brother-in-law. And after the death of Charles X in 1660, during the minority of Charles XI, De la Gardie became de facto leader of the country, serving throughout the 1660s and 1670s as what we could call prime minister and foreign minister combined. Upon Charles XI's coming of age and assuming the powers of government, De la Gardie's enemies made sure that his administration was rigorously audited. He was found guilty of mismanagement and deprived of all his important offices, and most of his estates were resumed by the crown. He spent his remaining years on the one estate left to him, seeking comfort in religion and pondering the truth of an exclamation from a spectator who had shouted, when De la Gardie as a young man had taken the part of Apollo in a ballet at the court of Christina: "Non semper ridet Apollo!" (Apollo cannot always be joyful). U.G.J.

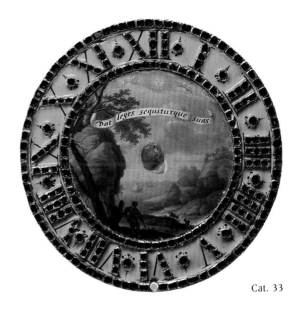

Cat. 33

32

Magnus Gabriel De la Gardie c. 1645

Alexander Cooper, 1605–1660?

miniature on parchment in gold locket

6 x 4.2 (2⅜ x 1⅝)

engraved: *Effigies Magns Gab Delagardie Reg Cancell J. Senat. Cuper pinxit*

Nationalmuseum, NMB 2235

Portraits of Count Magnus Gabriel De la Gardie as a young man are very rare. This one was probably painted in Holland, where De la Gardie studied in the early 1640s. He befriended many artists during his stay there, among them Alexander Cooper. As a result of their meeting, Cooper was summoned to the Swedish court in 1647.

Little is known of Cooper's earlier activities. He was born in London around 1605, four years earlier than his brother Samuel, and both were brought up by their uncle, John Hoskins, who probably taught them to paint in miniature. The next reference to Alexander identifies him as court painter to the Dutch royal family in The Hague. His name can then be followed in the Swedish court accounts from 1647 until 1657.

Alexander Cooper worked simultaneously in two different styles throughout his life. One is very refined and precise, with minute brushwork. The other is broader, as in the De la Gardie portrait exhibited here, where light and shadow play an important part in molding the face. Here the artist is noticeably influenced by his brother Samuel. The two can be said to have introduced Dutch realism into English miniature painting.

This portrait was probably a present from De la Gardie to Queen Christina, like the costly enamel watch by Signac shown in catalogue 33. G.C.-B.

BIBLIOGRAPHY: K. Asplund, "Den svenska porträttminiatyrens historia," *Konsthistoriska Sällskapets publikation* (Stockholm, 1916), 58; Cavalli-Björkman 1972, 122, cat. 57; Cavalli-Björkman 1981, 20–22; Görel Cavalli-Björkman, "Alexander Cooper in the Nationalmuseum," *Nationalmuseum Bulletin* 1, no. 3 (1977), 114–120.

33

Queen Christina's Watchcase 1646

attributed to Pierre Signac, 1623–1684

gold, enamel, originally encrusted with 575 diamonds

8.4 (3¼) diam.

Royal Collections, ss 244

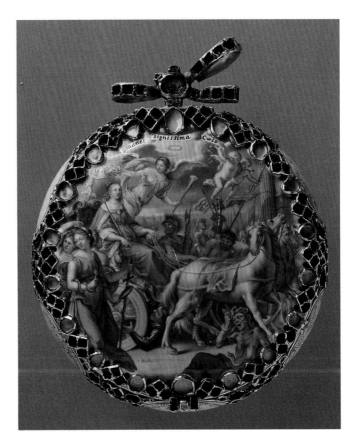

In 1646, while he was Swedish ambassador to Paris, Count Magnus Gabriel De la Gardie commissioned a decorated watch as a present for Queen Christina. In a letter of September 1646 to his fiancée Maria Eufrosyne, a cousin of the queen's, the count wrote: "The watch I am having made for Her Majesty is more than rare, and I trust it will be welcome." It was De la Gardie who procured the services of the French enamelist and miniature painter Pierre Signac for Sweden in 1646, and this watch is attributed to Signac both for definite stylistic reasons and on account of the relationship between Signac and the count.

The watchcase is decorated with five enamel paintings: two on the outside, two on the inside, and a fifth on the dial. These five paintings form a political apotheosis, a tribute to the reigning queen of a great power—Sweden. Much of the pictorial language can be related to the ballets of the court of Queen Christina, performed so frequently that a special ballet room was eventually furnished in the east wing of Stockholm's Three Crowns Castle (see plan, Walton fig. 8). Danced by members of the court, the ballets were created to an accompaniment provided by Italian musicians. De la Gardie was one of the courtiers who helped produce them.

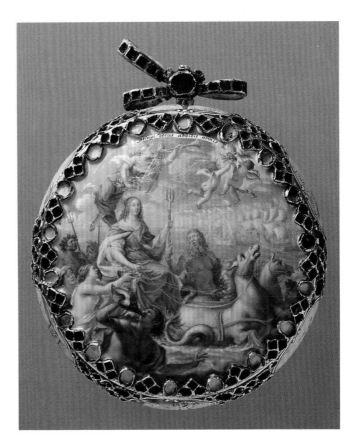

The symbolic language of the court ballets was often highly topical, alluding, for example, to Queen Christina's role as defender of the political and human values guaranteed by the Protestant states. A number of librettos for these ballets survive, but Signac's decorative watch represents the first known use of such themes in pictorial art. The "libretto" for the watchcase was probably composed by De la Gardie, as a court dignitary with a firsthand knowledge of the court ballets and their programs. The outside of the watchcase depicts the triumphs of Queen Christina by land and sea, which should be interpreted as Christina Victorious and Christina the Peacemaker.

On the front of the watchcase the queen holds the orb and scepter—symbols of the realm—and is seated in a triumphal carriage drawn by white horses. The nation's enemies are crushed beneath the coach, and the queen is surrounded by three of the cardinal virtues: Fortitudo, Justitia, and Prudentia. In front of the carriage can be seen an embittered Individia, and in the

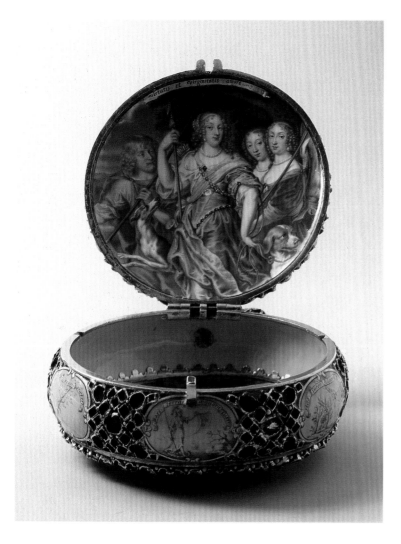

background, Bellona in a triumphal procession. Above the queen is Fama, the goddess of fame, holding a laurel wreath. The scene is topped with the device MANET DIGNISSIMA CAELO: "the worthiest crown awaits in heaven."

On the back—the triumph at sea—the queen is again borne in a coach, drawn this time by white seahorses. Neptune surrounded by maritime deities presents the queen with his trident, with the Swedish and Danish fleets in the background. Fama, with a laurel wreath, broadcasts Christina's reputation as a peacemaker throughout the world, and the device of this motif reads PELAGI DECUS ADDIDIT ARMIS: "The god of the seas surrenders his weapons." The maritime triumph depicted here alludes to the Battle of Femern in 1644, in which the Danish navy was defeated by the combined naval forces of Sweden and Holland. This battle was part of the war waged by Sweden against Denmark in 1643. The *casus belli* was a series of moves by King Christian IV of Denmark to thwart Sweden's expansion around the Baltic. Denmark was the last major obstacle to the conversion of the Baltic into a Swedish lake.

Inside the lid Christina is depicted as Diana with a spear and hounds. She is receiving the tribute of a young huntsman and two ladies. The device reads VIRTUTIS ET VIRGINITATIS AMORE: "For love of virtue and virginity." This scene is described in the 1655 inventory of Maria Eufrosyne De le Gardie's jewelry: "Inside the lid, a portrait of Queen Christina as Diana, with His Excellency Magnus Gabriel De la Gardie, Her Royal Highness Maria Eufrosyne De la Gardie, and Her Royal Highness's sister the Landgravin as shepherds." Inside the watchcase on the other side, wild animals and birds of prey are suspended from an oak tree in an autumn landscape, with the device HAEC DE SPOIIS CHRISTINA NOCENTUM: "These marauding beasts [trophies of victory] Christina took from the enemy." The watch dial

shows a pastoral landscape and a shepherd, with the sun shining in the sign of the zodiac between Leo and Libra. The device reads DAT LEGES SEQUITURQUE SUAS: "Make the laws and follow them yourself."

The edge of the watchcase is set with six medallions displaying the emblems: 1) TE SEQUAR, "I shall follow you," or "May I follow you"; 2) HAS INTER FULIMA TEMNO, "Between these I have no fear of the lightning"; 3) POST TERRAS AEQUDRA LUSTRO, "After the lands I will take command of the seas"; 4) ET BELLUM ET FOEDERA PRAEFERT, "It [the hand] proffers both war and peace"; 5) NISU ET VISU, "Striving upwards [toward the sun] and in the sight [of the sun]"; and 6) TIBI SOLI, "To Thee alone," or "To Thee the sun."

This watch shows that the court of Queen Christina was determined to leave its mark as a leading center of European politics and culture. It is remarkable in more than just an artistic sense. There is a curious antithesis between this tiny watch and the political apotheosis of the paintings. The watch is a private, intimate article and at the same time a grandiloquent vision of the political ambitions of kingdom and monarch. Evidently, this exquisite gift to the queen from the powerful De la Gardie was intended to bring to mind the aspirations of Sweden, the parvenu great power, to dominate the Continent of Europe in war and peace. It is a unique icon of Sweden's imperial period.

After her abdication in 1654, while traveling to Rome, the queen sent the watch to her cousin, Maria Eufrosyne De la Gardie, as a memento. G.A.

BIBLIOGRAPHY: Stockholm 1930-1931; Stockholm 1966; Magnus von Platen, ed., *Queen Christina of Sweden: Documents and Studies* (Stockholm, 1966); Steingräber 1969; Cavalli-Björkman 1972; Fogelmarck 1982; Birgitta Sandström, in Lindgren, et al., *A History of Swedish Art* (Stockholm, 1987), 124, 130 (fig.).

The Coronation of Queen Christina 1650

Detail, cat. 34

CHRISTINA BEGAN HER majority rule in 1644, at the age of eighteen, but her youth and the question of her marriage caused a lengthy delay in the planning of her coronation. When she was very young, it was presumed by her ministers that her function as queen would be primarily to assure the continuation of the Vasa dynasty. She was the only legitimate offspring of Gustavus Adolphus, and it was hoped that she would marry and her husband would then rule. Christina chose not to marry, however, and it was not until 1647 that the royal council decided to proceed with planning the coronation.

Two early commissions of art works indicate that the aim of the planners was the enlargement and enrichment of the coronation of the queen's father, to demonstrate the new status of Sweden as an important European power following the long string of Swedish military victories in Germany and around the Baltic. The royal tapestry collection (which already contained about 150 major hangings) was to be expanded to allow for the decoration of castle rooms, the interior of the cathedral, and possibly the house facades along the route of the coronation procession. Pieter Spiering, the Swedish minister at The Hague, who was a member of a family of famous tapestry weavers, received an order for forty-six new works (Gustavus Adolphus had com-

missioned tapestries from the same firm for his coronation). And the queen commissioned thirty-four paintings from Jacob Jordaens of Antwerp depicting the story of Cupid and Psyche. These were to decorate the ceiling of the Throne Room of Uppsala Castle, the proposed site of the coronation banquet. The pictures were eventually installed in the library of Stockholm's Three Crowns Castle, where they burned in 1697.

Magnus Gabriel De la Gardie, the husband since 1647 of Princess Maria Eufrosyne, a cousin of the queen, was Christina's favorite at this time. He lavished great gifts and attentions on her, making her coronation the most extravagant Swedish royal ceremony of the century. Among his presents was the spectacular silver throne commissioned from Abraham Drentwett of Augsburg, made of repoussé silver over a wooden frame and surmounted by two silver female allegorical figures—Justice with a sword and Prudence with a mirror (Fogelmarck fig. 5). De la Gardie provided additional Augsburg silver in the form of candlesticks and a crucifix for the altar signed by Andreas Hamburger. He was also instrumental in the negotiations with France for clothes and a number of new coaches for the coronation procession.

Christina wished to be thought of as the queen of peace, responsible for the resolution of the conflicts that had brought triumph and fame to her country. To this end, she was willing to delay the coronation ceremony until the treaties of Westphalia were signed. The political message she intended to convey was expanded further at the last minute, when in June 1650, after a long struggle, Christina succeeded in obtaining the nomination of her cousin Charles Gustav as hereditary heir to the Swedish throne. This allowed her to remain unmarried. Just seventeen days before the ceremonies the queen reminded her council that special attire was necessary for an heir apparent. Charles Gustav cut a magnificent figure at the ceremonies, and a splendid livery, including a caparison embroidered in gold, was used for his horse (cat. 35).

The coronation party became so large and elaborate that the queen eventually decided to move it from Uppsala to the Storkyrkan in Stockholm. The principal events included a triumphal entry of the queen into Stockholm and a procession from the castle to the Storkyrkan, where Christina wore the crown her mother had worn in 1620 (cat. 1). A coronation banquet was held in the castle's state chamber, and many festivities for the court took place over several days. A stuffed, roasted ox filled with turkeys, geese, and chickens was offered to the people in the market square (Stortorget).

G.W.

34

Embroidered Textiles from Queen Christina's Coronation Coach 1650

French; coach assembled in Stockholm by Royal Stables tailor Hans Frisell and French coachmaker Simon Maveil

carmine velvet with embroidery in gold, silver, and colored silk; fringe and tassels of gold and silver

84 x 120 (33 x 47¼); 84 x 121 (33 x 47⅝)

Royal Armory, 751a,b

door panels shown in Washington, D.C.; reconstruction of coach shown in Minneapolis only

Christina's coronation coach was one of the most remarkable objects of Swedish ceremonial history and can justifiably be said to epitomize the baroque splendor of the coronations that took place during the century in which Sweden rose to great power. The coach was extravagantly upholstered with an "imperial" (slightly arched roof cover), two door curtains, four side curtains, a front and a rear curtain, and cushions for two vis-à-vis seats and the floor. All were made of rich carmine velvet or carmine ribbed silk and were decorated with ornate appliqué embroidery in gold and silver depicting trophy groups surrounded by laurel twigs and palm leaves. The importance of the textiles adorning Christina's coronation coach was heightened by their abundance and by the lavishness of their decoration, which identified the coach as royal, even without the national coat of arms or the queen's monogram.

In addition to the extant textile fittings for the carriage, there survive costly trappings for a team of six horses, including caparisons to match the upholstery of the coach; harnesses, bridles, and reins of plaited gold, silver, and silken thread; as well as a postilion's saddle and stirrups. The chassis of the coach, made of carved and gilded wood, was lost in the eighteenth century.

For the coronation of Christina in 1650, which was one of the most notable and expensive coronations in Swedish history, two fully equipped coaches were made. The more splendid of the two is represented in this exhibition and was given to the queen by Charles Gustav, the heir apparent. Known as the Trophy Carriage after the patterning of its embroideries, this was the first in a succession of magnificent coaches ordered from Paris by Swedish monarchs. It was also the last coach of open form, with "aprons" to cover the door openings (fig. 34a). Only two other coaches from the same period are now extant, one in the Kremlin and one in Lisbon, but they are plainer examples and were not intended for use in royal processions.

Christina made a state entry—entré solenne—into the capital three days before her coronation, riding from Jacobsdal in the Trophy Carriage. Everyone of rank and importance took part. We are told the procession was so long that the vanguard had almost reached the palace 6 miles away before the end had left Jacobsdal. An exotic touch was lent to the proceedings by the inclusion of mules and camels.

On the day of the coronation, 20 October 1650, the weather was unusually fine as the queen traveled by coach to the Storkyrkan. The coach was drawn by six white horses, driven by a coachman with a postilion on the left lead horse. The equipage was surrounded by a guard of sixty halberdiers. Behind the carriage came the coronation canopy, followed by Magnus Gabriel De la Gardie on horseback carrying the banner of the realm,

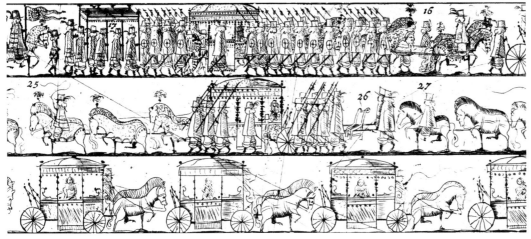

34a. Coronation procession of Queen Christina, engraved by J. Sass, 1650, courtesy Royal Library, Stockholm

134

and then by the queen's white coronation horse in its exquisite French coronation caparison, led by the reins and wearing an empty sidesaddle. The hooves of this horse were shod with silver. Charles Gustav, dressed in the garb of heir apparent, rode on a golden courser given him by Christina (cat. 35). In the procession following the coronation ceremony, Christina—wearing her royal robes and carrying the regalia—took a seat in a silver triumphal carriage drawn by a quadriga of four white horses harnessed abreast. These horses too were shod with silver.

On her abdication in 1654, Christina returned the coach to her cousin, now Charles X. But by the time of the coronation of Charles XI in 1675, it was considered old-fashioned, and a new coach was ordered from France, with glazed windows and panel doors more in keeping with the climate of northern Europe. Christina's coach and its accessories continued to be cared for, and the costly textile fittings were stored in the Royal Ar-

mory. The coach escaped destruction in the fire that swept through the Royal Stables in 1696; it was in Uppsala at the time. It also survived the Uppsala fire of 1702, after which it was returned to Stockholm. It can be traced in inventories until the second decade of the eighteenth century, but after that its fate is unknown.

The Royal Armory has reconstructed the coach chassis to display the entire ensemble of decorative textiles during the showing of this exhibition at the Minneapolis Institute of Arts, and has outfitted models of a team of six white horses as well. A.T.-J.

BIBLIOGRAPHY: Stockholm 1966, no. 332; Tydén-Jordan 1984, 12; Tydén-Jordan 1985, 28ff, 171f; *Historiska bilder*, vol. 2; Johann Christian Lüning, *Theatrum ceremoniale historico-politicum*, vols. 1–2 (Leipzig, 1719–1720); Elise Adelsköld, "Christina Regina," in *Historiska bilder*, 2:11ff; Gudrun Ekstrand, "Three Coaches of the Christina Era," *Livrustkammaren* 10 (1966), 11 (English summary); The Royal Armory, accounts and inventories from 1655, 1671, 1683, 1696, 1821, 1855, 1867.

35

Heir Apparent's Caparison and Saddle 1650

French

velvet; embroidery and fringe of gold and silver; pommel of gilt bronze

caparison, 117 x 235 (46 x 92½); saddle and pistol holsters, 56 (22) long; pommel cover, 34 x 40 (13⅜ x 15¾)

Royal Armory, 3877, 9037, 9038-9039, 9040

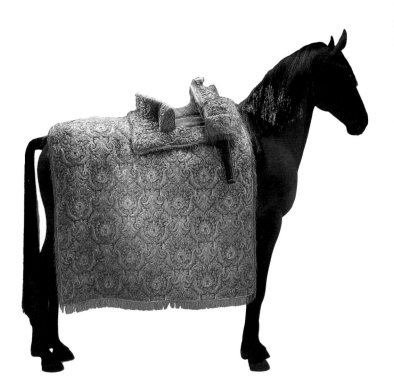

At the coronation of Queen Christina in Stockholm on 20 October 1650, Charles Gustav, as heir apparent, was assigned a prominent position in the coronation procession. He rode a "fine golden courser" given to him by Christina a few days earlier, and he wore a purple cloak embroidered with the golden flames of the Order of St. Esprit. On his head was a broad-brimmed hat, similarly decorated, and around that, the golden crown of the heir apparent.

Two magnificent saddle garnitures were among the large orders placed in Paris for Christina's coronation, and they seem to have been commissioned from the same Parisian workshop. They are identical in shape and pattern, but the saddle and caparison for the queen's coronation horse are more richly embroidered and are encrusted with pearls. The other caparison, on exhibition here, has a paler, incarnadine (flesh-colored)

velvet ground, and the gold and silver embroidery does not include pearls. Inventories state that this caparison was used at the coronation in 1650, but they do not say by whom. It is the only caparison having the design and dignity appropriate to the heir apparent, however, and was almost certainly used by him.

This caparison is unusually large and would have hung well down over the sides of the horse; in fact, early records call it a ''horse house.'' It was made for a sidesaddle but would have been paired with a man's saddle for Charles Gustav. Because the saddle and caparison shown here were not originally meant to be

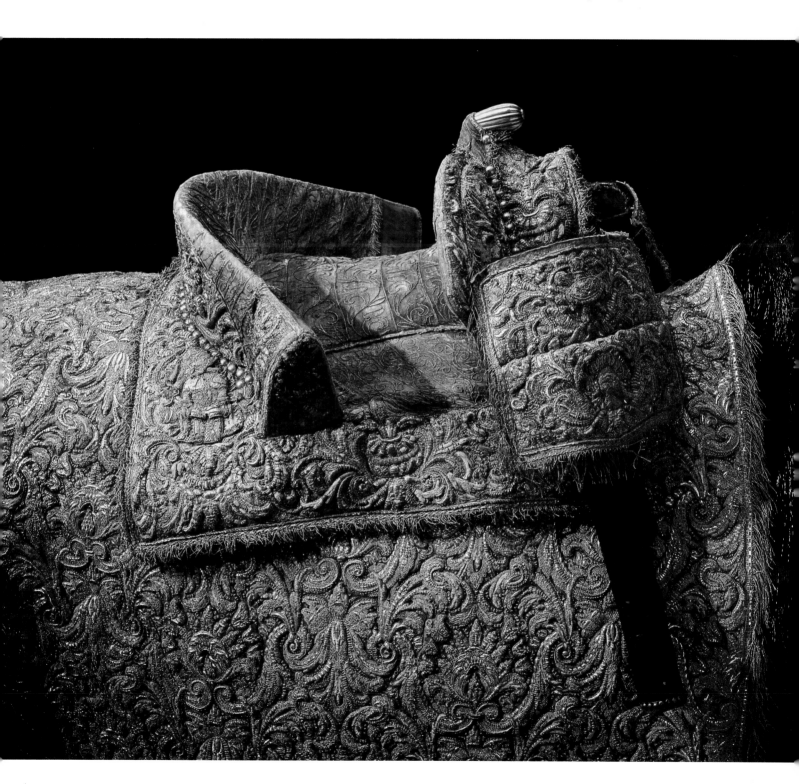

used together, their decoration and materials differ. Trophies are embroidered on the saddle alone. In the 1655 inventory of the Royal Armory, the saddle is described as "new" and "French," but its French origin seems to have soon been forgotten, for it is designated "German" from the 1671 inventory onward.

The 1683 inventory of the Royal Armory describes the items as follows: "The richly embroidered red blanket made for a woman's saddle and used at the coronation of Her Majesty Queen Christina in 1650 has since been changed into a man's saddle and was used at His Majesty's coronation in Uppsala in 1675."

The caparison and saddle are both of exquisite mid-seventeenth-century French workmanship. The caparison was used again with a new saddle by Charles XI at his coronation in 1675. With the queen's coronation caparison, these two are among the finest saddle garnitures of their kind in the collections of the Royal Armory and are unrivaled in any collection in the world. A.T.-J.

BIBLIOGRAPHY: Stockholm 1966, no. 332; Tydén-Jordan 1984, 12; Tydén-Jordan 1985, 28ff, 171f; *Historiska bilder*, vol. 2; Johann Christian Lüning, *Theatrum ceremoniale historico-politicum*, vols. 1–2 (Leipzig, 1719–1720); The Royal Armory, accounts and inventories from 1655, 1671, 1683, 1696, 1821, 1855, 1867.

Charles X 1622–1660

CHARLES X (Karl X Gustav) was carried to Sweden in the womb of his Protestant mother, who had to leave Germany with her husband, Johan Kasimir, mainly because of their creed. At the time Germany was torn by the religious dissensions of the Thirty Years War and as yet still dominated by the imperial Catholic troops. His mother, Katarina, was the daughter of Charles IX and half-sister of Gustavus Adolphus, which made it natural for the king to give them sanctuary in Sweden.

Following the death of Gustavus Adolphus, the Swedish privy council appointed Johan Kasimir and Katarina to take charge of the young Christina. Thus Christina and Charles Gustav grew up together. He was four years her senior, and it was assumed that they would marry when they were old enough. But although the two were close, in the end Christina made it clear that she did not intend to ever marry. She had Charles declared her heir, however, and on the day she abdicated the throne at Uppsala Castle, he was crowned in Uppsala Cathedral a few hours later. After two months, Charles married an eighteen-year-old princess from Holstein-Gottorp, Hedvig Eleonora, and the following year Charles XI was born.

A combination of skill and dash earned Charles X great military successes in Poland, but the real triumphs of his determination and daring were achieved against

Denmark. He boldly seized the chance offered him by a cold winter of leading his army over the none too solid ice of the Little and Great Belts—assumed by the Danes to be natural defenses against attack. The Danish forces were caught completely off their guard, and the resultant Treaty of Roskilde in 1658 marked a turning point in Swedish history, giving Sweden its present-day frontiers in the south.

After a time, Charles X felt that the Danes were defaulting on their treaty obligations, and he embarked on a new war against them. The fortune of war now deserted him for the first time, however, and Denmark prevailed. Shortly afterward, Charles X summoned the Riksdag to approve funding for a war of revenge, but he died suddenly before the members had gathered. He was only thirty-seven years old, and he left behind a twenty-three-year-old widow, a four-year-old-son, and a war-weary kingdom. U.G.J.

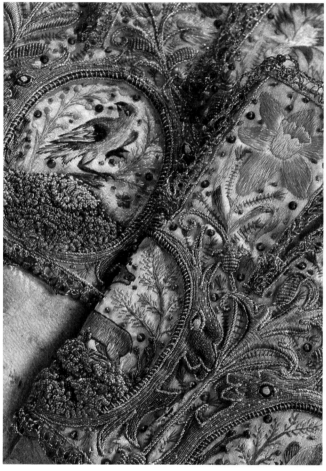

Detail, cat. 37

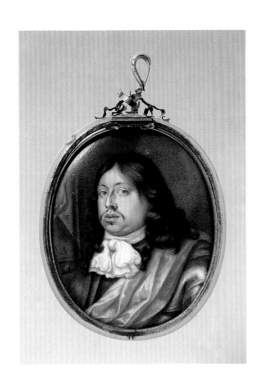

36
Charles X c. 1654

Pierre Signac, 1623–1684
enamel; case of turquoise blue enamel
7.5 x 6.3 (3 x 2½)
Nationalmuseum, NMB 2173

Many of Christina's court painters, Pierre Signac among them, entered the service of her successor, Charles X. Signac painted a large number of portraits of the king, both enamels and miniatures. The first of these was executed in 1654 at the time of Charles' coronation. The enamel exhibited here shows the king in his prime. His face does not yet reveal the heavy, pouchy lines that characterize later portraits, but his corpulence, so evident in the cut of his clothes (see cats. 41–42), is apparent here as well. Another variant of this portrait is in the Royal Collections. G.C.-B.

BIBLIOGRAPHY: *Swedish Portrait Archive*, Index 3 (Stockholm, 1943), 266; E. Lemberger, *Die Bildnisminiatur in Skandinavien* (Berlin, 1912); Cavalli-Björkman 1972, 99-100, cat. 29; Cavalli-Björkman 1982, 35.

37

Gloves of Charles X 1650s

Dutch/English?

pale white glacé goat skin, pink taffeta, gold lace, gold wire, embroidery of colored silk

35 (13¾) long; gauntlet 9 (3½) to 16 (6¼) wide

Royal Armory, 3389

Perfumed gloves were a luxury article in the seventeenth century, but they were not always intended to be worn—as can be seen by the elongated fingers of the gloves exhibited here. They were regarded as exclusive presents, and they had a symbolic value as tokens of loyalty and courtesy. Elizabeth I of England always received two or three pairs of gloves as a New Year's gift, and it was common practice in England to present wedding guests with simple gloves. Many glovers were also perfumers, creating leather that was pleasing in every way. They worked in cooperation with embroiderers, who took their motifs from special pattern books.

The unlined gloves in this exhibition have long narrow fingers, a distinct back seam, and embroidered, silk-lined gauntlets trimmed with gold bobbin lace. Small incisions in the palms—for ventilation—form decorative triangular patterns. The gauntlets are embroidered with flowers in the upper part and birds within oval cartouches beneath. G.E.

BIBLIOGRAPHY: Uppsala 1921, no. 274.2; *Tre Karlar* [exh. cat., Royal Armory] (Stockholm, 1984), no. G.2.12; Ekstrand 1956; V. Cumming, *Gloves: The Costume Accessories Series* (London, 1982); Royal Archives, inventory of the royal wardrobe from 1661.

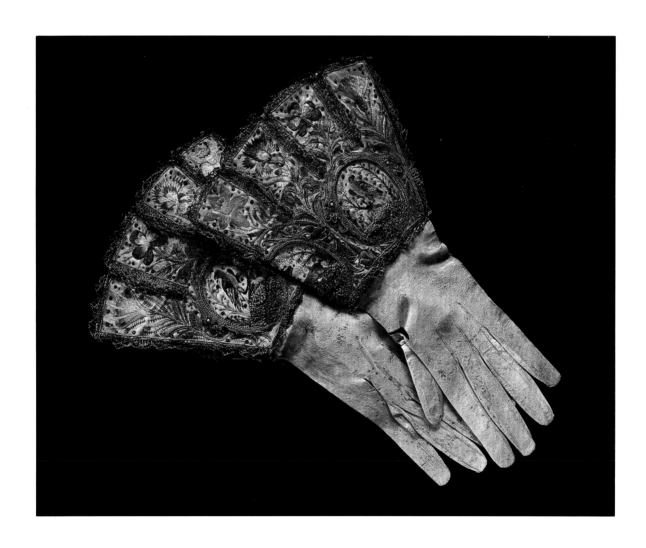

38

Rapier c. 1650–1655

German

annealed steel

102.3 x 10.8 (40¼ x 4¼); blade, 86.1 x 2.4 (33⅞ x ⅞)

Royal Armory, LRK 5025

This rapier has a straight, two-edged blade with an illegible punched inscription and a blurred smith stamp. Its half-hilt is cast of dark annealed steel, covered with chiseled reliefs against a gilt ground. It is typical of this type of hilt that the inner side has no guard at all, as if the hilt had been halved and the inside peeled away.

This style was not uncommon at the time of Gustavus Adolphus, but it had not yet been refined (a thumb-guard was still considered necessary). Evidently, the inner parts of the hilt were eliminated to prevent unnecessary wear on the costly jackets with which such rapiers were worn. Its slender proportions suggest that it was not regarded as a military weapon, but as an article of formal dress. Even so, it was the basis of the standard model adopted for the French army and navy toward the end of the seventeenth century.

The half-hilt appeared in its perfected form in Sweden around 1650, as confirmed by Carl Gustav Wrangel's sword at Skokloster, shown in the great equestrian portrait by David Klöcker von Ehrenstrahl (1645). The latest known example—Colonel Daniel de Besche's rapier—comes from Valö Church in Uppland and is dated 1681. Several swords can be dated between 1650 and 1681, including a number in the Royal Armory (inv. nos. 1861 and 3871).

The origins of this type may be Continental, though whether German or French it is hard to say. Wrangel's rapier was unquestionably bought in Germany during the final phase of the Thirty Years War. And we know from inventories that the rapiers in the Royal Armory once belonged to Charles X and are of French origin.

L.N.

BIBLIOGRAPHY: Seitz 1965–1968, 2:85, fig. 79; Seitz 1955, 163–166; Nordström 1984, 58, 59 (plate), no. 87.

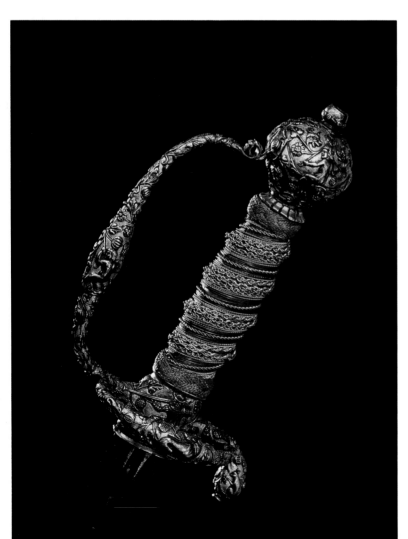

39

Partisans for Yeomen of the Guard 1654

Swedish; decorated by David Kohl, 1628–1685

etched and partly gilt steel, with pine

214 (84¼) long; blade, 56 (22) long

Royal Armory, LRK 5872, 5874, 5878, 24591, 24599

Three months after his coronation, on 24 October 1654, Charles X married Princess Hedvig Eleonora of Holstein-Gottorp. Sixty partisans were ordered for the wedding, and of these, twenty-two remain in the Royal Armory. They were decorated by the best etcher in Sweden at the time, the royal armorer David Casparsson Kohl, and the ornaments include the coat of arms of Sweden with a Pfalz shield and the king's monogram, *CGRS* (the *C* and *G* crowned with the same royal crown, *R* and *S* with one each).

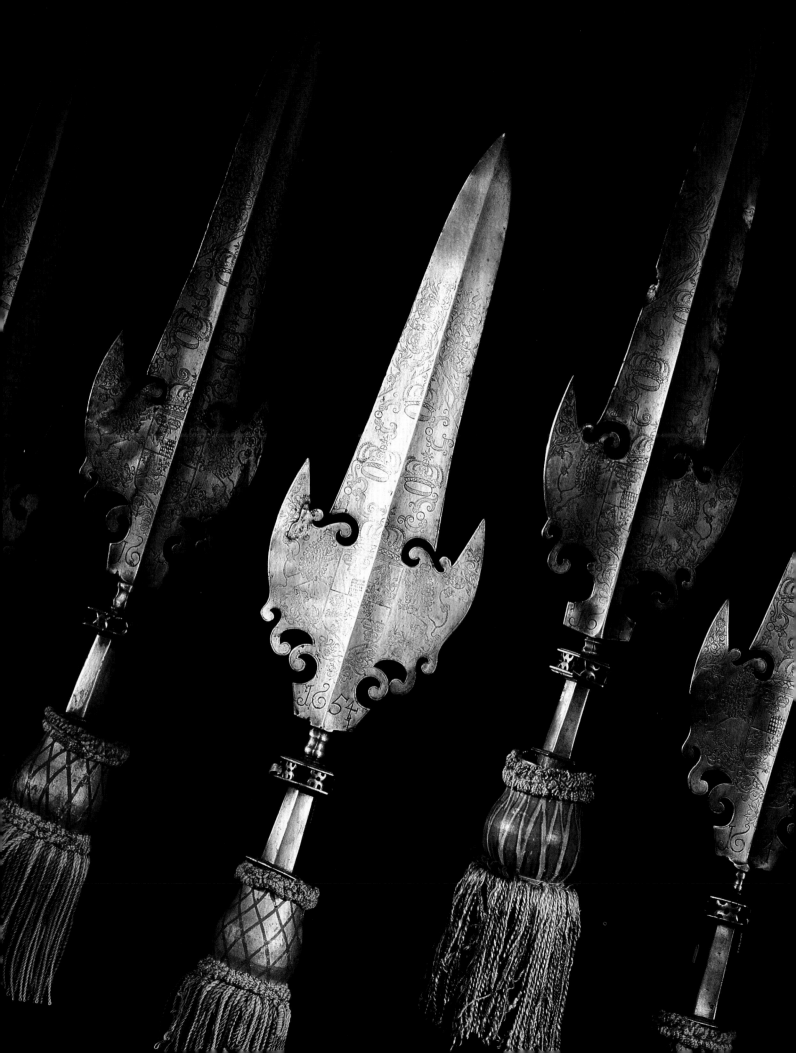

These partisans, the last ones ordered for the royal yeomen (see cat. 18), were used not only during the reign of Charles X but also in the following centuries, until yeomanry was dissolved in 1844. The partisans are equipped with a wool tassel, often replaced, usually in the Swedish colors of blue and yellow. N.D.

BIBLIOGRAPHY: Heribert Seitz, *Bardisanen som svensk drabant-och befälsvapen* (Stockholm, 1943), 83–93, pl. 42, 116 (English summary.)

40

Coats of Arms from the Funeral Procession of Charles X 1660

Friedrich Feuerbrun

silk mounted on paper, embroidery (appliqué work) in gold and silver with golden galoon

70 x 38.5 (27½ x 15⅛); 56 x 38 (22 x 15)

Royal Armory, 60/2a, 60/50b

The most spectacular royal funeral procession in seventeenth-century Sweden was that for Charles X, which took place on 4 November 1660, and almost all of the arms from the banners and horse caparisons are preserved at the Royal Armory (see also cat. 20). The procession is also well documented by a magnificent engraving by Jean Lepautre after a drawing by Erik Dahlberg, "De rebus a Carlo Gustavo gestis," published at Pufendorfis, Nuremberg, in 1696.

Charles X, whose reign represents the period of greatest expansion for the Swedish empire, was the son of a Count Palatine of the house of Wittelsbach and a Swedish princess, granddaughter of Gustav Vasa. His funeral procession included heraldic banners and caparisons— each banner followed by a caparisoned horse— that represented the fifty-nine provinces of the kingdom of Sweden and grand duchy of Finland, as well as possessions across the Baltic and the king's hereditary duchies in Germany. Every banner and caparison had a coat of arms embroidered on both sides, which explains why some of the designs were reversed (heraldically speaking). The embroiderers' names are known, thanks to the invoices preserved in the Archives of the Kingdom. Most of the arms were executed by Friedrich Feuerbrun and Nils Stare, the rest by Georg Ulrich and Jean Beranger.

The two shields exhibited here constitute a good example of the remarkable emblems that played such an important role in the seventeenth-century "pompe funèbre." One represents the arms of Götaland and corresponds to one of the main titles of the monarch: "King of Swedes, Goths, and Wends [Western Slavs]." It is blue with a gold lion "rampant" overlying three "bends wavy sinister." The other features the arms of Charles X as Count Palatine, with eleven "quarterings" altogether.

A.T.-J./A.H.

BIBLIOGRAPHY: Sigurd Wallin, "Carl X Gustafs Begravningsfanor," *Livrustkammaren* 8 (1960); 253–310.

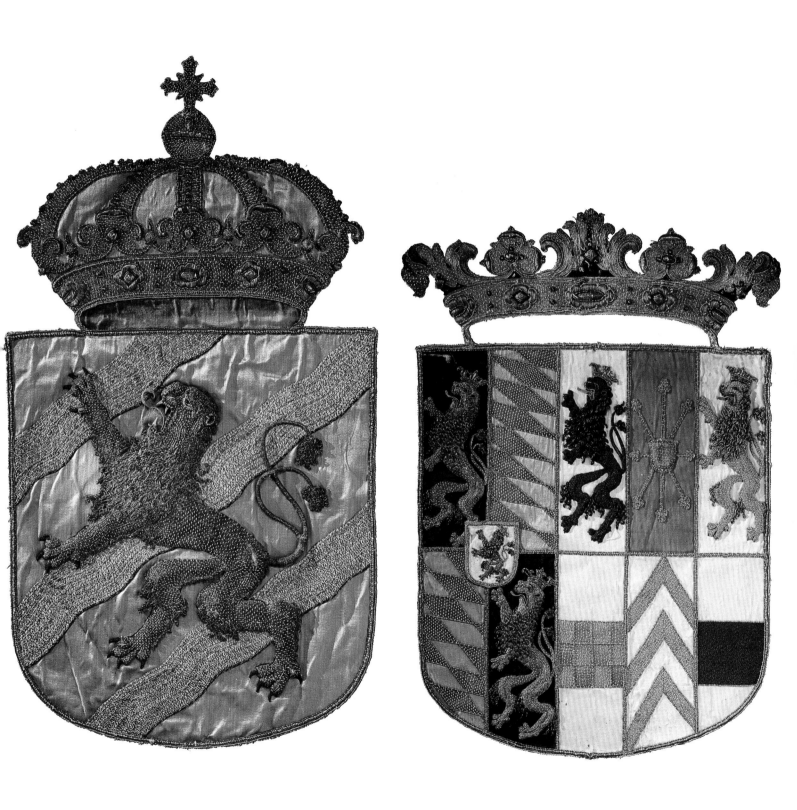

Detail, cat. 41

The Coronation of Charles X 1654

THE DRAMATIC high point of 6 June 1654, the day Charles Gustav was crowned King Charles X, was not the splendid investiture of the monarch with the Swedish regalia, which took place in the afternoon, but the events of the morning. Queen Christina had decided to abdicate that day. The court rose early and came in gala dress to the queen's chambers in Uppsala Castle—all except Charles Gustav, the heir to the throne, who was dressed discreetly in black. The queen appeared with the coronation mantle draped over her shoulders. Axel Oxenstierna, now grown old, handed her the orb; the admiral of the realm gave her the scepter; and Per Brahe, an old friend of her father's, placed the crown on her head (see cat. 1). The assemblage then moved on to the Hall of State just after nine in the morning.

Christina's silver throne stood on a platform; and to the right below the throne was a chair for Charles Gustav and a table with cushions for the regalia. The lower part of the hall was reserved for the four estates of the Riksdag. A proclamation was read releasing the queen's subjects from their oath of allegiance to her; and with certain conditions duly enumerated, the power to rule was transferred to Charles Gustav. At a sign from the queen, the highest officers of the realm advanced to re-

receive the orb and scepter, which were placed on the table with the sword and key of state. Then the queen's mantle was taken. She lifted the crown from her head with her own hands, and it was placed with the other regalia. At this point Christina stood in a white dress with only a fan in her hand and gave an account of her reign, recalling the great merits of her father, Gustavus Adolphus. She then proclaimed, "In the prince [Charles Gustav], I give you a king who possesses such great qualities that he will diligently follow in the footsteps of my father and bring you prosperity. . . ." Christina led Charles to the regalia and begged him to assume them. He entreated her to take up her throne again, which she refused. Finally, Charles gave thanks and vowed to rule according to the word of God and the laws of Sweden.

Although the preparations for the coronation of Charles X had to be made on very short notice, since Christina had informed her council of her irrevocable decision to abdicate only four months before, it was nonetheless a sumptuous affair. The magnificent works made for Christina's coronation four years earlier were much in evidence: the silver throne was quickly moved from Uppsala Castle to the cathedral, where the coronation ceremony took place. Christina's coaches and horse fittings were used in the processions. The altar silver given by De la Gardie was brought from the Storkyrkan in Stockholm, and the Dutch tapestries were hung. When Charles arrived at the cathedral, he no longer wore black, but a suit of white satin, as demanded by Swedish tradition, decorated with glittering silver lace (this costume is still in the Royal Armory, but without lace); the archbishop then placed the royal mantle over his shoulders. The service itself, at which Charles was anointed king of the Swedes, Goths, and Vends, followed the traditions of Erik XIV and Charles IX (see cat. 3) and was followed by a coronation banquet at the castle for which the king wore the splendid, embroidered gold costume on view in this exhibition (cat. 41). There was nothing unusual about several changes of clothing in the course of such a day, and the strikingly beautiful red and silver French costume also exhibited here (cat. 42) may well have been worn at some point that day. On 24 October of the same year, King Charles was again wearing a white suit when he married Hedvig Eleonora of Holstein-Gottorp. Two days later she was crowned queen at the Storkyrkan, with suitable festivities. G.W. and G.E.

41

Gold Coronation Costume of Charles X
c. 1654

French embroidery; assembled in Stockholm

doublet of gold lamé, gold brocade, yellow moiré; breeches of uncut golden brown velvet, lining of white linen tabby; embroidery overall of gold with cannetille and lamellas

doublet, 40 x 52 (15¾ x 20½), with sleeves 57 (22½) long; breeches, 61 x 64 (24 x 25¼)

Royal Armory, 3408, 3409

The suits of Charles X in the Royal Armory constitute a unique collection, not only by virtue of their quantity—there are more than thirty ensembles—but also because they give such a many-sided picture of European men's fashion in the 1650s. Only Rosenborg Castle in Copenhagen has a nearly comparable collection of royal clothing. The reason Charles X's costumes have survived in such numbers may be that he spent so little time in Stockholm, being often away on campaign. The suits were stored in the Royal Wardrobe from 1654 until 1697, when they were rescued from the palace fire. Later they were deposited in the Royal Armory.

The costumes can be divided into two groups: sumptuous robes of essentially ceremonial character and antiquated style (including those on exhibition here; see also cat. 42); and more up-to-date, comfortable, less expensive garments. The great majority of the king's suits are black. Royal courts would go into mourning following the death of not only immediate relatives but also remote kinsmen in other countries. One such costume has wide petticoat breeches, an early example of a fashion popular in the 1660s.

Purchases of garments from France for "needs of His Royal Highness," the heir apparent Charles Gustav, are recorded as early as 1647 and were probably arranged through Sweden's ambassador to Paris at the time, Christina's favorite, Magnus Gabriel De la Gardie. A Royal Wardrobe inventory of 1671 mentions "a costume made for the joyful coronation of His Majesty," which refers to the gold-embroidered ensemble on exhibition here.

Originally, this was the costliest of the king's costumes and included no fewer than 140 diamond buttons. It comprised a doublet, knee breeches, a circular cloak—a legacy from traditional Spanish costume, later made into a precious chasuble and antependium at the dowager queen's command—also garters, shoe ribbons,

and gloves with matching gold embroidery, pink taffeta draws and silk stockings, a wide, gold-embroidered baldric for the sword (the hilt of which was gilded), a gold hatband and a plume of red, gold, and reddish yellow feathers, and finally, gilt spurs. Today only the doublet and breeches survive.

The short loose-fitting doublet is believed to reflect French fashion from the time of Louis XIV's childhood. The breeches show traces of original ribbon decoration—bows or "favors"—in two rows over the belly and were probably decorated in a similar fashion at the knees. Both garments are embroidered in relief with an all-over floral and foliate pattern in gold wire. It is a remarkably small repeated pattern for the time, without any special royal emblems.

It is worth noting that Gustavus Adolphus' white coronation robes, now in the Royal Armory, were embroidered with an emblematic crown. The only garment worn by Charles X that was embroidered with gold crowns was the royal mantle passed on to him by Queen Christina.

It is possible that the gold costume shown here was worn by Charles as heir apparent at the coronation of Christina and then made ready for his own coronation only four years later. Christina's abdication came so suddenly that there would have been no time to order new robes such as these from Paris. Moreover, it would have been difficult to surpass the magnificence of the embroidery, the shimmering gold brocade lining, gold lace and ribbons, and diamond buttons. G.E.

BIBLIOGRAPHY: Uppsala 1921, no. 1290; S. Flamand-Christensen, *Kongedragterne fra 17. og 18. aarhundrede*, vols. 1-2 (Copenhagen, 1940); Ekstrand 1956; Ekstrand 1957; Gudrun Ekstrand, "1600-talets vita kröningsdräkter," *Livrustkammaren* 8 (1960); Gudrun Ekstrand, "Maktens klädspråk," in Tydén-Jordan 1987; Royal Archives, inventory of the royal wardrobe from 1661.

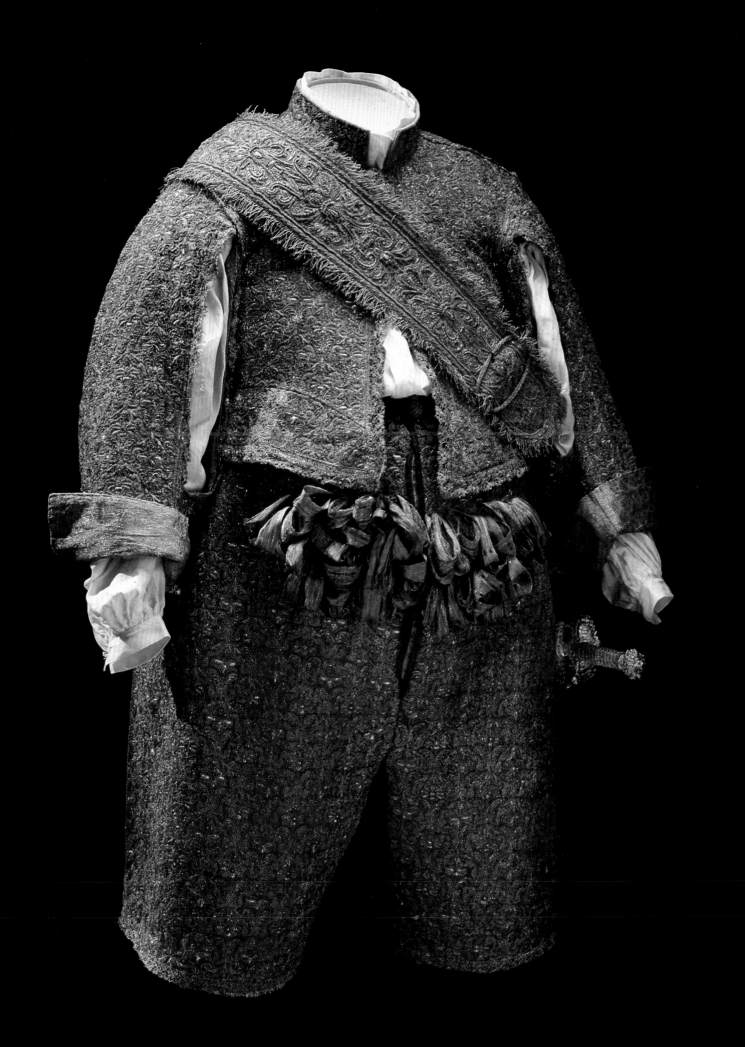

42

Scarlet and Silver Costume of Charles X
c. 1654

French embroidery; assembled in Stockholm

scarlet broadcloth, silver brocade, white linen tabby; embroidery of silver wire, cannetille, lamellas, and spangles

cassock, 86 x 76 (33⅞ x 29⅞), with sleeves 78 (30¾) long; doublet, 39 (15⅜) long, with sleeves 57 (22⅜) long; breeches, 59 x 64 (23¼ x 25¼)

Royal Armory, 3386a–c

In 1654, the year of Charles X's coronation, the master of the royal household signed for six princely costumes. Among them was this red, silver-embroidered ensemble, which included a loose-fitting cassock, knee breeches, and a short doublet.

The cassock—suitable for riding—is lined with a silver brocade. It fastens completely down the center front with buttons and loops; and the center back, outsleeve, and side seams fasten the same way for approximately half their length. The breeches are gathered at the top into a straight waistband, and have wide straight legs with pocket slits at the sides. They are decorated with eighteen ribbon bows at the knees and twelve more in two rows over the belly. The gloves and bows of the shoes (ribbons serving as laces), now lost, were of the same design. Busks stiffen the lower front pieces of the doublet, which gives the garment a distinctive silhouette and makes the shirt more readily visible.

The decoration of this costume does not include any specifically royal emblem or motif, which makes it seem likely that the ensemble formed part of an earlier commission having no immediate connection with the king's own coronation, but relating to his nomination by Queen Christina as hereditary heir. At a later occasion it was altered to fit the king's measurements. G.E.

BIBLIOGRAPHY: Uppsala 1921, no. 427; Ekstrand 1956; Ekstrand 1957; Astrid Tydén-Jordan, "Lyx och modecentra, Paris-London-Wien," in Tydén-Jordan 1987; Royal Archives, inventories of the royal wardrobe from 1661 and 1671.

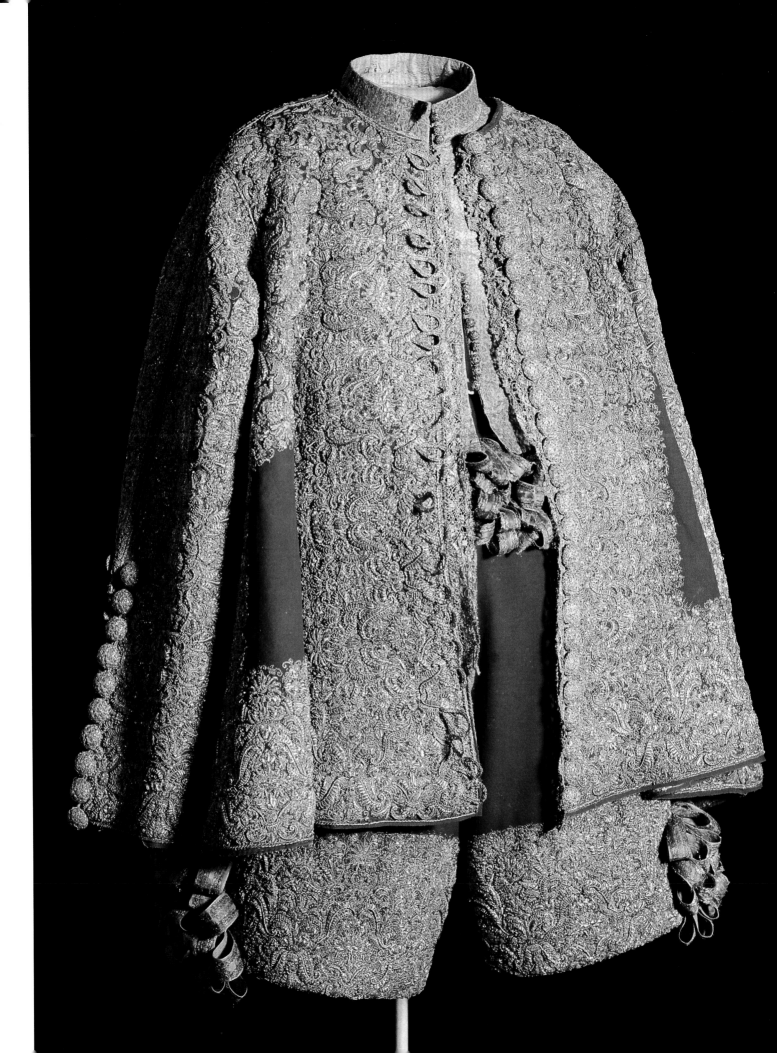

43

Rapier 1640s

probably French

cast silver and steel

106.5 x 10.1 (41⅞ x 4); blade, 90 x 2.5 (35⅜ x 1)

Royal Armory, LRK 10784

The hilt of this rapier, which has no knuckle-bow, is of cast silver, with chiseled decoration. It is chased all over in high relief, with scenes of cavalry fighting. These figures are surrounded by auriculate ornamentation, partly of open work on the shell-guard.

Two rapiers of the same pattern were ordered for the coronation of Charles X. One rapier, with a bright silver hilt, was intended to be used with the white costume the king wore during the actual coronation ceremony; while the other, with a gilded hilt, accompanied the gold-embroidered costume worn during the post-coronation banquet (cat. 41). L.N.

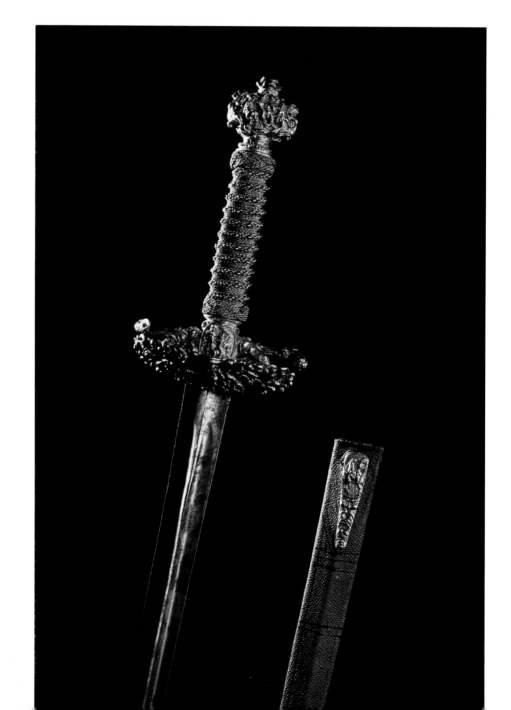

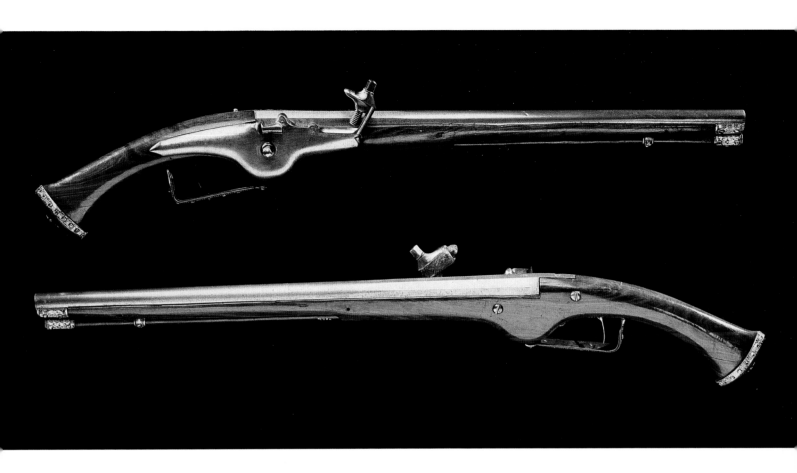

44

Pair of Wheel-Lock Holster Pistols 1650

Dutch; mounts by Jürgen Dargeman, 1646–1688

engraved steel, jacaranda, gold, enamel, and diamonds

62.7 (24⅝) long, 13.7 mm caliber; 62.6 (24⅝) long, 14.0 mm caliber

Royal Armory, 4722–4723

These pistols were given by Queen Christina to her cousin and successor, Charles X, at his coronation on 6 June 1654. They have round smoothbore barrels with faceted breeches and jacaranda stocks of French-Dutch form. The locks have an inner wheel and rounded lockplates of the Dutch type, while the wheel spindles are surrounded by blued plates, each with an engraved rose.

The furniture is of steel and gold enameled in white and light blue with details in black, red, and yellow. Of the seventy diamonds bought on 5 October 1650 from the Stockholm jeweler Alexander Deboch and given to the royal goldsmith, Jürgen Dargeman, thirty appear in these fittings.

A mark with the initials *IIC* and a crowned head is known only from these pistols and a flintlock fowling piece that also belonged to Charles X (LRK 11683). The gun may be Dutch as well, but from about 1630-1640.

N.D.

BIBLIOGRAPHY: John F. Stockel, *Haandskydevaabens bedømmelse*, vol. 2 (Copenhagen, 1943), 673, mark no. 3383; *Svenskt silversmide*, vol. 1 (Stockholm, 1941), 240, pls. 516–518; Arne Hoff, *Dutch Firearms* (London, 1978), 43.

Charles XI 1655–1697

CHARLES XI (KARL XI) was born in 1655, the only child of Charles X and Hedvig Eleonora. He was only four years old when his father died, and for the next twelve years Sweden was governed by a regency administration headed by Magnus Gabriel De la Gardie. Through De la Gardie's leadership and example, the power and wealth of the higher nobility greatly increased. Their special privileges and Sweden's new position in Europe created a society whose consumption of luxury goods rivaled that of any other European country of the time—but at the expense of the crown.

Although Hedvig Eleonora was given considerable power in the regency government, she chose not to exercise it. As a result, Charles was also removed from the political arena. Moreover, his academic education was limited due to a learning disability. But he developed a lifelong passion for riding, hunting, and military life.

After succeeding to the throne, Charles was talked into asking for the hand of the Danish princess Ulrika Eleonora as a means of improving relations with Denmark, and they were engaged by correspondence. But Sweden had recently allied itself with Louis XIV, and Denmark was one of France's enemies. The Danes, believing themselves to have the upper hand on account of the Swedish king's youth and inexperience, declared

154

war on Sweden instead. Charles himself fought at the Battle of Lund in 1676 when the Danish attack was repulsed, though with tremendous loss of life on both sides. This cleared the way for the projected wedding, which took place in 1680. Ulrika Eleonora, who died in 1693 after a long illness, bore the king seven children, three of whom attained adulthood; the eldest eventually reigned as Charles XII.

Once the threat from abroad had been eliminated, Charles XI addressed himself to problems at home. He proclaimed a more autocratic government and was vigorously supported in this by the lower aristocracy and the peasants. Charles was thus no longer bound to submit his decisions to either his council or the Riksdag. The restoration of lands taken from the crown under Christina and during his own regency was ruthlessly implemented as well, to the lament of its victims (among them De la Gardie), but to the benefit of the national economy and the strength of its army and navy. This stabilized the government and provided money for the country to function as the Baltic power that it had become. With this foundation, the artistic ambition and military triumphs of the end of the century and beginning of the next were made possible. U.G.J., G.W., and M.C.

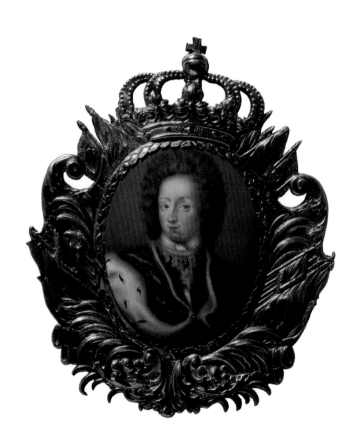

45

Charles XI 1697

Eric Utterhielm, 1662–1717
enamel; frame of pressed, gilt copper
10 (4) high
Royal Collections, ss 255

Magnus Gabriel De la Gardie summoned the French en-
amelist and miniaturist Pierre Signac to Sweden in 1646
(see cat. 33), and on arrival, the French master formed
a school and recruited young Swedish assistants. Eric
Utterhielm was one of his pupils. In this way, French
expertise was transplanted into Sweden, reinvigorating
Swedish art.

Utterhielm was a nobleman at the court of Dowager
Queen Hedvig Eleonora, and in addition to training un-
der Signac, he took lessons from David Klöcker von
Ehrenstrahl, the Swedish court painter. In 1700 and
1704 Hedvig Eleonora commissioned Utterhielm to
paint a series of gouache miniature portraits of her rela-
tives, which were then put together into pedigrees. The
queen's personal pedigree comprised sixty-three minia-
ture portraits. G.A.

BIBLIOGRAPHY: Stockholm 1930–1931; Fogelmarck 1982.

46

Child's Frock of Charles XI c. 1660

French/Italian(?); assembled in Stockholm

purple and gold brocade; embroidery of silver and gold; lining of russet taffeta

95 (37⅜) long, with sleeve 18.5 (7¼) long

Royal Armory, 3450

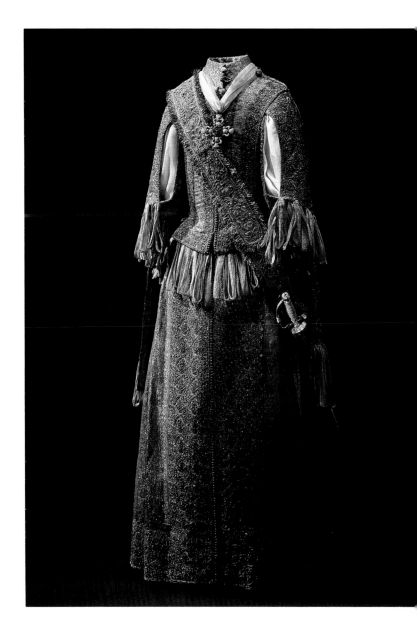

Charles XI, child heir to the Swedish throne, probably wore this purple brocaded frock, the color and material of which indicate ceremonial use, at the opening of the Riksdag in Gothenburg on 4 January 1660. He may also have worn it when receiving tribute as king there 1 March following his father's sudden death on 13 February. A portrait painted by the Dutch-Danish artist Abraham Wuchters while serving at the Swedish court in 1660–1661 shows the young prince wearing this very costume.

This ceremonial costume of the young Charles XI is an example of the kind of dress worn by children in this period. By the age of four or five, they were dressed like adults in fashionable clothing. The bodice of this frock, stiffened with interlining and possibly whalebone, laces up the center back. Its short sleeves have open front seams, and false hanging sleeves are sewn along the back of the armhole on each side. The five-gored skirt has a center back opening and pockets in the side seams. Ribbon bows form loops beneath the waist tabs and at the hems of the false hanging sleeves. G.E.

BIBLIOGRAPHY: Uppsala 1921, no. 662; *Tre Karlar* [exh. cat., Royal Armory] (Stockholm, 1984), no. H.3.5; I. Wintzell, *Så var barnen klädda* (Stockholm, 1972); B. Hammar, "Lindebarn, koltbarn och miniatyrvuxna," in Tydén-Jordan 1987; Royal Archives, inventory of the royal wardrobe from 1671.

47

Baldric for Child's Frock of Charles XI
c. 1660

Swedish/French?

white taffeta, red velvet, leather lining, with gold cannetille, lamellas, and fringe

shoulder strap, 100 x 10.5 (39⅜ x 4⅛); sword sleeve, 27 x 10.5 (10⅝ x 4⅛)

Royal Armory, 3459 (marked N 90)

A man of rank was not fully dressed without his sword, carried in a baldric around the waist or over the shoulder. In Gustavus Adolphus' day baldrics were worn at the waist, but Charles X left a unique collection of extravagantly embroidered shoulder baldrics. These had been supplied from France, where the embroiderers, using needles, gold wire, and pearls, sculpted small allegorical scenes. The open crowns incorporated in the gold-embroidered foliage on the example shown here make it clear that this baldric was intended for Charles XI and no other. The embroidery is of the kind usually associated with baldrics, with the patterns on both pieces composed to meet at the shoulder so that they are fully displayed whether viewed from the front or behind. G.E.

BIBLIOGRAPHY: Ekstrand 1956; Royal Archives, inventory of the royal wardrobe from 1671.

48

Child's Sword c. 1660

French or Italian

gold and enamel

46.6 x 5.7 (18⅜ x 2¼); blade, 36.9 x 1.0 (14½ x ⅜)

Royal Armory, LRK 5359

This is clearly the rapier presented by Queen Christina to the four-year-old Charles XI when she visited Stockholm for the funeral of Charles X. Johan Ekeblad, in service at the Swedish court, wrote a weekly account of events in Stockholm for the benefit of his father, who lived on the family estate at Stola Manor. On 3 October 1660 he mentioned Christina's return from Rome. And when Christina left Stockholm on 27 December, Ekeblad wrote that on Christmas Eve she had presented a sword fitted with diamonds to the new monarch.

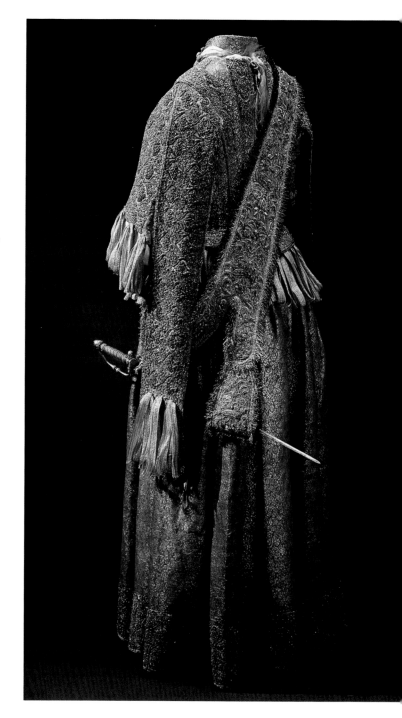

In fact, there were no diamonds, although as a courtier, Ekeblad presumably viewed the presentation from a distance, and the sight of the bright gold of the new hilt, shining with white, red, and black enamel, could well have led him to believe that there were such stones. The shell-guard of the sword features Charles' monogram of opposing *C*s, and the three-edged blade is etched with gilt foliage. The grip is wound with gold wire.

There is no mark or signature to indicate where or by whom the sword was made, but a French origin seems likely in view of the design of the hilt. It has exquisite enamel work, a small shell-guard (somewhat asymmetrical), and drop-shaped bulges on the middle of the knuckle-guard. In addition, Christina journeyed from Italy to Sweden via France, and was accordingly in a position to commission a sword there.

The inventories at the Royal Armory say nothing about the sword's origin. It is mentioned in a list from Rosenborg Castle dated 1854 as having been used by Charles XIII as a child. Prior to that it was no doubt regarded as an heirloom by the royal families and used by the princes during their childhood. L.N.

BIBLIOGRAPHY: *Johan Ekeblads brev. utg. av N Sjöberg*, vol. 2 (Stockholm, 1915), 237; Lena Nordström, "Julgåva till en gossekung," *Livrustkammaren* 8, nos. 11-12 (1960), 360.

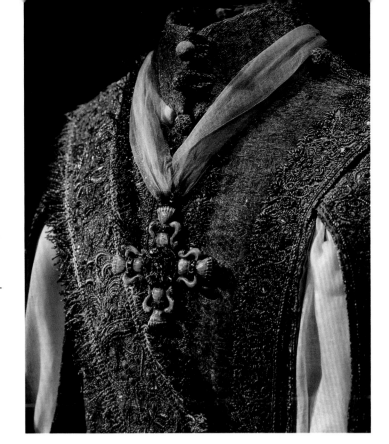

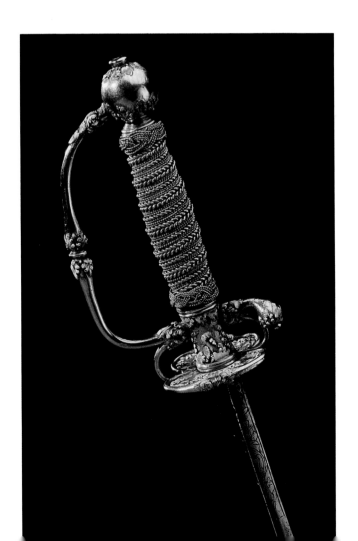

49

Badge of the Royal Order of the Name Jesu
1655

Gregoire Chique (Gregorius Schick), 1651–1678

gold, enamel, and diamonds

7.2 (2⅞) high

Royal Armory, LRK 5

The Order of the Name Jesu was conceived in 1656 by Charles X, and it is the first Swedish order whose statutes are preserved (though never signed). The order was, according to its statutes, never to be dissolved by future kings. Since Charles X went to war before the actual creation of the order, only the first badges, given to members of the royal family, are known to have existed. The badge of the order was to be suspended on a four-inch-wide white silk ribbon (symbolizing the purity of Christ), and on festival days, on a chain. The statute manuscript describes the badge of the order and notes that "Gregoire Chique orfèvre a fait l'Ordre pour le Roij. L'An 1655."

Chique belonged to a family of goldsmiths working in Stockholm who were said to be from Cracow. But in the letter of passage from Queen Christina dated 18 August 1651, Chique is called a "French goldsmith." He was obviously very proud of the badge he created for

the king, for he once signed himself: "Orfeure qui a fait l'ordre pour sa Majesté l'an 1655."

Two badges are known to have existed. A more elaborate one, corresponding to Chique's preserved bill of 5 May 1655, was in the Radziwill Collections at Castle Nieswiez, Minsk (Russia), in 1913. The badge shown here does not tally at all with the description. It is, however, firmly linked to the order, since it was formerly kept in the Royal Treasury, left to it in 1743 by Queen Ulrika Eleonora (1688–1741), youngest daughter of Charles XI. In 1735 the badge was kept wrapped in a paper with a handwritten inscription by Dowager Queen Hedvig Eleonora (1636–1715), wife of Charles X and mother of Charles XI: "This order with four sheafs (Vasa) and the Name of Jesus was meant to be created as the right Order by the late King [Charles X] given by His Majesty (the same) to his son [Charles XI] to wear, which His Majesty (the same) always did until His Maj-

esty (the same) went to war [the Swedish-Danish war in 1675]." This text is substantiated by many portraits of the young Charles XI. In one, painted by Abraham Wuchters (c. 1610–1683), the boy king is shown wearing the badge on a short blue (not white) ribbon over his right shoulder.

The badge is in the form of a cross made of four Vasa sheafs of gold and yellow enamel with diamonds. The garbs surround a ring of diamonds with the letters *IHS* in the middle, also made of diamonds. Today thirteen stones are missing, together with the cipher on the back; according to a note they were already missing in the eighteenth century. N.D.

BIBLIOGRAPHY: Rudolf Cederström, "Karl Gustav's Jesu Namns orden," *Livrustkammaren* 1 (1937–1939), 2-6 (plate); *Svenskt silversmide 1520–1850*, vol. 1 (Stockholm, 1941), 515 (plate); Stockholm 1930–1931, no. 493.

50

Toy Cannon and Soldier 1669(?)

Dutch/Swedish

blued and gilded steel, with brass, wood, and leather

cannon, 51 x 162 x 56 (20⅛ x 63¾ x 22), 34 mm caliber; soldier, 125 x 100 x 43 (49¼ x 39⅜ x 16⅞)

Royal Armory, LRK 17537, 24640–24664

In 1669 the fourteen-year-old Charles XI of Sweden received a magnificent toy artillery set as a gift from the two brothers Abraham (1623–1690) and Jacob Momma (c. 1625–1678). The set included two cannon with their equipment, a "colonel" on horseback, and two officers on foot, the soldiers as automatons with clockwork heads and arms.

The Momma brothers were of Dutch origin and migrated to Sweden in 1644. They built up a vast commercial and industrial empire comprising copperworks, brassworks, tarworks, and a shipyard, as well as a fleet of merchant ships. In 1654 Abraham Momma made the first exploratory voyage up the River Torne (today the frontier between Sweden and Finland) and over the mountains to the Atlantic Ocean, traveling in an *ackja* drawn by a reindeer. In commemoration of this feat, the brothers took the name "Reenstierna"—that is, "head of a reindeer"—when ennobled in 1669. Abraham Momma was portrayed traveling in the *ackja* by Sweden's most famous painter of the time, David Klöcker von Ehrenstrahl (1628–1698).

Today only the cannon and the colonel on horseback remain from the original artillery set. The foot officers left the armory (together with the colonel on horseback) on 11 November 1749 for use in the royal nursery of Prince Gustav (1746–1792) (later Gustav III) and never returned; all that remains is the blade of a partisan carried by one of them. The cannon were kept separately, probably at the Royal Palace of Karlberg just outside Stockholm. In the 1888 catalogue of the Artillery Museum (now Army Museum), they are described as "six-pounders with carriages, given to the museum by the Army Cadet School at Karlberg and, according to legend, used by King Charles XII [*sic*] as toys." They were transferred from the Army Museum to the Royal Armory in 1907.

The colonel wears half-armor of blued steel with brass nails, and a helmet with a nasal and a plume. In the breastplate there is a keyhole for winding the clockwork, but the toy was already out of order when it was mentioned in the inventory in 1696. Now only the head is connected to the mechanism. The colonel wears a baldric over his shoulder, in which he originally wore a sword with a steel hilt; the sword was stolen from the Nordic Museum in 1949.

The horse is of painted wood and wears a saddle and trappings of black leather and brass nails. The girth is glued to the horse, but the other accessories are detachable. The saddle is fitted with pistol holders of leather and blue velvet; the pistols were already missing in the inventory of 1803.

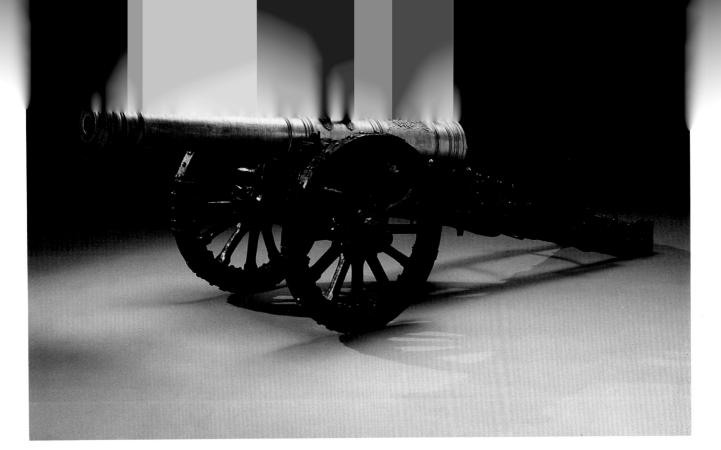

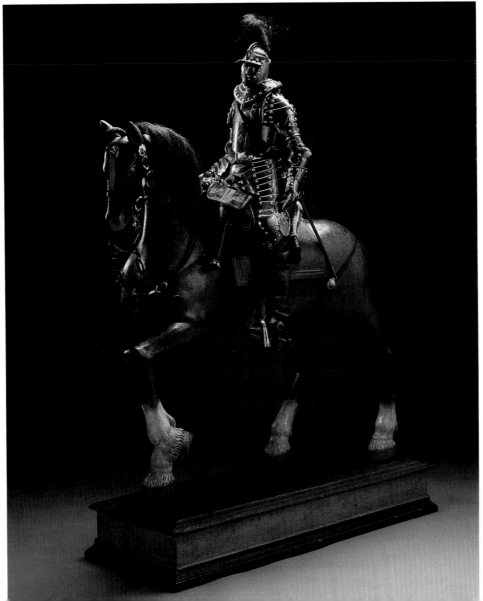

The cannon shown here is dated 1669 and bears the crowned cipher *C* of the king, the oldest known version of the famous Pfalz cipher, used on military equipment until the death of Charles XII in 1718. The carriage is of painted wood, with black steel fittings. The partisan has a gilt steel blade, signed *DK* for David Kohl (see cat. 39). The shaft is a copy. N.D.

BIBLIOGRAPHY: Heribert Seitz, "Det karolinska monogrammet," *Fataburen, Journal of Nordiska museet* (Stockholm, 1937); A. Chapuis and E. Droz, *Les automates* (Neuchâtel, 1949); Torsten Lenk, "En storpolitisk gåva," *Historiska bilder,* vol. 2 (Stockholm, 1949), 224; Fredrik Adolf Spak, *Catalog of the Artillery Museum* (Stockholm, 1888).

Charles XI's Coming of Age

CHARLES XI WAS declared of age at the 1672 Riksdag, and his accession was marked by festivities in Stockholm between 18 and 20 December. On this occasion no expense was spared. The city was gloriously illuminated, and a tournament in the grand style, emulating French examples, was staged in the tiltyard at Hötorget. This kind of tournament, known as a carousel, was a brilliant costume show. The leading men of the kingdom took part, headed by the king himself, dressed as "a knight of honor" in Roman armor. Some of the horsemen on this occasion used the elaborate caparisons made for Queen Christina's coronation horses in 1650 (see cat. 34). The carousel was immortalized in a sequence of engravings after drawings by David Klöcker von Ehrenstrahl, entitled "Certamen Equestre."

The period of Charles XI's coming of age also saw Sweden renewing its ties with France. In 1670 King

Louis XIV had succeeded in breaking the Triple Alliance between England, Holland, and Sweden. Now through an alliance with Sweden, he wanted to isolate the German principalities expected to assist Holland when France attacked that country. The French king sent his best diplomats, Arnauld de Pomponne and Honoré de Courtin, to Sweden for the negotiations, which resulted in a treaty signed on 14 April 1672. To further cement the alliance and secure the assistance of Swedish forces, a new ambassador, Isaac Pas de Feuquières, arrived in Sweden in 1673. That same year, as part of the diplomatic maneuverings, the ambassador presented the king of Sweden with a spectacular gift from Louis XIV— twelve expensively caparisoned horses. A.T.-J.

Detail, cat. 51

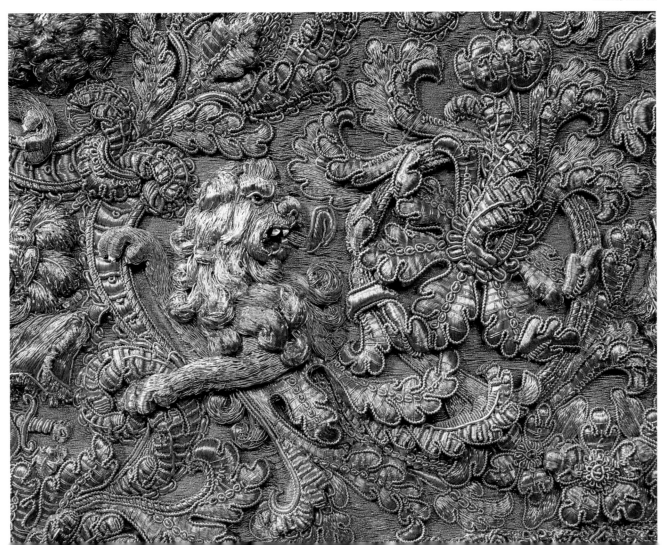

51

State Gift to Charles XI from Louis XIV of France: Saddle, Harness, Caparisons, and Horse Blanket 1673

French

velvet, with embroidery of silver, gold, and colored silk; fringe and tassels of gold; harness of gold-embroidered red morocco leather, with stirrups, pommel, and buckles of gilt bronze; reins of plaited gold and silk thread; saddle girth of silk

saddle, 50 x 50 x 60 (19⅝ x 19⅝ x 23⅝); caparisons: incarnadine, 133 x 63 (52⅜ x 24¾); blue, 120 x 66 (47¼ x 26); yellow, 117 x 62 (46 x 24⅜); red, 120 x 63 (47¼ x 24¾); gold, 113 x 59 (44½ x 23¼); horse blanket, 162.5 x 154 (64 x 60⅝)

Royal Armory, 3881, 3881a, 599a, 600a, 601a, 3882a, 714

The archives of the French ministry of foreign affairs contains a list of official gifts from the king of France to foreign monarchs and dignitaries dating from 1662 to 1727. Because Sweden during this period was closely associated with France, by treaty or otherwise, the list includes many Swedish recipients. In 1665 Sweden's dowager queen, Hedvig Eleonora, was sent ribbons, perfumes, and other *ustensils de Femme* worth 17,012 *livres*. The next year the chancellor of the realm received two silver services, one of them gilt, worth 30,000 *livres*. The list also records a gift in 1673 to young Charles XI so immensely rich that no value is given.

Detail, cat. 51

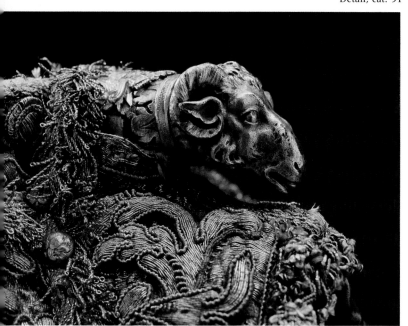

The gift was presented during negotiations on the subject of Swedish support for an attack Louis XIV was planning on Holland. Although the alliance between Sweden and France was consolidated in a treaty signed in 1672, Louis XIV had not received any guarantee of Charles XI's support. The new French ambassador to Sweden, Isaac Pas de Feuquières, arrived in Stockholm on New Year's day 1673 and soon afterward informed Louis XIV that riding and hunting were the Swedish king's greatest pleasures. In April the French foreign minister, Arnauld de Pomponne, replied that Louis XIV had selected as a gift twelve of the most beautiful horses in the royal stables, all fitted with saddles, caparisons, guns, and pistols of the finest craftsmanship, "worthy of both the King giving them and the King receiving." One of Louis XIV's grooms was to deliver the exquisitely equipped horses.

In July, with the French gift on its way, de Feuquières reported that the king of Sweden proposed making a return gift of copper roofing, and he extolled the fine qualities of this material. Understandably, an offer of this kind would be much appreciated at the French court, with large building projects like Versailles currently in progress.

The ceremonial delivery of the caparisoned horses took place on 12 December 1673 when Charles XI returned to Stockholm. He was delighted with the gift, and unexpectedly thanked the ambassador—without an interpreter, it was particularly noted. Court connoisseurs declared they had never seen anything to match the beauty of these horses and their accoutrements. The horses were *des Chevaux d'Espagne ou barbes*—Spanish or Arabian—and became great favorites in the Royal Stables. "Briljant," the gray ridden by Charles XI at the Battle of Lund on 4 December 1676, was one of these. The horses also made highly appreciated secondary gifts, with or without their original saddles. The admiral of the realm, Gustav Otto Stenbock, and Nils Bielke each received one horse. Charles XI, a superb horseman, also wanted pictures of his horses, so David Klöcker von Ehrenstrahl, the court painter, produced more than twenty full-scale equine portraits, including the favorite "Briljant" and several others from the French gift.

All twelve horse blankets are still in the Royal Armory, along with seven of the saddles and eight of the caparisons. Of the equipment shown here, the saddle, incarnadine (flesh-colored) caparison, and harness belonged to the horse named "L'Assure" and were used

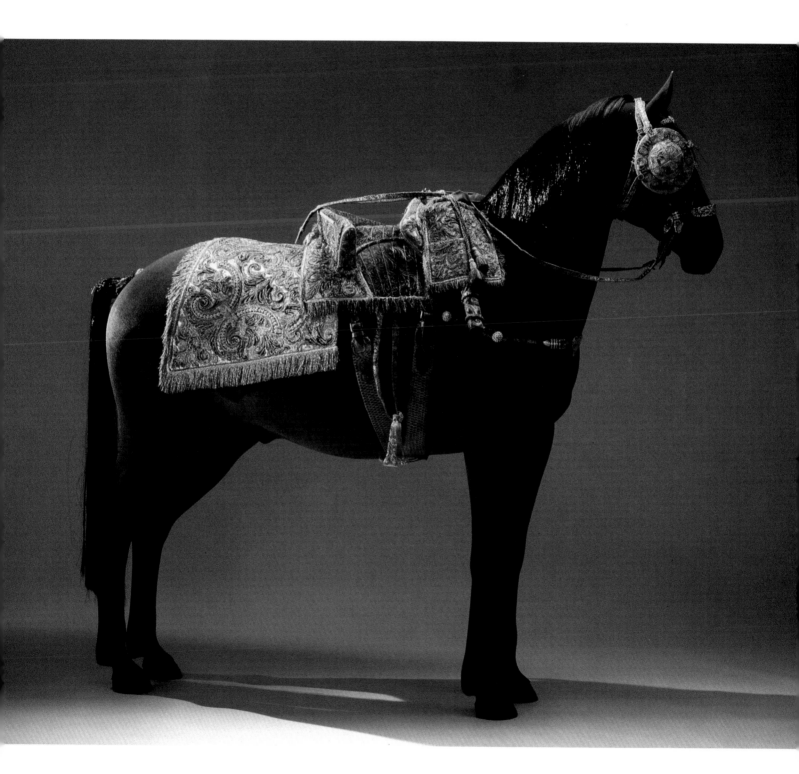

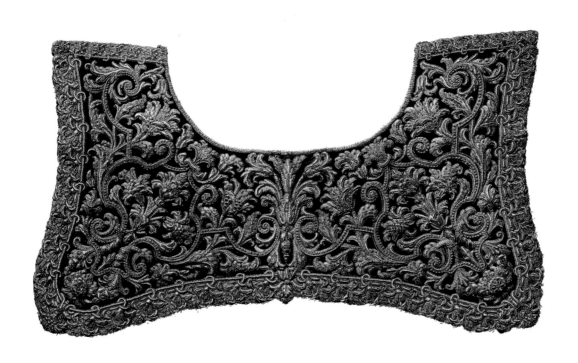

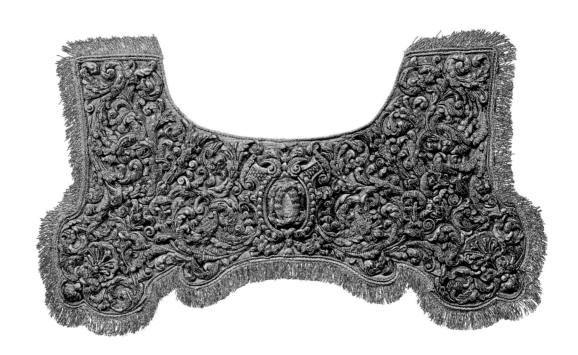

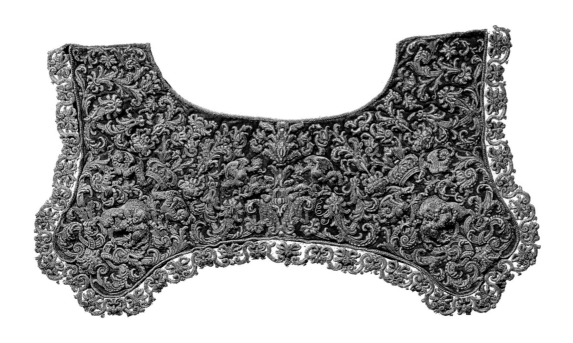

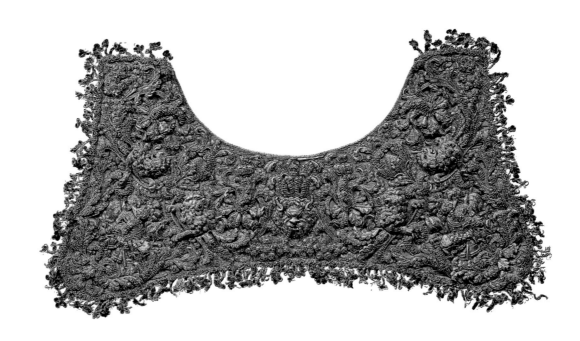

167

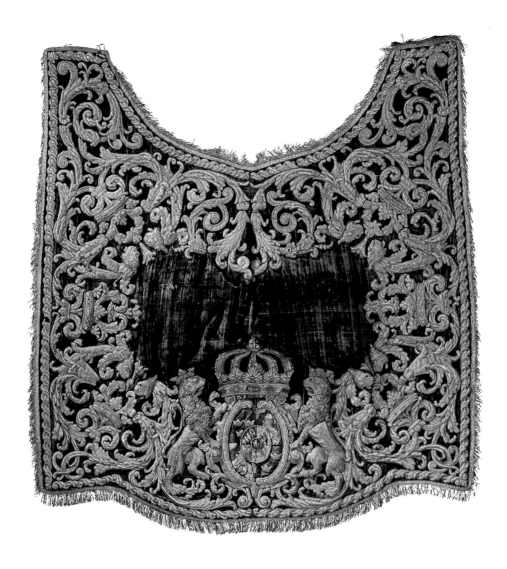

again at the coronation of Frederick I in Stockholm in 1720. The blue caparison was worn by the horse "La Plaie" and was used by Charles XI during the Scanian War in 1676. (We also know that at least one of the French saddles was used during the Scanian War.) The yellow and flame-colored caparisons belonged to the horses "Le Frontinaux" and "Le Crillan," respectively. We do not know to which horse the gold caparison belonged, for the saddle—carrying the name and number of the horse—has not survived. The horse blanket was meant to be laid over the saddle and caparison when leading the horse by the reins.

The saddles, caparisons, and other accessories are lavishly decorated with gold and silver embroidery in the elaborate baroque style evolved at the Gobelins by Charles Le Brun and known from the prints of Jean Lepautre. Each set of saddle equipment is specially composed in terms of color and form. Thickly embroidered acanthus designs predominate as the basic pattern, enclosing trophy groups, flowers, birds, fighting beasts, and monograms. Sophisticated techniques have been used: appliqué embroidery in high relief, with exquisite shading and nuances achieved by means of colored silks. This important political gift is a unique example of the extraordinary level of mastery achieved by French seventeenth-century embroiderers in creating intricate three-dimensional patterns. A.T.-J./N.D.

BIBLIOGRAPHY: Lenk 1949, 213ff; Astrid Tydén-Jordan, "Harnachement français: Partie du présent politique de 1673, Versailles à Stockholm," *Nationalmusei skriftserie* 5 (1985), 239ff; Astrid Tydén-Jordan, "Sadelmundering ur franska gåvan 1673: Kung Sol i Sverige," *Nationalmuseum catalogue* 40 (Stockholm, 1986), 48; *The Royal Armoury* (Stockholm, 1978), 32f.

52

Pair of Flintlock Holster Pistols 1670

French; D. G. de Foullois the Younger, fl. c. 1670–1675

engraved steel; inlayed and engraved silver; walnut ("Bois de Grenoble")

51.4 (20¼) long, 12.9 mm caliber; 51.7 (20⅜) long, 12.8 mm caliber

Royal Armory, LRK 3536–3537

These pistols were part of the diplomatic gift sent by Louis XIV to Charles XI in 1673. They belonged to the eleventh saddle ensemble in the series, which was of flame-colored velvet. This saddle is no longer in the Royal Armory collections, having been presented by Charles to Prince Frederick of Holstein (1671–1702), who in 1698 married Princess Hedvig Sofia (1681–1708), the king's eldest child.

The guns and pistols in the French gift, unlike the horse trappings, were not all of the latest fashion. Some were taken from the finest and most richly decorated weapons to be found in Louis XIV's collection. Four pairs of pistols, together with two single pistols and five guns, are still in the Royal Armory. The Royal Armory in Copenhagen also has a pair of pistols and a gun; and

Castle Lowenburg, near Kassel, in Germany has another gun—all given as secondary gifts by Charles XI to his relatives.

De Foullois was among the foremost French gunsmiths of his day, and this pair of pistols—signed DE FOULOIS LE IEUNE A PARIS, and FOULOIS LE IEUNE A PARIS, on the locks—are among the most beautiful of the arms included in the French gift. Guns and pistols by de Foullois are found in many collections of the world. The barrels of these pistols are round smoothbore, faceted and fluted on the breech and overlaid with engraved silver. The locks are silver with steel parts, and the walnut stocks have engraved silver inlays.

These pistols have immensely rich decorations, mostly on the triumph theme so popular at the end of the seventeenth century and appropriate for the victorious king of the powerful Swedish state. On the barrels are found the Swedish coat of arms, while on one lock Fama, the goddess of fame, blows her horn, and on the other Minerva, goddess of military art, sits among trophies. N.D.

BIBLIOGRAPHY: Hoff 1969, 268 310, colorplate 6; Lenk 1939, 81, 87-88, pl. 72; Heer 1978, 387.

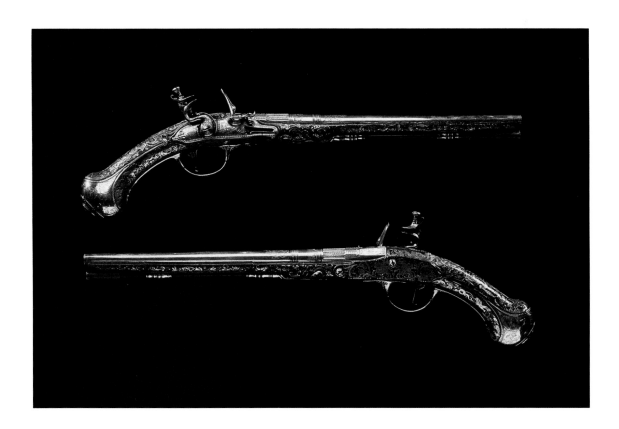

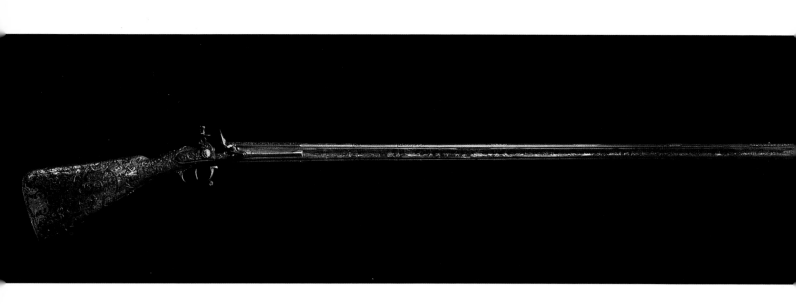

53

Double-Barreled Turn-Over Flintlock Gun
c. 1660

French; Louis le Conte, c. 1650–c. 1700; decorated by
Jean Berain the Elder, 1637–1711

blued and engraved steel; inlayed and engraved silver; gold
incrustations; walnut ("Bois de Grenoble")

160 (63) long

Royal Armory, LRK 3538

Louis le Conte was one of the leading gun masters in
the employ of Louis XIV, but few of his works have sur-
vived apart from this magnificent gun. Along with the
pistols in catalogue numbers 52 and 54, this gun was
part of the diplomatic gift from the French king to
Charles XI of Sweden in 1673. It is one of the most
beautiful guns included in the gift and was registered
first among the guns in the inventory.

The gun has two smoothbore revolving barrels of
blued steel overlaid with gold damascening. The release
for the barrel rotation is in the trigger guard. The lock
has an engraved flat plate and flat cock, with the gilt
head of the cock-screw in the form of a lion mask.
The butt of the gun is of the early French type, and the
walnut stock has richly engraved and chiseled furniture
of silver.

Jean Berain the Elder, one of the greatest French or-
namentalists and engravers of the seventeenth century,
had an uncle Claude working as a gunmaker in Paris.
In 1659, the twenty-two-year-old Jean published his
first gunmakers' pattern book, later producing two fur-
ther editions. One of Berain's favorite motifs is two
monkeys with their backs toward each other, patting a
cat and a dog, a scene to be found on the butt of this
gun. It was most unusual for a decorator to sign his
work in France at this time, as Berain has here—BERAIN
FECIT (fig. 53a)—on the stock inlays. No doubt Berain
engraved the decoration on many other fine French fire-
arms that remain unidentified.

The decoration of this gun glorifies Louis XIV, not
Charles XI. Mythological representations form the main
theme: on the barrels Minerva and Fama; on the stocks
Minerva, Fama, Mars, Amor, Venus, and Apollo; and
on the trigger guard, Minerva again. Berain's fondness
for the grotesque is shown on the cock, where an ara-
besque is developed into a man in a Phrygian cap, stab-
bing a snail with a dagger. On the back of the stock is
the principal glorification of the king, Fama riding an
eagle with the ribbon of a medallion bearing the initials
and title of the king, *LDGR*, in its beak.

53a. Berain's signature

Nearly thirty years after the gun was made, Berain played a major role in the art of design in Sweden. Nicodemus Tessin the Younger befriended the artist and collected many of his drawings (see cat. 65). Berain also designed the state coach of the Swedish kings (cat. 63). N.D.

BIBLIOGRAPHY: Hoff, 1969, 264, fig. 200; Arne Hoff, "Sideblik med antikke vogne," *Våbenhistoriske Årböger* 26 (Copenhagen, 1980), 59; Lenk 1939, 96-100, 141, 145, pls. 59-60, 117.1; Lenk, 1949, 213-235; Heer 1978, 83, 691; Hayward 1962, 1: pl. 53, 2: 36; Maurice Cottaz, *L'arme à feu portative française* (Paris, 1971), 48; J. P. Reverseau, *Les armes et la vie* (Paris, 1982), 109–110; Carl Hernmarck, "Daniel Cronströms gåva till Karl XI," *Livrustkammaren* 7 (1957), 209; Jean Berain, *Diverses pieces de Serruriers inuentées par Hughes Brisuille, Maitre Serrurier A Paris, Et grauez par Jean Berain . . .* (see Lenk 1939); Jérôme de la Gorce, *Berain, Dessinateur du Roi Soleil* (Vicenza, 1986), 16, 29, 30 (plate).

54

Flintlock Holster Pistols 1670–1673

French, by "Champion"

blued, chiseled, and engraved steel, with gold incrustations; walnut with engraved silver inlays

34.6 (13⅝) long, 13 mm caliber

Royal Armory, LRK 3542–3543

These pistols are signed CHAMPION on the barrel tangs and CHAMPION A PARIS on the locks. Among the Paris gunmakers commissioned to work on Louis XIV's gift to Charles XI, Champion is the least known master, but in technical and artistic quality, his pistols rival the finest weapons included in the gift. The barrels of his pistols are of blued steel, round with a faceted breech overlaid with gold. The locks are of rounded form, with engraved decoration, and the walnut stocks have profuse engraved silver inlays.

The decoration is influenced by the pattern books of Berain, Thuraine, and Le Holladois (see Lenk). It includes no mythological scenes, but the lockplates are engraved with human heads and nude female figures; the thumb plates with the Swedish three crowns; and the trigger guards with buzzards holding snakes in their beaks. N.D.

BIBLIOGRAPHY: Hoff 1969, 31, fig. 235; Lenk 1939, 96, 100, 143, 144, pl. 73.3, 74.1-2; John F. Stockel, *Haandskydevaabens bedømmelse* (Copenhagen, 1943), 203.

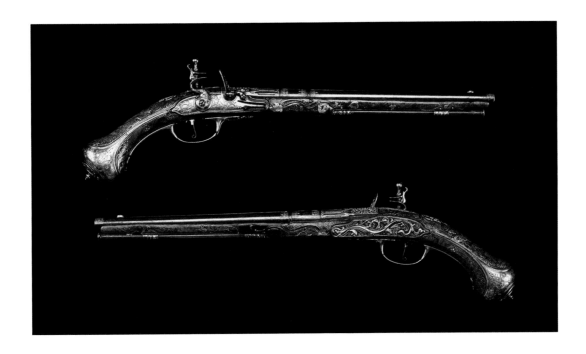

Hedvig Eleonora 1636–1715

HEDVIG ELEONORA WAS BORN in 1636 at Gottorp Castle in the north German duchy of Holstein-Gottorp. Her father, Duke Frederick III, was a sworn enemy of his northern neighbor Denmark, so a marriage between the German princess and the king of Sweden, one of Denmark's other historical enemies, seemed logical. Hedvig Eleonora was therefore sent to Stockholm at the age of seventeen, and on the day after her eighteenth birthday she was married to Charles X. He was fourteen years her senior and had been proclaimed king of Sweden just a few months before.

One year later, in November 1655, Hedvig Eleonora gave birth to their only child, the future Charles XI. But after only five years of marriage, Charles X died suddenly of pneumonia, and Hedvig Eleonora found herself chairman, with two votes, of the regency administration appointed for the minority of her son. She soon tired of the business of government, however, and the other members of the regency carried on alone, needing only her signature.

Hedvig Eleonora doted on her fatherless son, but the rest of her time and money were devoted to the arts, especially building: she refurnished and enlarged Gripsholm Castle, had new castles built at Strömsholm and

Drottningholm, and redecorated at Vadstena and Ulriksdal. The royal architects were Nicodemus Tessin, father and son, and the new settings designed by them called for sculptors, plasterers, painters, landscape gardeners, craftsmen of all kinds. It was due to Hedvig Eleonora, in fact, that Sweden was able to establish an artistic output and tradition of its own during the second half of the seventeenth century. In 1659 she had prevailed upon her husband to make David Klöcker von Ehrenstrahl the court painter. And during his long career in Sweden, Ehrenstrahl taught a number of Swedish and foreign painters in Stockholm and organized them into a service for projects for the crown and nobility.

Hedvig Eleonora was also, after Christina, the most important royal collector in early Swedish history. She had a treasury at Ulriksdal that was filled with objects, and the range of her taste may be surmised from an inventory of her belongings at Drottningholm made in 1719: 350 pieces of oriental porcelain and Dutch faience, along with porcelain dolls, ivory boxes, and vessels of rock crystal and marble mounted in gilt silver and enamel. She even kept a crystal cutter, Christoffer Elsterman, who engraved many pieces for her. U.G.J.

Detail, cat. 60

55

Miniature Monkey Playing the Violin and Miniature Frog late seventeenth century

pearls, gold, and enamel

monkey, 2.2 (⅞) high; frog, 4.4 (1¼) high

Royal Collections, ss 4, ss 6

The collections of Queen Hedvig Eleonora included a number of miniature objects of various characters and materials. In 1685, for example, the queen purchased about twenty-five miniatures from her Dutch art agent, Carl Chr. Mandel. It was typical of the time that the bill remained unsettled until 1689. Of the two miniature animals shown here, only the frog was included in the 1685 consignment. The acquisition date of the monkey is uncertain.

It was a supremely fashion-minded queen who incorporated these objects in her collection. During the second half of the seventeenth century, miniatures like these, very often composed around an irregular, or "baroque," pearl, came to be included in all notable royal collections in Europe. G.A.

BIBLIOGRAPHY: Stockholm 1930–1931; Fogelmarck 1982.

Enlarged

Enlarged

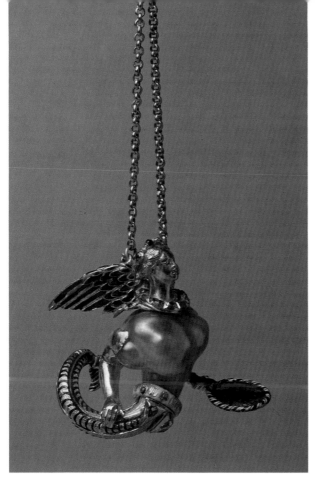

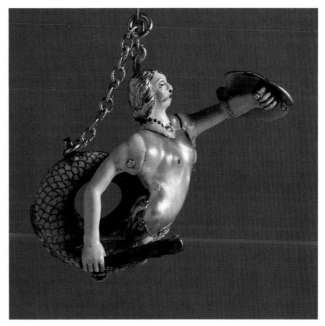

Enlarged Enlarged

56

Hedvig Eleonora's Pendants c. 1600

pearls, gold, enamel, and diamonds
siren, 4 x 2.7 (1½ x 1); triton, 4 x 3.5 (1½ x 1⅜)
Royal Collections, ss 223, ss 224

During the second half of the sixteenth century and the early years of the seventeenth, a new kind of jewelry became fashionable in Europe. Skillful, imaginative goldsmiths created pendants in the form of animal or human figures, with an irregular pearl for the bodies. It was the curious shape of the pearl that suggested the final form of the pendant. In the catalogue of the Waddesdon Bequest in the British Museum, Hugh Tait writes as follows concerning these baroque pearls, as they were often called: "They were a novelty in Europe, having been discovered in the waters of the New World and no doubt were associated with tales of exploration, of danger in uncharted seas."

The Royal Treasury collection includes a large number of pendants, some of which had belonged to the Swedish royal family before Hedvig Eleonora's time. Others were purchased by the queen herself. It is impossible now to say when the two jewels exhibited here were acquired, because they are not identifiably described in the inventories until after the queen's death in 1715.

The triton pendant is also a secret cruet, with the fish-tail opening to reveal six compartments for different spices. G.A.

BIBLIOGRAPHY: Stockholm, 1930–1931; Steingräber 1969; Fogelmarck 1982; Stockholm 1966; *Princely Magnificience: Court Jewels of the Renaissance 1500–1630* [exh. cat., Debrett's Peerage Limited, with Victoria and Albert Museum] (London, 1980).

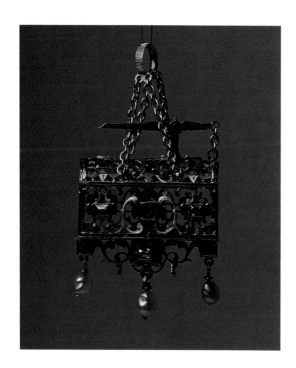

57

Mousetrap Pendant c. 1600

German?

gold, enamel, diamonds, rubies, and pearls

3.9 (1½) long

Royal Collections, ss 222

Known portraits of the ladies of the Swedish family in the late sixteenth and early seventeenth centuries give a clear indication of the way accessories were worn and which forms were in fashion. Pendants were very popular, for instance. They could be attached to a suitable necklace or could in themselves constitute the principal decoration, in which case they would simply be suspended from a thin gold chain. Pendants could also be worn as brooches, with large, richly adorned necklaces. Cameos or cut precious stones, surrounded by an elaborately worked gold frame, were the most typical kind of pendant. Less common were highly miniaturized reproductions of everyday objects, such as the mousetrap on exhibition here.

On 25 March 1630 the Chamber of Receipts drew up an inventory of "His Majesty's possessions" that describes "a mousetrap encrusted with diamonds and rubies and with -Z [abbreviation for '1'] suspended pearl inside. Weight 141/4 kronor. Lining to be made for." This description makes the mousetrap pendant the earliest item in the Royal Treasury collection identifiable from an inventory. It can be traced through the documents of the Chamber of Receipts until 1828, when it was transferred, with other heirlooms, to the institution now called the Museum of National Antiquities. There it was incorporated in the Royal Treasury collection composed of items from various royal residences.

This mousetrap pendant is an exquisite example of European goldsmithwork c. 1600. South Germany has been suggested as a likely place of manufacture, but the style is so general in character that the pendant could have been made at any one of several leading Continental centers of the goldsmith's art. G.A.

BIBLIOGRAPHY: Stockholm 1930–1931; Steingräber, 1969; Erich Steingräber, *Alter Schmuck: Die Kunst des europäischen Schmuckes* (Munich, 1956); Fogelmarck 1982; Stockholm 1966.

58

Agate Bowl early fifteenth century (?)
with late seventeenth-century mounts

Prague?

agate set with amethysts, gold, rubies, and enamel

21.5 (8½) diam.

Royal Collections, SS 39

This bowl, turned from a single agate, is the oldest arti-fact in the Royal Treasury today. A similar agate bowl, retaining its original gold setting and dated to the mid-fourteenth century, is in the Kunsthistorisches Museum, Vienna. That bowl is presumed to have been made in the court workshop of Emperor Charles IV in Prague. Comparison of the two pieces suggests that the Stock-holm bowl was very likely made in the early fifteenth century, probably also in Prague.

During the work on this exhibition catalogue, one of the world's leading specialists in applied arts of this type has suggested that the Stockholm bowl might be more than one thousand years older than we have proposed. According to this new opinion, the agate bowl should be considered late Roman and dated c. 300 A.D. Efforts must be made to investigate the evidence in support of this theory, but for the time being we prefer to retain the traditional date and attribution.

This bowl was brought up to date in the seventeenth century with the substitution of new, fashionable mounts for the earlier setting. Perhaps larger mounts were used to conceal the marks of the former setting. This bowl once belonged to Queen Hedvig Eleonora and formed part of her collection at Ulriksdal, where it was one of the more valuable items. G.A.

BIBLIOGRAPHY: Stockholm 1930–1931; Fogelmarck 1982; Steingräber 1969.

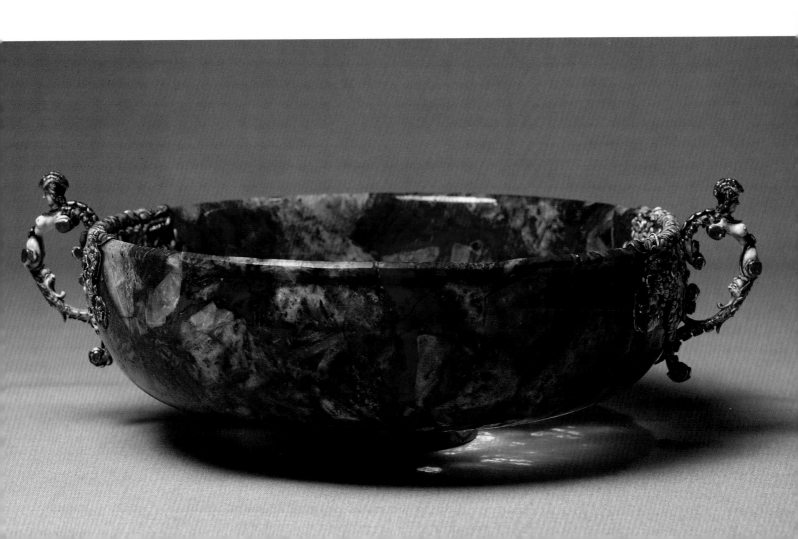

59

Rock Crystal Tankard 1650–1675

German/Bohemian?

jug of rock crystal; lid, handle, mounts, and foot ring of gold, decorated with enamel, diamonds, sapphires, and rubies

14.6 (5⅞) high

Royal Collections, ss 220

The simplicity of the cylindrically turned rock crystal jug makes an effective foil to the extravagant decoration of the lid, handle, and foot ring. This combination of opposites is an artistic device typical of the baroque period, used both in large-scale and small-scale projects. South Germany and the city of Augsburg have been mentioned by earlier scholars as possible places of origin. Another possibility is Bohemia, which was also well known for its high quality enamel work at this time; in addition, many of the finest stonecutters of the period were active in Prague.

The jug is first identifiable in the testamentary documents drawn up following the death of Queen Hedvig Eleonora. It is mentioned as a crystal jug with a lid, handle, and foot of enameled gold decorated with diamonds, rubies, and a large sapphire. The jug may have been in Sweden since the mid-seventeenth century, however, even though it is not mentioned in the inventories. The difficulty of establishing the history of various objects in the collection is suggested by the discrepancy between Queen Christina's inventory of 1652, which lists ten objects of rock crystal in her art cabinet, and an account of her abdication two years later, which states that the queen took twelve objects of rock crystal with her to Rome. Did the collections at Stockholm's Three Crowns Castle include pieces of rock crystal omitted from the inventories? All we know is that the royal treasury collection today includes about twenty-five items of rock crystal, most of which, to judge by their age, could have belonged to Queen Christina. G.A.

BIBLIOGRAPHY: Stockholm 1930–1931; Fogelmarck 1982.

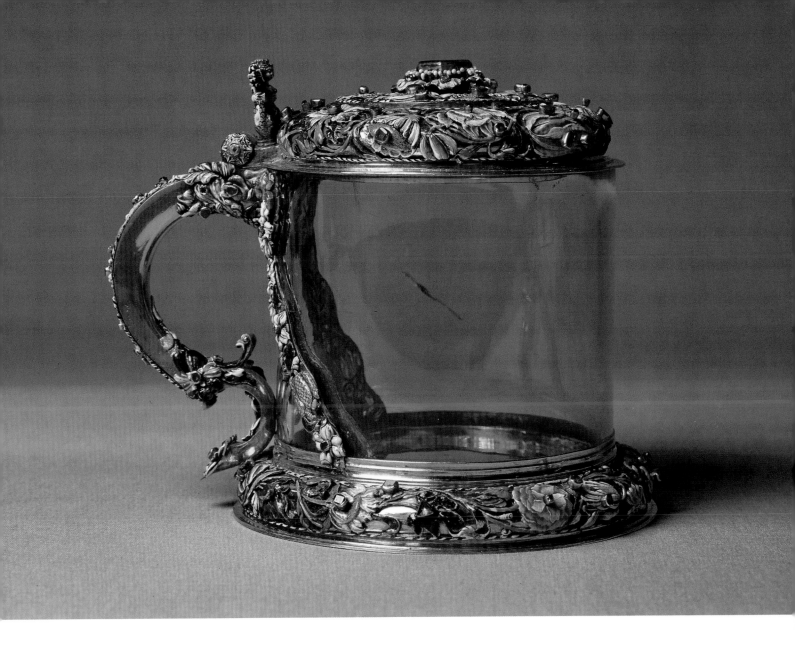

60

Cameo Bowl mid-seventeenth century

Dutch?

gilt silver, enamel, cameos

17 (6⅝) high

Royal Collections, ss 22

This covered bowl is one of the most extraordinary objects from the collection of Hedvig Eleonora, a verdict already pronounced in the queen's lifetime. The Ulriksdal inventory of 1719 describes the bowl and assigns it a value over four times greater than that of any other object in the queen's collection, including a large ivory clock 31½ inches high. It is not clear how the bowl came to the Royal Collections. Although it was probably made in the mid-seventeenth century, it cannot be identified in the inventories until 1719, by which time it had presumably belonged to Hedvig Eleonora for decades.

The richly enameled bowl is decorated with flowers and birds against a turquoise ground, and there is a painted landscape under the foot. The outsides of the lid, bowl, and foot are also adorned with cameos of different materials depicting a variety of subjects. Portraits of Roman emperors mingle, for example, with fabulous beasts and a portrait of Queen Elizabeth I of England. The large cameo in the center of the lid may represent Judith with the head of Holofernes. It is difficult indeed to elicit a coherent pictorial program from these highly varied images.

Earlier scholars thought that the bowl was made in Bohemia, but Holland is now taken to be a likelier place of origin. The Rosenborg Collection in Copenhagen and the Landgrave's Collection in Kassel include similar bowls, with Holland specified as the probable country of origin in both cases. G.A.

BIBLIOGRAPHY: Stockholm 1930–1931; Fogelmarck 1982; Stockholm 1966; Steingräber 1969.

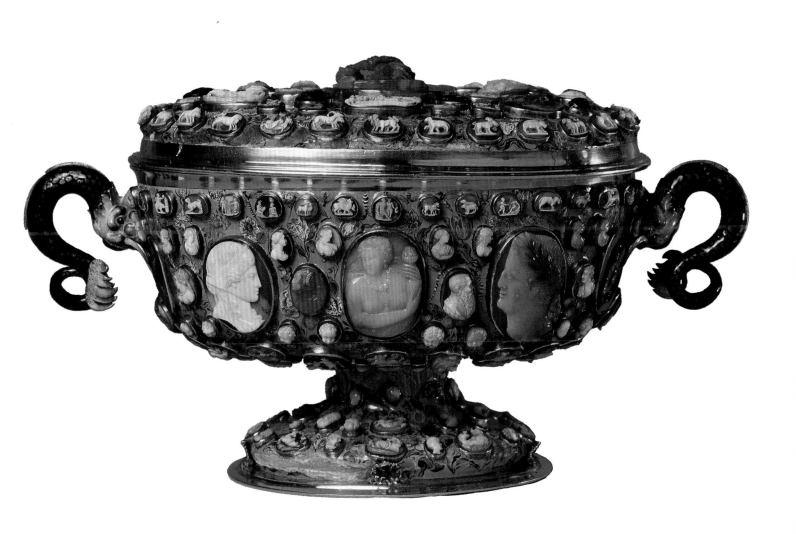

Charles XII 1682–1718

CHARLES XI DIED of cancer in April 1697 at the age of forty-two, when his son and heir was only fourteen years old. The new monarch, Charles XII (Karl XII), turned fifteen that June and was declared of age in November. He was crowned king of Sweden in the Storkyrkan in December, dissolving his regency administration. It is not known whether Charles XII felt any desire to perpetuate the warlike traditions handed down by his father and grandfather. But he had no choice, for Denmark, Poland, and Russia moved against Sweden almost immediately upon the accession of the adolescent king, at a time of apparent weakness. The purpose of the anti-Sweden alliance was to obliterate Swedish influence in spheres of interest outside territorial Sweden—which to Denmark meant Holstein-Gottorp; to Poland, the Livonian territories; and to Russia, all the other Baltic territories and their ports.

At the beginning of 1700, the Poles attacked Riga, the Danes invaded Holstein, and the Russians entered Ingria. Charles XII left Stockholm that summer never to return. Assisted by his allies, Holland and England, Charles landed in Denmark, forcing that country to sue for peace. He then turned eastward, and over the next few years led the Swedish armies to an unbroken series of victories: Narva, Dvina, Klissow, Holowczyn. The legend of Charles' invincibility rivaled that of Gustavus Adolphus, and he was quickly ranked as the greatest military leader of his era. His defeat at the hand of Peter the Great at the Battle of Poltava in 1709 ended Charles' record of successes, however, and marked the beginning of the end of Sweden's status as a great power.

Charles XII took refuge in Turkey, remaining there for five years while negotiating for allies and money with which to mount a war of revenge against Russia. He finally returned to Sweden in December 1715, landing in Skåne. Then in October 1718 he mobilized 20,000 men to march on Norway. But on 30 November, while on the Norwegian campaign, a stray bullet from the Norwegian lines (or a well-aimed one from a Swedish musket) ended the life of the man whose enormous expenditures and great sacrifices of lives on the battlefield had brought his country to the verge of collapse. At the time of his death, Charles XII was thirty-six years old.

U.G.J.

61

Charles XII 1701

Axel Sparre, 1652–1728

gouache, gold and silver frame encrusted with uncut emeralds

12.7 (5) high

Royal Collections, ss 258

This portrait of Charles XII was painted by the Swedish artist Axel Sparre in 1701 when the king was in Russia at the head of the Swedish army. On 26 July of that year the Swedish army captured the town of Bauske in Courland, as is recorded in a blue enamel inscription on the reverse of the medallion. The portrait is of the young king as a victorious warrior, plainly dressed in armor and a fur-edged tunic.

The artist Axel Sparre was a Swedish nobleman who served during the Russian war as a colonel in the Swedish army. He was also one of Charles XII's closest friends. This portrait is the first one known to show the king without a wig, and it set the fashion for all subsequent portraits of the king. Its military austerity makes an effective contrast to the luxurious design of the frame, which together with the royal crown, is made up of uncut emeralds and other precious stones long since vanished (presumably diamonds). The portrait served as a pendant and was probably worn by Dowager Queen Hedvig Eleonora as a "domestic order" at solemn ceremonies. This would have been appropriate since she represented the royal family in Stockholm while the king was engaged in war abroad. Even today, ladies of the Swedish royal family wear the present king's portrait in a frame of diamonds on gala occasions.

The reverse of the medallion previously enclosed an allegorical enamel painting: a vertical scepter irradiated by the eye of God and encircled in a sun. Behind the sun can be seen cloud formations and flashes of lightning. The motto of the allegory is IT HARMS NOT. G.A.

BIBLIOGRAPHY: Stockholm 1930–1931; Fogelmarck 1982.

Nicodemus Tessin the Younger 1654–1728

NICODEMUS TESSIN THE ELDER (1615–1681) came to Sweden from Germany at the age of twenty-one, hoping to find patrons in the newly powerful country. After ten years, he had performed so creditably that he was appointed royal architect. Nicodemus Tessin the Younger was born in 1654, the year of Queen Christina's abdication and departure from Sweden. Thanks to his father's position, he was assured of a fine career, and when only twenty-two years old was appointed royal architect. With a royal pension, he was able to devote several years to an educational tour of Italy and France. Queen Christina, then living in Rome, introduced him in the best circles, and he absorbed the Italian high baroque, as represented above all by Gian Lorenzo Bernini and Carlo Fontana.

Three years after his return to Sweden, Tessin's father died and he took over several works in progress. His principal assignment was Drottningholm Palace, which had burned down in 1661 soon after its acquisition by the young dowager queen, Hedvig Eleonora. It had been redesigned by Tessin the Elder. The son now com-

pleted some of the interiors, finished the chapel, and supplied drawings for gardens in a supremely French baroque style, complete with parterres after the manner of Le Nôtre. In his work at Drottningholm, Tessin the Younger could be said to present a formula by which he was principally guided thereafter: Italian, above all Roman taste is apparent in his churches and in the facades of the secular buildings, whereas the interiors, like the grounds, bear an emphatically French imprint. Tessin was indeed a great borrower, but an intelligent one, never slavishly imitating his artistic models.

As Charles XI established his absolutist government in the 1680s, Tessin's role as court architect expanded to include festive and funeral decorations and the increasingly elaborate furnishings of the court. He expanded the Royal Buildings Office and sent an official representative to work permanently in Paris keeping him informed about new developments in the arts and recruiting artists for Stockholm. Tessin came to see himself as an expert in the autocratic life style; his services and advice were sought abroad, and he actually wrote a "how-to" treatise, informing his contemporaries about the history and state of the art of interior design. He admitted the superiority of a few foreign designers and tried, when he could, to commission them to design major works. Jean Berain the Elder, Louis XIV's draftsman of the king's chamber, was commissioned to design the decoration of a Swedish flagship and a state coach. In Tessin's mind, only the best available design was suitable for his monarch.

Tessin's chef d'oeuvre, as befitted a royal architect, was Stockholm's new Royal Palace. Shortly after Charles XI's death, the old castle caught fire and was completely devastated, except for the wing that had just been modernized and rebuilt to Tessin's drawings. Immediately after the fire, Tessin presented detailed plans, facades, and sections for a new palace to the dowager queen, Hedvig Eleonora, herself an inveterate builder. Work began at once. His own exquisitely composed residence was situated opposite the south front of the palace and was by far the most elegant town residence of its time in Sweden. U.G.J. and G.W.

62

Embroidered Upholstery for the Interior Rear Wall of the State Coach of Charles XI and Charles XII
1696–1699

design by Jean Berain the Elder, 1637–1711; embroidery by Tobias Leuw; painted silk appliqué by Jacques Foucquet

silver and gold fabric (moiré) with silk embroidery and painted silk appliqué

138 x 134 (54⅜ x 52¼)

Royal Armory, 5722.1

In February 1696, a year before fire consumed the Three Crowns Palace in Stockholm, another fire swept through the Royal Stables. All of the royal carriages were destroyed, among them the coronation coach and three other coaches made in France in the 1670s for Charles XI. Nicodemus Tessin the Younger immediately ordered a new state coach from Paris for the king. Drawings were prepared by Louis XIV's coachbuilder, and the decoration was provided by Jean Berain, "designer of the king's chamber."

The body of the new coach was made in Paris and shipped to Sweden, but by the time it arrived in Stockholm in May 1697, Charles XI was dead. It was not assembled and decorated until 1699, when minor alterations were made to Berain's designs to relate them more closely to the young King Charles XII. This work was completed by the foremost French sculptors, painters, and silversmiths employed on the new Royal Palace in Stockholm. The external and internal embroideries were done in 1699 by Tobias Leuw, an embroiderer of German origin; and the silk appliqués were painted by the Frenchman Jacques Foucquet.

The carriage was intended for use as Charles XII's wedding coach, and the allegorical paintings were adapted accordingly, but the king never married. Instead the coach was first driven in July 1699, when Charles honored his sister Hedvig Sophia and brother-in-law Duke Frederick of Holstein-Gottorp with a state entry into Stockholm. Among all coaches of the highest royal rank, this is the oldest surviving coach of the classical French type known as *carosse moderne*.

Jean Berain's designs for the decoration of the coach were carefully worked out, and they represent the artist's delicately linear ornamental style at its most mature. This style evolved from the Italian grotesque, and through the medium of engraving, it was a major influence on interior design and fine arts throughout Europe. The interior of this coach has points in common with the ceremonial rooms of palace apartments built in France during the baroque era, with floor and ceiling

incorporating the same general patterns. The roof or imperial of the coach should have been given the form of a star-spangled heavenly dome, but for lack of time it was decorated with a flat rosette oval instead. Its design is reflected in the boulle inlay (turtle shell and brass) of the coach floor, in which the central oval, like a reflected image of the ceiling's oval with stars, is filled with flowers.

Berain's drawings for the upholstery of the rear wall of the coach (see cat. 63) have been followed with one exception: the border has been removed because Tessin felt this would make it possible to enlarge the figures, thus rendering the whole composition more monumental. Tessin also changed the color of the background, choosing brilliant silver fabric instead of blue velvet.

The textiles were removed from the coach in 1751 when it was partly modernized for the coronation of Adolph Frederick and Lovisa Ulrika. The coach remains largely as it was after that alteration and occupies a central position in Swedish ceremonial history, having been used from 1751 until the end of the nineteenth century as a coronation coach for the queens of Sweden. A.T.-J.

BIBLIOGRAPHY: Tydén-Jordan 1985; Astrid Tydén-Jordan, "Projet de décoration de Jean Berain pour la carrosse de gala de Charles XI de Suède," *Versailles à Stockholm* (Nationalmusei skriftserie 5) (Stockholm, 1985); Tydén-Jordan 1984, 12; Astrid Tydén-Jordan, "Jacques De Meaux," *Svenskt biografiskt lexikon,* Häfte 122, bd 25 (Stockholm, 1985); Astrid Tydén-Jordan, "Karosser," in Stockholm 1986, 44ff; Carl Hernmarck, "Jean Berains förslag till galakaross för Karl XI," *Kunglig prakt från barock och rokoko* (Nationalmusei handteckningssamling 5) (Malmö, 1948); Carl Hernmarck, "1699 års kröningsvagn," *Livrustkammaren* 6 (1952), 1–2; Rudolf H. Wackernagel, *Der französische Krönungswagen von 1696–1825* (Berlin, 1966); Rudolf H. Wackernagel, "Festwagen," *Reallexikon zur deutschen Kunstgeschichte* 87–88 (Munich, 1982–1983); *The Royal Armoury* (Stockholm, 1978), 54; Jérôme de la Gorce, *Berain: Dessinateur du Roi Soleil* (Paris 1986), 55ff.

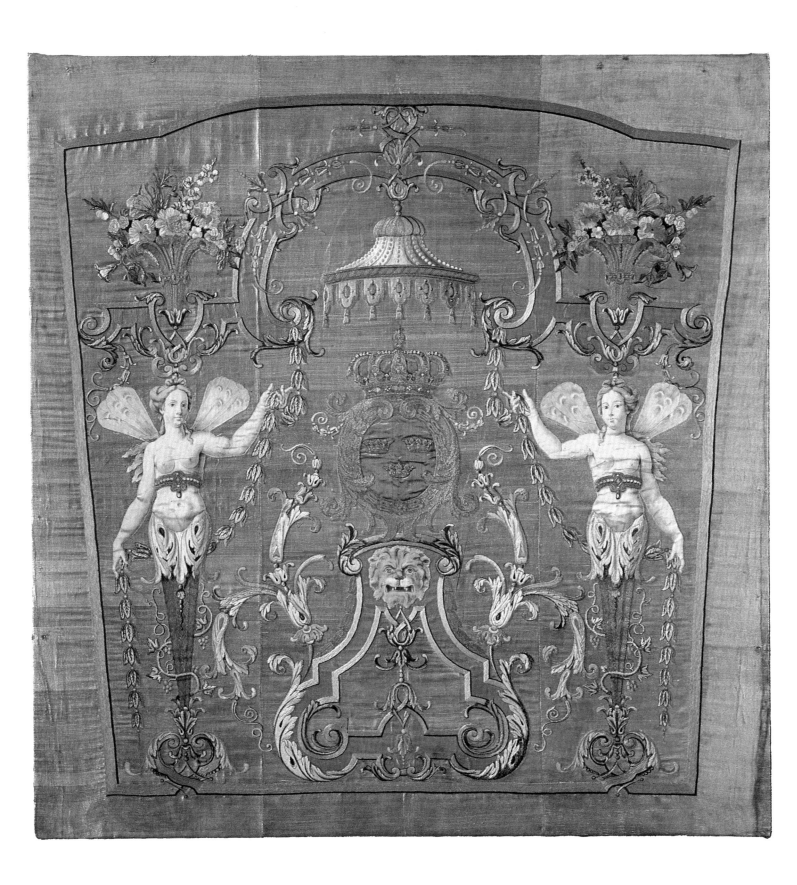

63

Drawings for a State Coach for Charles XI
1696

workshop of Jean Berain

pen and black ink, watercolor

ceiling, 19.8 x 20.8 (7¾ x 8⅛); back, 21 x 20.2 (8¼ x 7⅞)

Nationalmuseum, THC 930, 925

Nicodemus Tessin the Younger, in his capacity as royal architect, was responsible not only for building activities but also for the overall aesthetic organization of court life and entertainment. This included interior decoration, furniture and other applied arts, decorations for ceremonial occasions, stage design, and costumes for masquerades. Tessin sought out the best European models and adapted them for these purposes, or he ordered designs from other artists. He was constantly on the lookout for prints and drawings that could be of use or simply would keep him informed. In architecture he favored the Roman baroque, but for interior decoration and other needs he turned to Versailles and the court there.

The Swedish envoy Daniel Cronström reported to Tessin on the work going on at the French court. He made friends with the artists and collected their drawings. When he could not get the originals, he commissioned copies, and he constantly strove to add to Tessin's collection, filling in gaps whenever possible. Occasionally, Cronström negotiated the purchase of whole groups of prints and drawings. He also served as intermediary and advisor for Tessin's many commissions for the court and for members of the Swedish nobility. Whenever possible the artists who worked for the French king were used. Tessin himself met the French artist Jean Berain in Paris in 1687 and remained a life-long friend and admirer. His collection of Berain's works in Stockholm was therefore extensive.

Berain produced a series of sketches for a state coach, and in August 1696 sent to Stockholm finished drawings suitable for presentation at the court. Eight of Berain's drawings are preserved, showing the main aspects of the exterior, the decoration of the interior, and some details. The exhibited drawings are for the ceiling and back panels inside the coach. The stars in the center of the ceiling in the drawing are an allusion to Charles XI's motto, *Nescit occasum*. The surrounding ornamentation cleverly uses the king's monogram, the letter *C* with a mirrored *C* intertwined. This ceiling design was substantially modified in the finished coach (see cat. 62). B.M.

BIBLIOGRAPHY: Carl Hernmarck, "Jean Berains förslag till gala-kaross för Karl XI," *Kunglig prakt från barock och rokoko* (Nationalmusei handteckningssamling 5) (Malmö, 1948), 63-83; Carl Hernmarck, "1699 års kröningsvagn," *Livrustkammaren* 6 (1952), 1-2; R.-A. Weigert and Carl Hernmarck, *L'Art en France et en Suède 1693–1718: Extraits d'une correspondence entre l'architecte Nicodème Tessin le jeune et Daniel Cronström* (Stockholm, 1964), 138ff.; Rudolf H. Wackernagel, *Der französische Krönungswagen von 1696-1825* (Berlin, 1966), 66ff.; Tydén-Jordan 1985, pl. 2; Paris, Hôtel de Marle, *Versailles à Stockholm* (Stockholm, 1985), nos. R6 and R5.

64

Model for an Equestrian Statue of Charles XI
1699

Bernard Foucquet, fl. 1640–1711

bronze

65 x 53.5 (25½ x 21)

Royal Collections, 63

The architect Nicodemus Tessin the Younger prepared drawings for a new Royal Palace to replace Three Crowns Castle, destroyed by fire in 1697. But he also wanted to surround the building with a magnificent townscape in the Italian baroque style. The inner courtyard of the palace was the focal point of this vision. A parade ground, measuring almost 262 x 295 feet, it was to resemble an Italian piazza or a Parisian ceremonial square such as the Place Vendôme. Tessin planned a gigantic equestrian statue of Charles XI as the centerpiece of the courtyard.

As usual, the architect closely specified the design of the statue, but the construction of a model was entrusted to Bernard Foucquet, a French sculptor working on the palace and a pupil of François Girardon. Foucquet's work followed the French tradition. Some twenty different equestrian statues of Louis XIV had been planned at this time, and Girardon was in fact working on one for the Place Vendôme. It is obvious that both Tessin and Foucquet were inspired by this French sculptural tradition, but Foucquet invested his work with an original force and vitality.

Sebastian le Clerc prepared a perspective drawing of the monument, with the metal parts painted gold and the model painted yellow. This drawing shows that the sides of the base were to be decorated with reliefs, and the corners marked with frieze sculptures extolling the virtues of the king: strength, justice, moderation, and wisdom. Le Clerc's drawing was sent to Paris for examination by the foremost French experts. It was even shown to the king of France, Louis XIV. Daniel Cronström, a Swedish diplomat in Paris, wrote to Tessin in Stockholm:

> They find: The figure proud and beautiful. The horse noble and tasteful. The virtues on the pedestal well conceived and originally devised. The bas reliefs rich. The form of the base beautiful and the whole very beautiful. One would like: The field marshal's baton to be made shorter, the upper part of the base to be made longer, the cornice to have greater depth. They find that the cornice, which is underneath the moulding, does not accord with taste here, any more than the semi-circular moulding underneath, that the bas reliefs are too large, that the swords and spears of the figures will be liable to get broken in a public place, and also that the repetition of the two steps in the base detracts from the beauty of the foundation. . . .

The grandiloquent dream of an equestrian monument to Charles XI never advanced beyond a bronze model and another version, now lost, cast in silver. The new Swedish king Charles XII took an active part in rebuilding the Royal Palace, but was not interested in sculpture. As a result, a number of Tessin's sculptural projects for the palace were never realized, the equestrian statue included. The king's representative, Casten Feif, informed Tessin: "His Majesty feels, moreover, that the statue to be installed in the courtyard will not only detract from its beauty but will also obstruct the beautiful view otherwise obtainable all the way from the outer courtyard through both wings as far as Djurgården or Skeppsholmen. . . ." This shows clearly the considerable personal involvement of the king in the artistic projects of his reign, which continued even when he was abroad in the field. G.A.

BIBLIOGRAPHY: Hjalmar Friis, *Rytterstatuens Historie i Europa* (Copenhagen, 1933); Ragnar Josephson, *Nicodemus Tessin d.y.*, 2 vols. (Stockholm, 1930-1931); Andreas Lindblom, *Fransk Barock- och Rokokoskulptur i Sverige* (Uppsala, 1923); Stockholm 1986.

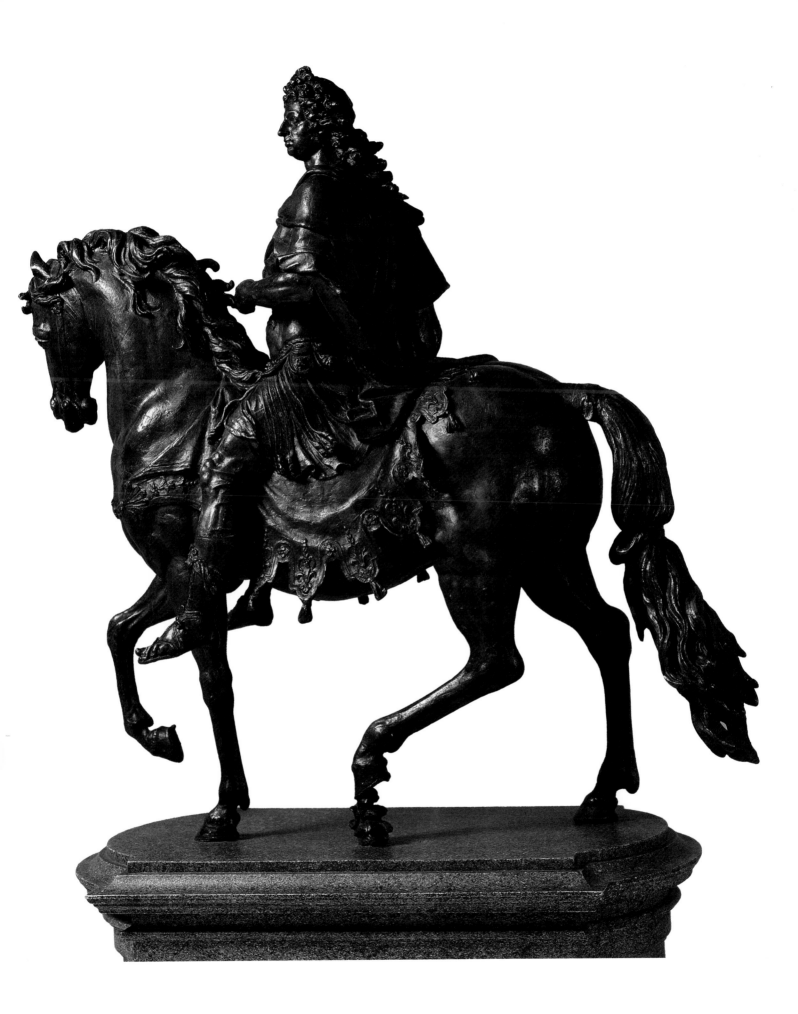

65

Design for a Ceiling in Nicodemus Tessin's Palace in Stockholm

René Chauveau, 1663–1722

pen and black ink, watercolors

47.8 x 58 (18¾ x 22¾)

Nationalmuseum, THC 4870

The building of the new Royal Palace in Stockholm was the greatest artistic achievement of its time in Sweden. Construction began in the late 1690s and continued into the 1750s. French artists and artisans were called in, and their work was influential in the development of the Swedish art of design. The first tangible result of their skills, however, was the royal architect Tessin's own house, erected just opposite the Royal Palace, on the south side, and completed while nothing more than the foundations of the south facade of the palace were laid. Tessin's house was largely finished by 1697, but work on the interior decoration continued for another four years.

The most important feature of the interior is a suite of state rooms—salon, anteroom, and bedchamber—elaborately decorated according to contemporary French taste. For this task, Tessin employed the French artists who were working on the Royal Palace. The drawings for the ceilings were worked out by René Chauveau from Tessin's program. Chauveau, who was active in Sweden from 1693 to 1700, was actually a sculptor, but his facility as a draughtsman made him well suited for a project of this kind. Among his other works are sculptures for the Royal Palace, reliefs for Tessin's house, as well as designs for festive occasions, including fireworks.

The decoration of the anteroom in Tessin's house is the most restrained of the three rooms. The predominant colors are blue and gold, and the ceiling includes fewer figures than the adjoining ones. This note of austerity corresponded to the program for the room, which was "the contentment brought about through the study of philosophy." Inserted into the ornament of the ceiling are ten portraits of Greek philosophers; and in the four corners are small scenes depicting the defeat of Avarice, Fraud, Arrogance, and Lascivity.

The ornamental character of the ceiling closely resembles that of the ceiling for the Hôtel Mallet that Jean Berain the Elder designed in Paris. Tessin had acquired drawings of that ceiling, which are still in the Nationalmuseum's collections (THC 4682-4687). Tessin's ceilings were executed by another of the French artists in Stockholm, Jacques de Meaux, who had been working with Berain in Paris. De Meaux arrived in Stockholm in August 1697, and probably went to work at Tessin's house immediately. The ceilings were finished in the spring of 1699, and remain in place today. B.M.

BIBLIOGRAPHY: W. Legran (F. U. Wrangel), *Tessinska palatset* (Stockholm, 1912), 11ff.; Ragnar Josephson, *Nicodemus Tessin d.y.*, vol. 2 (Stockholm, 1931), 178ff., figs. 159, 160; A. Laine, *Invention och imitation* (Stockholm, 1972), 51-63; Per Bjurström, *French Drawings*, vol. 1, *Sixteenth and Seventeenth Centuries* (Drawings in Swedish Public Collections 2) (Stockholm, 1976), no. 319; *Nicodemus Tessin d.y. 1654–1728* [exh. cat., Nationalmuseum/Tessin Palace] (Stockholm, 1978), no. 12; Stockholm 1986, no. 136.

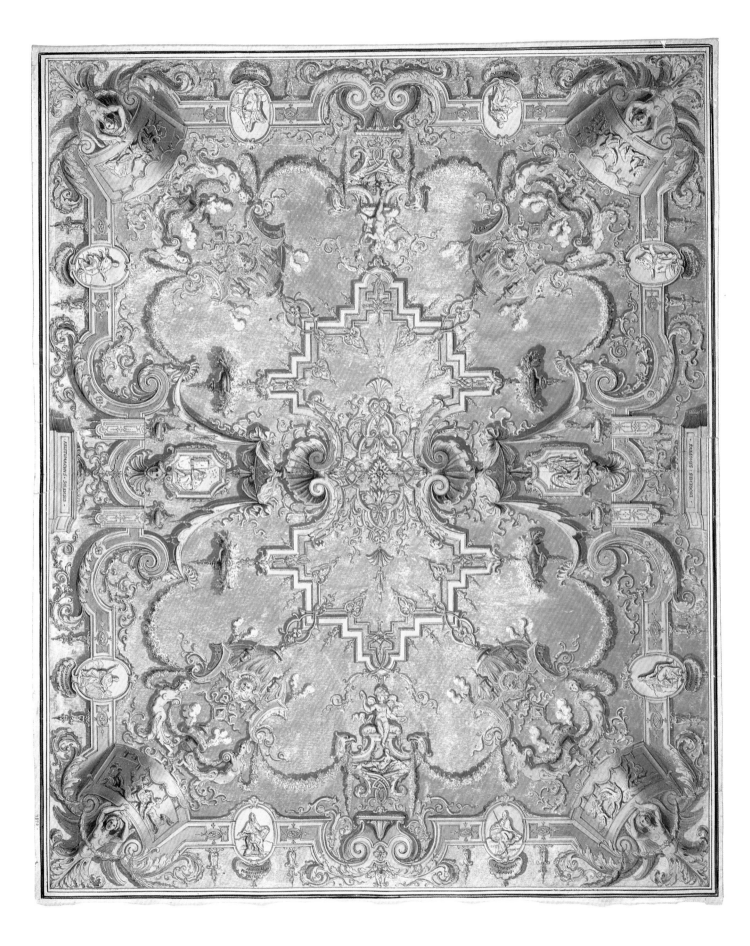

Photo credits

Credit for photographs is due as follows: Nationalmuseum, cats. 25 (Eric Cornelius), 28, 32, 36 (Alexis Daflos), 63, and 65; Royal Armory, cats. 18, 21, 22, 23, 26, 27, 29, 38, 39, 43, 44, 48, 52, 53, 54 (Per Åke Persson), and cats. 4-5, 6, 7, 8, 9, 10, 11, 15, 16, 17, 19, 20, 34, 35, 37, 40, 41, 42, 46-47, 49, 50, 51, and 62 (Göran Schmidt); the Treasury, Royal Palace, and Royal Armory (for Strängnäs), cats. 1, 2b (orb), 3, 12, 13 (Karl-Erik Granath); the Treasury, Royal Palace, and Royal Collections, cats. 2a (scepter), 14, 24, 30, 31, 33, 45, 55, 56, 57, 58, 59, 60, 61, 64 (Sven Nilsson).

Detail, cat. 2